# ACTIVATING DEMOCRACY
## The "I Wish to Say" Project

# ACTIVATING DEMOCRACY
## The "I Wish to Say" Project

★★★ EDITED by Sheryl Oring ★★★

**intellect** Bristol, UK / Chicago, USA

For Shira

First published in the UK in 2016 by
Intellect, The Mill, Parnall Road, Fishponds, Bristol, BS16 3JG, UK

First published in the USA in 2016 by
The University of Chicago Press, 1427 E. 60th Street, Chicago, IL 60637, USA
Copyright © 2016 Intellect Ltd

A catalogue record for this book is available from the British Library.

Copy-editing: Sue Jarvis
Cover Image: Courtesy of Damaso Reyes
Layout Design and Typesetting: Emily Dann and Holly Rose
Production Manager: Richard Kerr

ISBN: 978-1-78320-671-1
epdf ISBN: 978-1-78320-672-8
epub ISBN: 978-1-78320-724-4

Printed & bound by Gwasg Gomer Cyf / Gomer Press Ltd, UK.

# CONTENTS

Acknowledgments IX

Preface *Sheryl Oring* XI

Taking a Moment to Have a Say *Corey Dzenko* 01

"I WISH TO SAY:" 2004 07

PART I   Ruminations: The Artist's Perspective 31

Ruminations: The Artist's Perspective, *Sheryl Oring* 33

The Typewriter: An Ode to Its Smells, Sounds, and Tactile Responses *Sarah Shun-lien Bynum* 37

The Look: Patty and Her Avatars *Santiago Echeverry* 41

The Question: The Door to What We Most Want to Know *Chloë Bass* 45

The Camera: Coming to Terms with Photographing People *Dhanraj Emanuel* 47

The Digital Archive: Maintaining Privacy by Giving It All Away *Hasan Elahi* 49

The Paper, the Game, and the City Park: Places for Things to Happen *Lee Walton* 55

The Street: Fleeting Situations and Doings *Ed Woodham* 61

The City: The Political Equator and the Radicalization of the Local *Teddy Cruz* 67

The Road: Stories From the Navajo Nation *Stephanie Elizondo Griest* 71

Dissent: American Style *Ricardo Dominguez* 75

"I WISH TO SAY:" 2008 79

| | | |
|---|---|---|
| **PART II** | **Frameworks: Scholarly Views** | **99** |
| | Frameworks: Scholarly Views *Sheryl Oring* | 101 |
| | Toward a Sociability of Objects *Edward Sterrett* | 103 |
| | Socially Engaged Art, Photography, and Art History *Bill Anthes* | 111 |
| | Activism's Art: A (Very) Brief History of Social Practice and Artist Books *Miriam Schaer* | 115 |
| | Free Speech in a Digital Era *David Greene* | 121 |
| | Efficacy, Trust, and the Future of Civic Engagement *David B. Holian* | 127 |
| | "I WISH TO SAY:" 2010 TO 2016 | 133 |
| **PART III** | **Conclusion: Listening and the Power of Small Acts** | **159** |
| | Conclusion: Listening and the Power of Small Acts *Sheryl Oring* | 161 |
| | Turning Strangers into Neighbors *Kemi Ilesanmi* | 163 |
| | Let It Linger *George Scheer* | 167 |
| | Small Acts, Forlorn Practices *Radhika Subramaniam* | 171 |
| **PART IV** | **Postscript: An Activist's Discourse** | **177** |
| | Postscript: An Activist's Discourse *Sheryl Oring* | 179 |
| | Q&A: Sheryl Oring and Svetlana Mintcheva | 181 |
| | "I WISH TO SAY:" SEQUELS | 193 |
| | "I WISH TO SAY:" Chronology and Credits | 207 |
| | Endnotes | 213 |
| | Bibliography | 215 |
| | About the Contributors | 219 |

# ACKNOWLEDGMENTS

"I Wish to Say" was made possible first and foremost by the more than 2,500 people I have had the pleasure of meeting and typing for in dozens of locations across the United States over the past decade. My sincere thanks for sharing your thoughts, comments, and stories. A grant from the New York Foundation for the Arts came at a critical time near the beginning of this project, and the tremendous support from Creative Capital over the life of the project and, more recently, the Franklin Furnace Fund, has allowed this work to grow and thrive. Arts organizations such as these play an important role in supporting unconventional works and bringing them to a national audience. Hats off to these organizations and leaders such as Ruby Lerner and Martha Wilson.

Nonprofits such as the First Amendment Project, the National Coalition Against Censorship, the Free Expression Network, Bryant Park in New York, and the College Art Association have also played key roles in supporting this work. And a big thanks to the dozens of universities across the country that hosted shows on their campuses, from a 2004 show at Georgia State University organized by curator Cathy Byrd, to 2008 shows at the Claremont Colleges in Southern California, Wichita State University, and many other campuses thanks to the efforts of Jennifer Baumgardner at Soapbox Inc: Speakers Who Speak Out.

The project has received a tremendous response from the press, with reports appearing in *The New York Times*; the *Los Angeles Times*; on National Public Radio; and on ABC News, and in dozens of other newspapers and media outlets. Thanks to Patrick Kowalczyk at PKPR in New York; Sascha Freudenheim at PAVE Communications & Consulting in New York; and Barbara DeLollis in Washington, D.C., for your savvy communications strategies.

Thanks to Neil Katz and Ajmal Aqtash, who designed the "I Wish to Say" exhibition held at the McCormick Freedom Museum in Chicago in 2008. I met Neil and Ajmal while working at Skidmore, Owings and Merrill in New York and the entire architectural team I worked with there provided a tremendous amount of encouragement, support, and inspiration over the years.

Thanks to Jeff Holmes, Ken Lewis, Dan Weaver, Michael Kim, Sang Won Lee, Sophia Cha, Susan Lane, and the rest of the team.

This project has relied on help from so many volunteers, whose enthusiasm and belief in the project have kept me going. Thanks to Kate Carpenter Bernier, who provided tremendous support in Florida and Washington, D.C., in 2004, and the many others who helped make each show run smoothly.

A special thanks to the typists who joined me in the typing pool: the very first shows with additional typists were with Jessica Sledge and Stephanie Lie in 2010. Thanks to Polly Adkins, Corey Dzenko, Joanna Hardman, and Caitlen Nelis Masters, who joined me in Charlotte in 2012. And to Amy Sayre Baptista, Jessica Kearney, Caroline Macon, Nora Sharp, and Shane Zimmer, who did a fantastic job during the shows at the Out of Site festival in Chicago in Summer 2015, organized by the amazing Carron Little.

Ethan Lercher, the events director at Bryant Park in New York, has worked with me on several versions of the show, including the largest to date held in Spring 2016 in conjunction with the PEN World Voices Festival. I am grateful for the years of support and advice from Ethan, who has allowed me to show this work in my favorite park time after time. The 2016 show at Bryant Park was done with the help of nearly 100 volunteers, including sixty students from the University of North Carolina at Greensboro and a number of PEN writers in New York. A complete list of the project team is included in the project Chronology and Credits section at the end of the book. Special thanks to Special thanks to April Lynch, Barbara DeLollis, and Hans Tester for being there when I needed it most.

Another special thanks goes to graphic designer Amy Mees, whose design work has helped define the project going back more than a decade. Beyond that, heartfelt thanks must be extended to my MFA thesis committee at the University of California, San Diego: Louis Hock and Teddy Cruz, co-chairs of my committee, and Sheldon Brown and Sarah Shun-lien Bynum, who served on my committee. Their questions and suggestions throughout the years have made my work stronger and I am so thankful for that.

Support from the Art Department at the University of North Carolina at Greensboro allowed me to produce the largest-scale version of this project to date, and my deep thanks goes to Department Head Lawrence Jenkens for his belief in my work. Who else would have agreed to send a busload of students from North Carolina to New York to help with this project? Thanks to Amanda Crary Gallas, who spent many hours organizing the project archive, and to Julia Caston and Madelynn Poulson for the tireless work on the Bryant Park show. Finally, a big round of applause for the photographers who have documented this work over the years, from Damaso Reyes and Brian Palmer in 2004 to the decade of work by Dhanraj Emanuel and the team of student photographers who documented the 2016 show at Bryant Park. Beyond documenting the work for so many years, Dhanraj has supported this work in countless ways as my husband and partner. Dhanraj, I couldn't have done it without you.

Sheryl Oring
New York
June 2016

X

# PREFACE

*Sheryl Oring*

A few things have changed since 2004, when I first set out with my typewriter and a stack of blank index cards, determined to find out what ordinary Americans had on their minds.

Pat Myren, a woman from Briarwood, New York, sat down at my desk in Summer 2004 and said, "I have been with a wonderful woman for twenty years. We're upstanding members of the community and you should visit us in our homes and in our lives and see why us being married will not in any way affect you but will give future financial security to the woman that I love."

Eleven years later, the U.S. Supreme Court ruled that state-level bans on same-sex marriage were unconstitutional.

Back in 2004, healthcare was on the minds of many. George Zolinsky of Oakland, California, said, "If I were president, I would give every American citizen the same healthcare coverage that you and every member of the Senate and House have."

Obamacare doesn't go as far as Zolinsky suggested. But a decade later, the comments about healthcare are distinctly different. In July 2015, during a show in Chicago, Lauren Brigge said, "Thank you for my health insurance. My sister would still be sick if the policy hadn't changed, and she couldn't have gotten the treatments she needed."

Other things still have a long way to go. In 2004, I set up my typewriter in a laundromat on the Navajo Nation. One by one, I heard from people with stories that many people outside the reservation might find hard to fathom. Tonya Tsosie of Moenave, Arizona (some 25 miles west of Tuba City), said, "I've been living in my husband's area for the past three years and there's no electricity. We've gone through three generators and our local chapter house has been saying that they'd run electricity through. They keep giving us excuses for why it doesn't happen. My oldest is nine years old and she wants a computer. But because there's no electricity, we can't have a computer. Now that gas prices are skyrocketing, it's more expensive to get into town and to fill the generator. Maybe you can help with this."

I wish I could. A decade later, the Associated Press reported that across the 27,000-square-

mile Navajo Nation, some 15,000 homes do not have electricity. A 2015 report in *Indian Country Today* estimated that the Navajo Tribal Utility Authority, a nonprofit in charge of providing utility hookups on the Navajo Nation, brings power to an estimated 700 new customers each year (Fonseca 2014).

One of my students at the University of North Carolina at Greensboro (UNCG) recently asked whether I'd ever typed a postcard of my own. I was certain I had, but not at all sure when I had done it. Luckily, my research assistant, Amanda Crary Gallas, found it in the archive from 2004. On February 10, 2004, I wrote during a show in Oakland (the second show ever):

> Dear Madam President,
> When I was growing up, Geraldine Ferraro was a candidate for vice president. I was certain that before long we would have a woman president. It has taken many years for this to happen. And I wish to say I am very proud of you. Good luck with the tough decisions.
> Sincerely,
> Sheryl Oring
> Brooklyn

There weren't any women candidates who made it to the primaries that year, so my card was pure fantasy. Back in 1984, Ferraro was the vice presidential candidate on the Democrats' ticket, with Walter Mondale seeking the presidency. They lost in a landslide to Republican Ronald Reagan. Ferraro later helped with Hillary Rodham Clinton's 2008 presidential campaign. She died in 2011 without seeing a woman make it to the White House.

Fast forward to today, and to conversations with my daughter, Shira, who wants to know why there has never been a woman president. For some time, when she was five or six years old, she even told me she wanted to *be* the president. She hasn't mentioned it lately. I just hope the world hasn't stepped in and convinced her it's not a job for girls.

Shira, this book is for you.

When I conceptualized this book, it was important to me to include a broad spectrum of voices so that the book itself mirrored not only the project, but the field of contemporary art as well. The book begins with "Ruminations: The Artist's Perspective," which grew out of my desire to connect individual aspects of my work with the work of other artists. This part starts with an essay on *the typewriter*, and using a series of keywords as a guide, includes ten essays by artists, creative writers and an architect who put their work into conversation with mine and with others who use people and social structures as their creative material. This is followed by "Frameworks: Scholarly Views," which examines some of the theoretical frameworks and histories with which the "I Wish to Say" project – and many other socially engaged works of art – are in dialogue. The writers include two art historians, a book artist, a First Amendment rights lawyer, and a political scientist. The conclusion, "Listening and the Power of Small Acts," looks at the role of active listening in collaborative work, and argues that small acts can have powerful outcomes. The final section, "Postscript: An Activist's Discourse," features a question and answer discussion about "I Wish to Say" and related works. Documentation of more than a decade of "I Wish to

Say" performances is presented in chronological sections throughout the book, which concludes with a section of photographs of work that has grown out of "I Wish to Say." As I sit here with the essays in hand, I am overwhelmed with gratitude to all of the people who have come together to make this book possible.

The journey began with work on a different project, a sculptural installation called "Writer's Block" that was first shown in 1999 on Bebelplatz, the site of the Nazi book burning in Berlin. In working to bring this installation to New York, I collaborated with a number of free speech advocates. Chief among them were David Greene, at the time the Executive Director of the Oakland-based First Amendment Project, and Svetlana Mintcheva at the New York-based National Coalition Against Censorship. David, now the Senior Staff Attorney and Civil Liberties Director at the Electronic Frontier Foundation in San Francisco, writes about "Free Speech in a Digital Era," while Svetlana conducts the interview at the end of the book. Svetlana has also assisted along the way with advice and constructive criticism, and I am thankful for all the support she has offered over the years.

Geography plays a strong role in biography, and in this case also with project development. Many of the people I knew while living in New York from 2003–08 have greatly influenced my work, and especially the "I Wish to Say" project. I met Stephanie Elizondo Griest through Svetlana when they were both working at the National Coalition Against Censorship. Stephanie writes about her memories of our 2004 road trip, when she was promoting a book and I was typing postcards to the president along the way from Texas to California. As luck would have it, Stephanie now lives just an hour down the road from me in North Carolina.

Soon after returning from New York from the road trip with Stephanie, I met photojournalists Damaso Reyes and Brian Palmer in New York. The pictures by Damaso – who worked tirelessly documenting "I Wish to Say" shows in New York and Boston during Summer 2004 – tell the project's story so well by capturing the emotion and feeling inherent in each of the exchanges. Brian's photo, taken at Foley Square in New York, captures the essence of the project in just one image.

I first met Radhika Subramaniam in 2001, when I worked briefly at the now-defunct *Arts International* magazine in New York when she was editor of the journal *Connect: Art.Politics. Theory.Practice.*, both published by Arts International, Inc. A few years later, as director of cultural programs at the Lower Manhattan Cultural Council, Radhika was one of the first curators to present my work. Her essay, "Small Acts, Forlorn Practices," examines the power of small acts. While I was at *Arts International*, there was at some point a cover story crisis. Something had fallen through and we needed a good story at the last minute. I pitched a report on Santiago Echeverry's work, and in Summer 2001 the magazine ran a cover story titled "Bogota Cabaret: Colombian Artist Santiago Echeverry Presents Life in the Crossfire." For this book, I asked Santiago to write about the meaning of *the look* in connection to his performance referencing the murder of a transgender prostitute in Bogotá.

When Hurricane Katrina hit New Orleans in 2005, I felt compelled to travel to the South and document some of the aftermath of this storm. A New York friend put me in touch with one of her friends who was teaching art at the University of Memphis. He invited me down to present "I Wish to Say" in Memphis, and put me in touch with photographer Dhanraj Emanuel. Dhanraj

documented the Memphis shows and then a year later agreed to come on one of the project's cross-country tours. We got married after this trip, and a decade later Dhanraj has documented countless shows, tirelessly traveling with me from New York to California and back again several times, creating so many of the beautiful photos in this book and writing about *the camera*. I cannot thank him enough for his collaboration and support. Bill Anthes, who was once Dhanraj's professor at the University of Memphis, invited me to perform at the Claremont Colleges back in 2008. His essay, "Socially Engaged Art, Photography, and Art History," provides a broad overview of the importance of photography within the social practice genre of art.

I first met Miriam Schaer at the Lower Eastside Printshop in New York, where she taught a silkscreen class at which I printed covers for one of the first "I Wish to Say" artist books. Our paths have crossed now and then ever since, and when I decided this book ought to include a chapter on the role of artist books in socially engaged art, it was clear that Miriam was the person to write it. Her essay, "Activism's Art: A (Very) Brief History of Social Practice and Artist Books," provides a broad overview of the ways artists incorporate handmade books into social practice projects.

New media artist Hasan Elahi was sitting near me on a bus filled with artists going from Manhattan to the countryside for a Creative Capital retreat in 2005. The meeting proved fateful, as Hasan convinced me over the course of that long weekend that I should become an art professor. His essay examines the role of *the digital archive* in his work. I met Kemi Ilesanmi around the same time that I met Hasan, as she was working at Creative Capital. Now the Executive Director of The Laundromat Project in New York, Kemi writes about "Turning Strangers Into Neighbors" in the book's conclusion.

George Scheer, who writes about the importance of lingering, invited me to stay at Elsewhere back in 2006 when I was driving through North Carolina as part of a national tour. So many years later, I've landed in Greensboro. He writes about why we have to "Let It Linger." Elsewhere plays a vital role in our community as it hosts dozens of visiting artists each year. Thanks to George and Elsewhere, I recently got to know New York-based artist Chloë Bass, who writes about *the question*.

I first participated in "Art in Odd Places" in 2010, and when I heard that its founder, Ed Woodham, was interested in taking the show on the road, I knew we had to talk. We met up at the College Art Association meeting in Los Angeles in early 2012 and the following fall, we brought "Art in Odd Places" to Greensboro. It was a tremendous experience working with Ed and the dozens of artists who presented work throughout downtown Greensboro. Ed writes about the role of *the street* in a lyrical essay that recalls various work shown at the festival.

I met many of the writers along the path of my academic journey, from graduate school at the University of California, San Diego (UCSD) to a faculty position in the Art Department at UNCG.

Teddy Cruz was my advisor at UCSD, and his passion for seeking change at the local level was infectious. Teddy always pushed me to consider scale in my work, and with each iteration of the project I have to think of him. Teddy writes about *the city*. Studio visits with Ricardo Dominguez were one of the highlights of my time at UCSD. Ricardo would enter a room, look around and launch into a monologue of observations and associations that left important ques-

tions hanging in the air upon his retreat. Ricardo, who writes about *dissent*, came to see the very first large-scale "I Wish to Say" show (March 4, 2010, at the UCSD), in which a team of eight typists wrote postcards to the president of the University of California system.

Edward Sterrett, Sarah Shun-lien Bynum, and I all took Haim Steinbach's seminar on "The Object" at UCSD in 2010. Once a week for ten weeks, we met for three hours around a dingy 1980s-era table and contemplated the objects each of the participants had brought to the first class. My object of choice was a typewriter, Edward's a small broom and Sarah's a porcelain shoe. Each week, we stared at our objects, asked and answered questions about our objects, told stories about our objects, verbally dissected our objects. Let's just say we got to know a lot about ourselves and our objects by the end of the seminar. In his essay "Toward a Sociability of Objects," Edward writes about the role of objects in socially engaged art, while Sarah writes about *the typewriter*. Edward was one of the first people I talked to about this book, and the conversations we had during its development played a crucial role in finding the right structure for this rather unusual collection. The discussions we started around Haim's seminar table continue to this day.

Corey Dzenko and I were colleagues in the Art Department at UNCG before she moved to Monmouth University, and Corey kindly worked as a typist for the 2012 show in Charlotte. Her interest in new genre art as well as her practical experience as a project typist made her a natural for writing the book's introduction, "Taking a Moment to Have a Say." Corey has also provided much-appreciated criticism throughout the book's process and many iterations. Lee Walton arrived at UNCG a few years before I did. and in many ways paved the way for work like mine to be accepted. For that, I am truly grateful. In his essay, Lee writes about the role of *the city park*. Thanks to one of my art historian colleagues at UNCG, Heather Holian, I also met political scientist David Holian. David and I have a tremendous amount of fun co-teaching a class on art and politics, so I was curious about his take on this work, which he writes about in the essay "Efficacy, Trust and the Future of Civic Engagement."

The networks of people necessary to make works of art are often extremely complex and are not built overnight. Time is often a crucial element: time to meet, time to talk and to listen, time to reflect, time to create, time to revise, time to think. The typewriter itself serves to slow us down for a moment in time. The simple absence of an ability to delete makes one pause for a moment before committing words to paper.

As Gertrude Stein said in "Stanzas in Meditation," Stanza XXXVIII:

> Which I wish to say is this
> There is no beginning to an end
> But there is a beginning and an end
> To beginning.
> <div align="center">(Stein 2000)</div>

This book is an end to beginning. Thank you to everyone who has helped along the way.

# TAKING A MOMENT TO HAVE A SAY

*Corey Dzenko*

From September 3–6, 2012, the Democratic National Convention occupied Charlotte, North Carolina. During this time, news crews congregated downtown. Media trucks zigzagged their cables along the ground to carry their coverage into people's televisions, computers, and mobile devices. One can imagine the patriotic red, white, and blue graphics that flashed every few seconds due to the now near-ubiquitous use of quick cuts, repetitive sound bites, and daily talking points. But from the chaotic media spectacle, the antiquated clicks of typewriters filtered into the air.

Sheryl Oring's participatory artwork "I Wish to Say" offered visitors a respite from the twenty-first century's constant barrage of information. On Labor Day, Oring organized a bank of five 1960s-styled female secretaries who typed postcards from the public to the president of the United States; I was fortunate to participate as one of the secretaries. We arrived downtown at the Bechtler Museum of Modern Art early in the morning and donned our own reds, whites, and blues with the vintage dresses and accessories provided by Oring. We grabbed typewriters and marched single-file through the Bechtler and out to the plaza in front of the museum. There we took our positions in our portable office.

As we sat in the plaza throughout the afternoon, members of the public approached us to write to the president. "Dear Mr. President," many of them began.[1] Instead of being inundated by sensationalized snippets of information, Oring's "I Wish to Say" invited participants to take a moment and compose their letters thoughtfully. The only limitation was the size of the 4" x 6" cards onto which we typed. They dictated. We listened. They spoke. We recorded deliberately with the typewriters' keys. A piece of carbon paper replicated their messages onto another card. Then participants signed their cards and could stamp them with the date and suggestive phrases like "URGENT," "NEEDS WORK," and "INCOMPLETE." After the event, Oring archived the copies and sent the originals to the White House.

Unlike performance art, for which performers complete an action separate from the audi-

ence, Oring provides platforms for "performers" and "audiences" to collaborate towards creating a shared outcome, such as the letters that we typed. She fashions a controlled space but, by welcoming participation, she gives over some control of the situation. For numerous artworks, Oring has invited the public to dictate *what they want to say* about a given topic. In 2004, she began to travel across the United States for "I Wish to Say." She was concerned that "not enough voices were being heard about the state-of-affairs," and has now mailed thousands of cards to our nation's leaders (Oring n.d.). For "The Birthday Project" (2006), she again traveled cross-country, but asked a varied public to write to the then-President George W. Bush for his 60th birthday. And for "Collective Memory" (2011), held around the tenth anniversary of the attacks on the World Trade Center, Oring and a group of typists asked passersby in New York City's Bryant Park, "What would you like the world to remember about 9/11?" These are only a few examples from Oring's larger participatory practice.

Oring intentionally makes use of the nostalgic familiarity of 1960s secretaries toiling away. Secretarial trades historically ghettoized women, and Oring's use of this feminized type of work recalls other artworks that address the subordination of some labor and laborers.[2] For example, Mierle Laderman Ukeles wrote her "For Maintenance Art: Proposal for an exhibition 'CARE'" to critique the gendered, racial, and class divisions associated with particular forms of labor. Ukeles' 1969 manifesto proposed a multi-part exhibition, but she was unable to find a museum that would let her present her exhibition in its entirety. Even so, Ukeles' text is insightful as a founding document for the concerns she addressed throughout her career and as a precursor to Oring's more contemporary project.

Ukeles introduced her 1969 exhibition proposal by describing two systems: (White, masculine) Development and (the work of women, the working class, and people of color) Maintenance. She emphatically highlighted that the former only flourishes with the support of the latter and indicated through a diagram that, "The culture confers lousy status on maintenance jobs = minimum wages, housewives = no pay" (Ukeles 1969: 2). After offering her structural critique, Ukeles described the parts of her exhibition. For "Part One: Personal," the artist intended to live in a museum with her husband and baby; as an artist, woman, wife, and mother (in no particular order), she would then perform her mundane activities from daily life. She was to "sweep and wax the floors, dust everything, wash the walls (i.e. 'floor paintings, dust works, soap-sculpture, wall paintings'), cook, invite people to eat, make agglomerations and dispositions of all functional refuse" (Ukeles 1969: 3). Such actions would collapse underappreciated (Maintenance) labor with the productive (Development) labor of artists. There are strong ties between the role of Oring's secretaries and Ukeles' earlier artwork in terms of the use of gendered labor; as typists, we were there as neutral recorders in support of the public's sentiments. To use Ukeles' terms, as Maintenance workers, we supported participants' Development.

For "Part Two: General," Ukeles planned to display typed interviews with workers from various classes and occupations about their ideas regarding Maintenance. She would then interview the exhibition's spectators with the same questions asked of the previous interviewees. The spectators' recorded interviews would play throughout the exhibit's duration (Ukeles 1969: 3–4). Like Oring's contemporary pieces, Ukeles' "CARE" would have encouraged spectator participation, if a museum had ever granted her permission to hold her proposed exhibition.[3]

Ukeles' plan involved her performing her day-to-day activities in an unexpected space; it could be jarring to see a woman cooking and cleaning with her family in a museum. "CARE" suggested a way to bring attention to underappreciated forms of labor during the time of second-wave feminism and the civil rights era. Oring's contemporary art makes a different use of time and everyday life. It removes participants from their typical daily experiences – whether they encounter her projects in a park, a flea market, the sidewalks in front of the Bechtler, or some other public venue – and places them into a controlled, aesthetic space that suggests a bygone era.

Oring's deliberate use of the familiar secretary – particularly the curiosity of seeing this historical figure in the present day – encourages passersby to participate. This is one of the great strengths of Oring's artwork. Unlike the "non-aesthetic" approach associated with many participatory artworks, such as Marina Abramović's *Rhythm 0* (1972) and Rirkrit Tiravanija's *Untitled (Free)* (1992), Oring makes very striking decisions about the look of her various events.[4] During Charlotte's Democratic National Convention, we all wore patriotic colors and sat at matching tables in front of an equally patriotic banner. For "The Birthday Project," Oring wore a party dress. And, in a gesture of mourning, typists wore black for "Collective Memory." Such aesthetic decisions affectively mediate the present-day events that Oring facilitates while effectively attracting a broad constituency to participate.

There is a comfort in familiarity. Our beehives and flipped hairdos and outdated typewriters enticed older participants who remembered using this type of machine or wearing garments similar to ours. Our appearances and secretarial duties often reminded younger generations of their mothers or other female relatives. And, after some coaxing from adults, many of the child-participants approached us because they had never seen a typewriter before.

Participants' observations and comments, along with their interest in the typewriters and us as historical figures, quickly gave way to a collapsing of eras – those of our mid-century activity and their 2012 concerns. Such a collapse of time would not have occurred during Ukeles' performance of her daily tasks. Once the novelties of our historical appearances and machines wore off, participants shifted their attention to the content of the messages they wanted to convey. We were the medium through which they would communicate. Oring gave them an opportunity and, in what seemed to be a sincere exchange, they addressed the president.

Oring's employment of the secretarial figure is a very motivated, but not ironic, use of this trope. To explain the resulting affective exchanges I experienced, I find it best to situate her project in the contemporary structure of feeling recently termed "metamodernism" (Vermeulen and van den Akker 2010). This cultural framing acknowledges a shift away from postmodernism's employment of cynicism and irony as tools to challenge grand narratives and the discursive construction of culture, such as in photographer Cindy Sherman's performances of gendered signifiers for her postmodern "Untitled Film Stills" (1977–80). Metamodernism suggests a move away from postmodern nihilism and the apparent "end" of history, art, and other forms. Contemporary society now oscillates between (modern) affectivity, sincerity, and Romanticism, as well as the lessons learned from postmodernism, but without naïvely reinstating modern ideals.

For example, in Pilvi Takala's short film *Easy Rider* (2006), an undercover camera records a

recent transaction on public transport. A slightly disheveled man strikes up a conversation with a stranger – a well-dressed businessman. The disheveled man is an actor for the piece, though he leaves this information unknown to the passengers around him. He tells the businessman that he is on his way to a job interview but has left his jacket, wallet, and computer elsewhere. As he explains, this is because he was distracted; he met a woman the night before and fell deeply in love. Through further conversation, he asks the businessman whether he can borrow his jacket and tie for his interview and promises to return them. Then he asks to use the businessman's laptop for a brief moment to check the presentation files he has saved to a disc.

All of the borrower's requests raise immediate flags. Will the businessman ever see his jacket and tie again? Will the man who says he is in love – if we can believe his story – infect the businessman's computer with a virus or run away with his laptop? Despite his visible doubts, the businessman agrees to help out his fellow transit-rider. Now that the disheveled man is appropriately dressed with a jacket and tie, he leaves at his stop, and the passengers sitting around the businessman begin to voice their concerns. The businessman admits that he does not know why he agreed to the other man's requests. He justifies his actions by saying, "[H]e was so confused that I think he was really in love." The other passengers question him further, which causes him to lament, "Jesus, I'm an idiot." *Easy Rider* takes viewers and the unknowing participants back and forth from the cynical suspicion of the man who was supposedly in love to the belief that he was telling the truth. It is this oscillation that makes *Easy Rider* an example of metamodernism.

Participants in "I Wish to Say" knew that we were not actually 1960s secretaries. Some did ask, "Will these letters *really* go to the president?" Even so, Oring's reliance on participants' momentary suspension of disbelief encouraged a diverse population to take part in a civic activity. This collaborative engagement countered the formation of neoliberal citizenship as consumerism. Audience members conducted themselves as citizen-participants and producers rather than mere consumers or subjects under the state's control. They had a say.

Artistic participation for the sake of participation has its dangers when art and sociological projects intersect. Art historian Claire Bishop is especially wary of the critical writings about recent "anti-aesthetic" participatory artworks and how they are often judged based on their ethical value more than their engagement as "art." She warns, "Without finding a more nuanced language to address the artistic status of this work, we risk discussing these practices solely in positivist terms, that is, by focusing on demonstrable impact" (Bishop 2012: 18). Once art is judged quantitatively, its cultural and symbolic "worth" decreases, and the support of the arts – including its minimal funding – could receive further cuts based on art's perceived failures. Nevertheless, Bishop – as well as, I think, Oring – believes that art continues to offer a productive field that intertwines with, but is not the same as, social science.

Oring recognizes the political potential of art but has acknowledged that she does not track the outcome of her pieces systematically. She reflects:

> Just by talking to the people that I talked to, it makes a difference for them. Whether it's maybe a few more people that register to vote or a few people that actually do something then about the issue they're concerned about – there is some kind of power to that moment and that lingers beyond [the performance].
>
> (Klin 2011: 96)

Art has the potential to motivate participants to engage with important issues through the language of aesthetics and the affective and symbolic capital wielded by art. "I Wish to Say" is not just a lesson in civics, as if participants sat down in their daily lives and wrote letters to their government's leader. Instead, they participated in a symbolically orchestrated event that may influence them to repeat similar, or related, acts in their day-to-day lives.

Inevitably, the documentation of any performance will only contain fragments of the event. Photographs show fractions of seconds from a longer duration and from the photographer's vantage point. One can think of the well-known example of Joseph Beuys' *How to Explain Pictures to a Dead Hare* (1965). The most frequently reproduced images show Beuys seated in a chair, holding a dead rabbit in his arms. However, he spent much of the performance walking the animal around the gallery as he explained artworks to it. Viewers watched from a distance. Photography and time have worked against the complexities of his project. Similarly, film can frame only a portion of any larger event. Oring is aware of this inevitable simplification and employs various forms of media to extend her project. She documents her events with photography and film, sends the typed cards to the White House, collects them in artist books, and displays them in various exhibitions. This essay and the book that it is part of also present her artwork to a larger audience who, even though they may not have been at the live events, can still engage with the issues raised by her artwork.

Documentation may eventually erase some of the complexities and difficulties that impact Oring's otherwise controlled events. About two hours into our 2012 performance of "I Wish to Say," the sun began to beat down on the plaza in front of the Bechtler. Some of the photographs show the secretaries' faces turning red. It became so hot that the project's many volunteers – as fellow Maintenance workers – helped to rearrange the secretarial pool into a shaded part of the plaza. The summer heat became part of the experience and a sensation the audience, secretaries, and volunteers had to endure in order to work as a collaborative body to address the president.

Additionally, Oring's event at the Bechtler was part of the larger CarolinaFest that kicked off the Democratic National Convention in Charlotte. The festival included discounted entrance to a number of museums, a range of speakers, and live music on multiple stages. One of the stages sat only half a block away from our office. For part of the afternoon, music blared from the nearby stage. Typing dictation on a typewriter is difficult enough – especially in Charlotte's humid environment, which occasionally caused the keys to stick – and correcting typewriter text is not as simple as deleting or rearranging text on a computer. When the music drowned out some of the participants, we strained to hear and record what our fellow citizens wanted to say as accurately as we could. One man was unhappy with my first attempt at recording his message. He insisted that I retype a card that was clean of any visible edits. Because he was the producer of

his letter, and my role was to support his production, I smiled and obliged, terrified that I would make mistakes in my second attempt. Similar displays of power dynamics have occurred from times long before Ukeles' manifesto and continue for many workers today.

Instead of editing out the complexities that may have created discomfort or could seem to disrupt Oring's aesthetic project, I see the disruptions as important components of "I Wish to Say." The varieties of participants' responses and some of the disruptions to the ideal moments of the event more accurately coalesce into a metaphor for the workings of communities and democracy. They are complex systems. Challenges arise as competing voices are raised, lowered, and sometimes drown each other out, but it is the opportunities for difference and discussion that lead to more democratic, engaged, and nuanced societies.

Near the end of our afternoon in Charlotte, the sky blackened and the wind began to whip as the beaming hot sun gave way to a late-summer Southern thunderstorm. The public scattered for shelter in the museum and nearby spaces. My fellow typists and I grabbed our typewriters and scurried to join everyone else already inside as volunteers collapsed our portable office. And, with that, the plaza in front of the Bechtler returned to 2012 and the public returned to their media-saturated, fast-paced lives – that is, until they remember Oring's invitation to slow down, call cynicism and consumerism into question, and again participate in the complexities.

# "I WISH TO SAY:" 2004

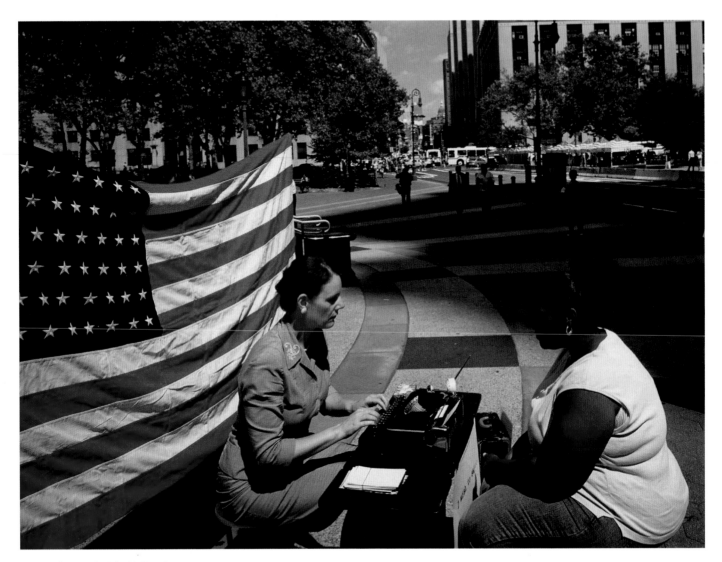

Shaquana Lowery (right) with Sheryl
Oring at Foley Square in New York,
Sept. 1, 2004.
*By Brian Palmer/brianpalmer.photos*

SEP 0 1 2004

Dear President,
I, Shaquana Lowery, is writing
you to let you know how I feel
about this comming up election.
Honestly, I don't vote because
I feel our votes don't count
anyway. But this year, I will
make sure that I will definitely
vote for a much improved
president. I have nothing
against you, except that I
feel that you are taking away
a lot of peoples education and
welfare for a lot of peoplex
that really need it. It's not
fair that you're using money that
could help NYC to bomb Iraq.
Sincerely,

your fellow American,
Shaquana Lowery

Brooklyn, NY

**RUSH**

FEB 0 8 2004

Dear Sir:

I've never felt more alienated
from the rest of the world.

Sincerely,

Annik Prasad
San Francisco

**CONFIDENTIAL**

FEB 08 2004

Dear Mr. President,

 In 12 short months you have
turned the entire world from
friend to foe. Even in high school,
it's hard to become unpopular
that fast. The world is to small
to not have friends.

Globally yours,

April Lynch
San Francisco

AIR MAIL

COPY

CONFIDENTIAL

FEB 10 2004

DRAFT

Dear President,
If I had a chance to tell you u
what I think, I would ask you
to give materials to the schools.
We need scissors, pencils,
sharpeners, journals, paper
and glue.

RETURN RECEIPT first class
REQUESTED
Sincerely,

Barry Huang

Barry Huang
Lighthouse Community Charter
School, Oakland

AIR MAIL

FINAL NOTICE

URGENT

PAST DUE

IMPORTANT

COPY

FEB 08 2004

Dear President,

I urge you to drop the funding of the Mars program and use the money to begin to alleviate poverty -- especially for children. We need to reinstate funding for family planning program of the United Nations.

Sincerely,

Kay Oring
Reno, Nev.

URGENT

**first class** DRAFT

AR 08 2

Dear President,
You ought to retire your military position. You are not knowlegable about war. And you are not knowledgeable about gang activities.
If you want to talke to me personally, come to El Paso.

Sincerely,

Ernesto Vasquez Jr

Ernesto Vasquez Jr.
El Paso, Texas

11

## FINAL NOTICE

APR 1 0 2004

Dear President,
I want a playground. I want
a bike. I want a bedroom.
I want another bike. I want
paper. I want a pencil and
a pen. I want books. I want
a blue bag. I want shoes.
I want a play car and a truck.
I want pants, shirts and a
door.

Sincerely,

Trevor Tsosie
Moenave, Arizona
(age 6)

**RETURN RECEIPT REQUESTED**

**first class**

## URGENT

## RETURN RECEIPT REQUESTED

APR 1 0 2004

Dear President,
I've been living in my husband's
area for the past three years
and there's no electricity.
We've gone through three generators
and our local chapter house has
been saying that they'd run
electricity through. They keep
giving us excuses for why it
doesn't happen. My oldest is 9
years old and she wants a
computer. But because there's
no electricity, we can't have
a computer. Now that gas prices
are skyrocketing, it's more
expensive to get into town and
to fill the generator. Maybe
you can mm help with this.

Sincerely,

Tonya Tsosie
Moenave, Arizona

APR 0 4 2004

Dear President,
Bring my husband home.

Sincerely,

*Megan Baeza*

Megan Baeza
El Paso, Texas

COPY

APR 0 4 2004

URGENT URGENT

Dear Mr. President,

If I was president, I would
give every American citizen
the same health care coverage
that you and every member
of the Senate and House have.

Sincerely,

*George Zolinsky*

George Zolinsky
Oakland, Calif.

URGENT

URGENT URGENT

URGENT

URGENT

**COPY.**

APR 2 1 2004

323. 295 3140.

Dear Mr. President,
My son was shot four times
in his chest and killed in his
own home. We need to do something
about controlling guns, to stop
young people from getting guns.
xxxxx My son was not a gang-
banger, he was in school on a
basketball scholarship. He loved
basketball and he worked too.
Supposedly gang-bangers shot him
because they were jealous, that's
what I heard. When that happened,
I just couldn't function.
I'm down here doing with this.
I want to hear an outcry, I want
somebody to tell me, why did they
kill my son. What are you doing?
Somebody knows something. A
private investigator costs 250
dollars an hour, I can't afford
that. I just don't know what
to do. We need to control these
kids with these guns.
My baby's dead. He was killed at
22 years old. It's destroyed the
whole family.
Sincerely, Diann Bailey
Los Angeles

If anyone can help, please call Diann Price

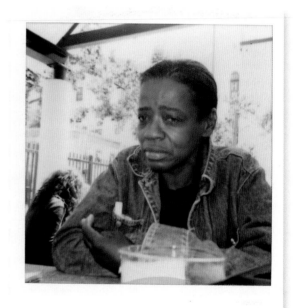

By Dagmar Hovestädt

APR 2 1 2004

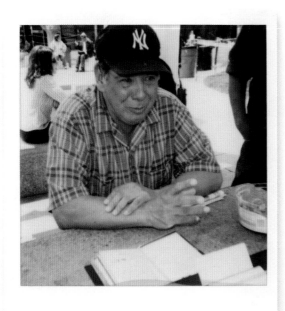

By Dagmar Hovestädt

Dear Mr. President,
We need more jobs for Latines
in America, to help the
children. We need the government
to give us more papers for legal
immigration. I worked for 18
years in this country and I'm
72 years old. And I need help
from the government. My family
lives in Fullerton, and they
need Green cards. The war should
end soon so there will be peace
in this country, and to stop the
pain to the families of the
soldiers.

Saludo,

*Juan F Morales*

Juan Morales
Downtown Los Angeles

COPYURGENT

15

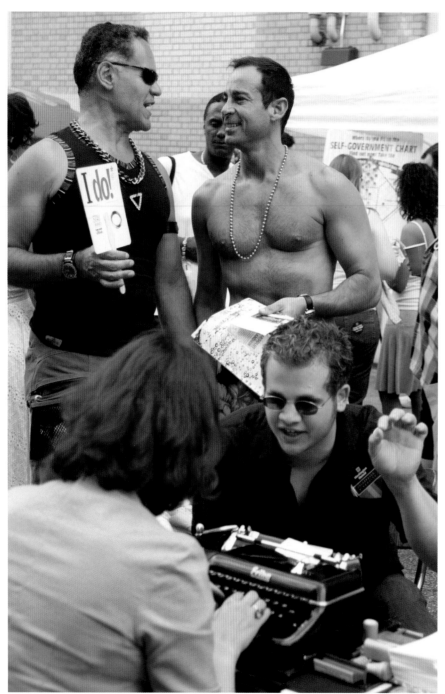

Anthony Pollotta and Vincent Pellegrino wait for a turn while Sheryl Oring types another card during Pride Fest in New York, June 27, 2004.
*By Damaso Reyes*

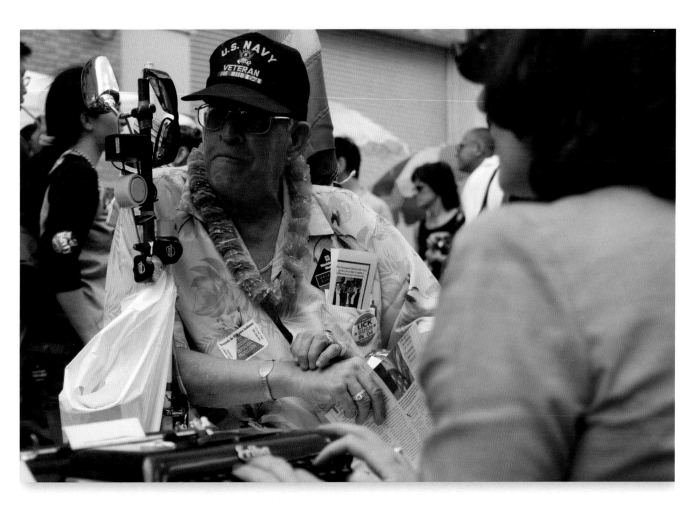

Michael Milligan of New York said: "We the people would like to see you take a long vacation in Iraq, without your title and be one of the people again. We'll see how well you fare over there. If you're lucky, you might make it back to Crawford, Texas."
*By Damaso Reyes*

[JUN 27 2004]

George,
I have been with a wonderful
woman for 20 years. We're
upstanding members of the
community and you should visit
us in our homes and in our lives
and see  why us being married
will not in any way affect
you but will give future
financial security tothe
woman that I love.

Sincerely,

Pat Myren
Briarwood, NY

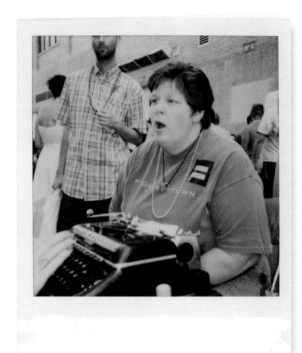

*By Damaso Reyes*

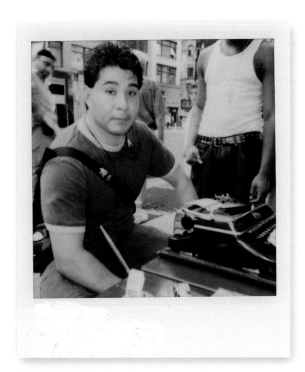

By Damaso Reyes

AUG 3 1 2004

Dear Mr. President,
I lost my brother on Sept. 11.
You promised to help illegal
immigrants became legal.
You have made Sept. 11 a

campaign issue. And you've
made a lot of promises. When
are you going to keep them?

Sincerely,

URGENT

Jose Morales
New York City

COPY

**COPY** JUL 19 2004

Dear Mr. President,
I've always been a Republican,
but you have made me question
what this means. I feel that
you've waffled quite often for
politcal purposes rather than
being true to the values of the
Republican Party. Example: you
got us into this war and I dont
believe you have a plan to get us
out. Leadership takes a complete
strategy to lean a nation. Quit
playing politics. Know thyself.
And lead with dignity.

Sincerely,

A Vietnam vet, 1969
Lawrence F. Green
Seattle, WA
(in Bryant Park, NY)

**IMPORTANT**

By Damaso Reyes

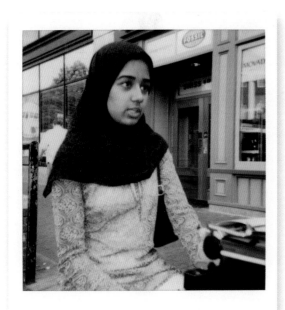

By Damaso Reyes

'JUL 2 6 2004

COPY

Dear Mr. President,
 I wish to say that the
 American public will not
stand being lied to and
deceived. We are ready to
 stand up and demand our
rights and the rights and
lives of innocent people
around the world that you
have jeopardized. Mr. Bush,
I believe you "misunderesti-
mated" America.

 Sincerely,

 Nareem Ahmad
 South Brunswick, NJ
 (in Cambridge, Mass.)

FINAL NOTICE

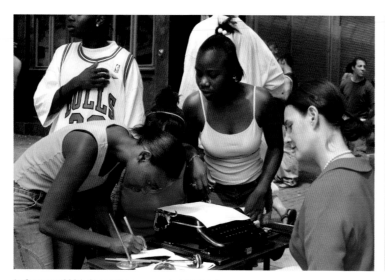 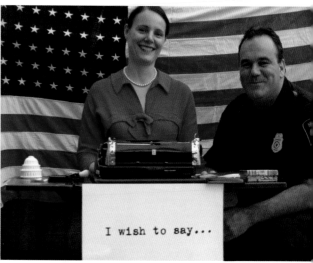

In Summer 2004, Sheryl Oring presented "I Wish to Say" on the streets of Boston during the Democratic National Convention (above) and New York during the Republican National Convention (following page).
*By Damaso Reyes*

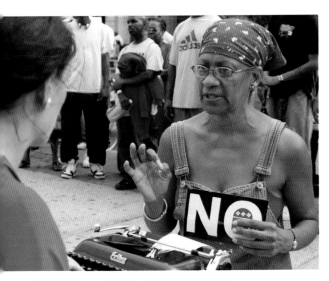 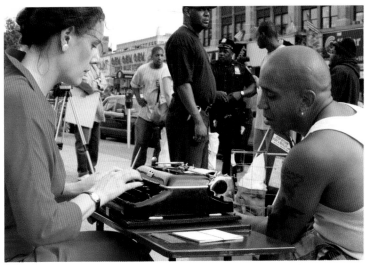

Patrika Sherwood (left) and John Farilla (right)
were among dozens of participants who lined up to
express themselves during a performance in Harlem
that coincided with the 2004 Republican National
Convention in New York.
*By Damaso Reyes*

**COPY**

JUL 1 9 2004

Dear Mr. President,
My name is Reginald Barham.
I am a homeless individual
living on the street because
the shelters are too dangerous
and full of drugs. I think
that we need to get some type
of order within he shelter
system, so I can be safe and
have a good nights rest.
Thank you, Mr. President.

**URGENT**

Reginald Barham
New York

*By Damaso Reyes*

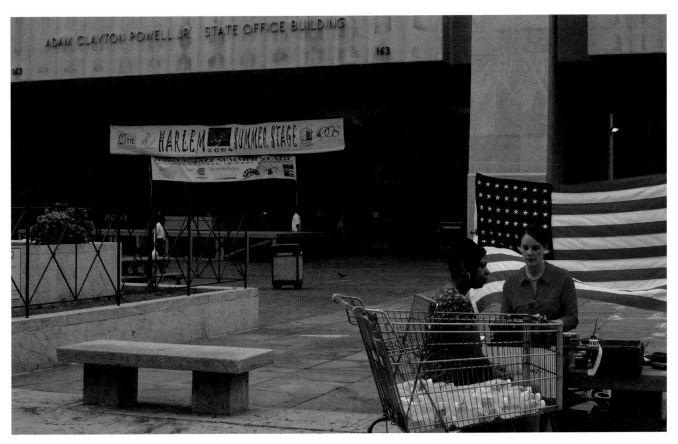

"The streets of Harlem are full of tension based on your policies," said Billie Holiday Jr. during a show on Aug. 30, 2004.
*By Damaso Reyes*

AUG 3 0 2004

Dear President,
 My name is Lonnie, Ive been
   homeless for 25 years. Sometimes
I don't like the way you run
   the country, but sometimes I
believe in you.sometimes I
hope you believe in yourself.

New York is trying to come back
and survive. And I believe it will.
I believe the World Trade Center
is going to be beautiful again.
 I don't vote.I don't know what
to think about politics, I
 really don't.
 Sincerely yours,

Lonnie Bowen
New York City

COPY

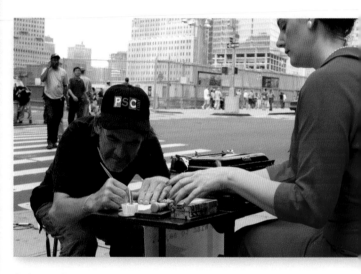

By Damaso Reyes

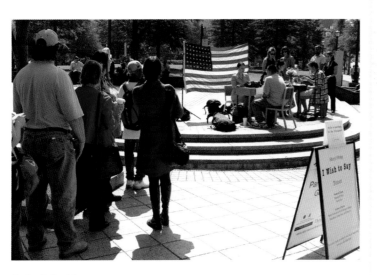

*By Sarah Barrick*

# URGENT

SEP 3 0 2004

Dear Mr. Bush,
I feel that the issue of being
black and young in America
is not addressed enough.
I know you won't address this,
I know this is not a concern
of yours and I don't expect a
reply or to see any difference.
I think that black people in
America have as many problems
as they do because we are not
taught our true history. We
learn what white people did in
this country. In reality,
this country was built on
slave labor and if we're taught
that, young black Americans
would have more to be proud of.
And white people will understand
our plight if they were
educated also. All americans would
understand
With my best intentions,

Lawrenthia Usher
Atlanta

# PAST DUE

OCT 1 9 2004

Dear Mr. President,
I'm aware that there are a lot
of things on your mind these
days. But I live amongst some
of your constituents that
cannot afford food and
healthcare and mothers that

have to choose between diapers
or medicine. I know that you
can change things with just
the stroke of a pen. But
maybe your pen is out of ink.
If it wasn't a security risk,
I would mail you a pen, because
we need help.
Sincerely,

Joseph Bryant
Gulfport, Fla.
5051 Jersey Ave. S.
33707

**IMPORTANT**

OCT 1 8 2004

Dear President,
I have full-blown AIDS,
and I'm on Medicare and
disability. I'm afraid I'm
going to lose everything I
have.

Sincerely,

Stewart Yoder
Sefnerr, Fla.

Stewart Yoder

## URGENT

COPY

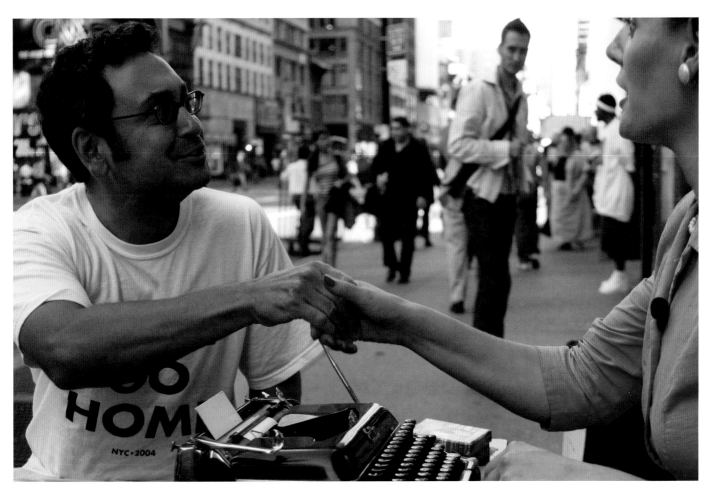

By Damaso Reyes

# Ruminations: The Artist's Perspective

# RUMINATIONS: THE ARTIST'S PERSPECTIVE

*Sheryl Oring*

Los Angeles-based writer Sarah Shun-lien Bynum starts out this section of artists' ruminations with a lyrical ode to the typewriter. "Do I mourn the typewriter's passing?" asks Bynum, the author of two novels. Her equivocal response to the question could well be my own. "My senses certainly do," she says, "the computer cannot come close to matching its array of smells and sounds and tactile responses – but to make any further claims of regret would be insincere: every story, essay, poem, term paper, and piece of correspondence I have written since the age of fifteen I have composed directly on a computer." But that's not the end, not the last word. "What I miss," says Bynum, "is the feeling of purpose and clarity that the typewriter gave me, the sensation of being a smartly dressed assistant sitting at attention, fingers poised, in service of an important assignment."

To create "I Wish to Say," my assignment for the past decade has been to listen closely as people sit down at my desk and offer up their hopes and dreams, critiques and complaints about the management of this country. The typewriter draws them in and ultimately creates a physical record of our conversation. In a digital era, the physical imprint of the typewriter's keys on a small sheet of paper is a simple but powerful reminder that we are here and we have something to say.

The essays in "Ruminations: The Artist's Perspective" grew out of my desire to connect individual aspects of my work to the work of other artists. This started with a list of keywords. What is a "keyword?" As a noun, it is a way of classifying and organizing things, of understanding meaning. In common usage, it also appears as a verb. Decades ago, I once got paid to keyword magazine articles; today, keywording has become ubiquitous in our daily lives (think of Instagram and the like). Keywords help us to connect and understand relations; they help us to navigate an increasingly complex world.

*Typewriter* was an obvious starting point in my effort to deconstruct my creative practice into keywords. The list that grew out of this exercise came to include: *look* (as in "*the look*"), *ques-*

*tion, camera, archive, park, street, city, road trip*, and *dissent*. In turn, these words led me to see connections in a diverse array of works. Santiago Echeverry, for example, engages with *the look* by using costumes to project the archetype of the drag queen in his powerful performance referencing the murder of a transgender prostitute in Bogotá. Echeverry, an Associate Professor of Art at the University of Tampa, writes, "The drag uniform was an empowering tool that allowed me to understand the tragedy of all of us who were being murdered, and who are still being targeted for being different." In my own case, my secretary costume helps me elicit responses toward political and aesthetic ends.

New York-based artist Chloë Bass ponders the importance of *the question* in her work. She writes, "I use questions to bring other people into my practice as quickly as possible … What's important is that once the question is posed, the conversation can begin." For me, "I Wish to Say" began with the question, "If I were the president, what would you wish to say to me?" The formulation was crucial. It is open-ended enough to provoke contemplation and this in turn leads to well-considered answers. My interest in questions and the way they are posed goes back to my time in journalism school, where I learned not to ask questions that elicit "yes" or "no" answers. That stops conversation, rather than moving it forward.

From the very start of "I Wish to Say," *the camera* has played a role. But what role? Dhanraj Emanuel, a North Carolina-based photographer who has photographed the project for a decade, writes:

> The role of the camera in this project is to contextualize the participants within the larger "public," thereby breaking down the public into the individuals who comprise it in the first place. Photography plays the crucial role of giving an identity to the text. Photographs give back to individual texts their individuality thereby distinguishing them from the series that tells a larger story.

My *archive* and *the digital archive* created by Hasan Elahi for his "Tracking Transience" project couldn't be more different. Elahi, who was falsely accused of being a terrorist in the aftermath of 9/11, decided the best way to prove his innocence was to document his life exhaustively and put it online for all to see. But the questions with which he struggles are connected to issues raised in the course of my project. While the physical "I Wish to Say" archive has power because of the way it connects to the personal, would it actually be more effective to scan the cards and put them all online? And by doing so, what issues of privacy would this engage? Elahi, an Associate Professor of Art at the University of Maryland, writes:

> We're still in a transition between analog and digital, and for as long as we're in this state of flux, we'll develop a more sophisticated understanding of the consequences of living under constant surveillance. For now, at least, we still have control over what information we put forth publicly. Being mindful of how we do that feels like a good first step toward retaining control.

In the early stages of working on this book, I knew I'd like to hear what artist and University of North Carolina at Greensboro colleague Lee Walton had to say. I knew our work had certain keywords in common, and was eager to see how Walton would approach an essay as open-ended as this. Many of Walton's projects take place in *city parks*, as do mine, so that was a starting point for what ultimately became a provocative essay examining connections between the open space of city parks, soccer fields, and even an empty sheet of paper. Walton writes:

> The open space of the paper is a place for something to happen, The function is indeterminate and undefined. It is an event space full of potential … Ultimately, the drawing space is social and the power is vested in the artists. The world is changed in some way from our participation in this space. The game is changing too.

Parks and city streets are the most common locations for "I Wish to Say" performances. In cities, these settings are filled with people, without whom my work would not exist. The next three essays explore various aspects of *the city*, from the scale of *the street* (by Ed Woodham) to that of the neighborhood and *the city* (by Teddy Cruz) and then to a essay that recounts a 2004 *road trip* from Austin to Los Angeles (by Stephanie Elizondo Griest).

For Woodham, whose "Art in Odd Places" project includes a festival that takes place along 14th Street in New York each fall, the street is his "adopted studio-laboratory employed as an open and free performative space to study communication in the public sphere." Woodham walked the street from east to west and conjured images from the past decade of his work. At Second Avenue, for instance, Woodham recalls, "Passersby tie blue ribbons onto a chain link fence on an empty lot. Someone asks us both to slow dance – suspending time. Car horns. A woman wearing a white wedding dress leads a group of dancing girls dressed in white – all wearing the number zero."

Cruz, whose urban laboratory is centered along the United States-Mexico border, sees the city and its neighborhoods as the most promising site of creative intervention. In our conversations about art and public practice, Cruz always pushed me to consider scale as a crucial element of my work – and to imagine ways of unconventional ways of intervening into established political bodies. Cruz, Professor of Public Culture and Urbanism in the Visual Arts Department at the University of California, San Diego, writes that

> a community is always in dialogue with its immediate social and ecological environment; this is what defines its political nature. But when this relationship is disrupted and its productive capacity splintered by the very way in which jurisdictional power is instituted, it is necessary to find a means of recuperating its agency, and this is the space of intervention that art and architecture practice need to engage today.

Griest, Assistant Professor of Creative Nonfiction at the University of North Carolina at Chapel Hill, specializes in writing travel memoirs. For this book, she recalls the meandering road trip

we took together from Texas to California back in 2004. She was promoting a recently released book and I was starting "I Wish to Say." She writes:

> Sheryl and I were road-tripping in post-9/11 America. Our nation had been embroiled in an unjust war in Iraq for a year by that point; in seven months, we would determine whether or not to halt the presidency of the man who had declared it. As former journalists, we knew the importance of bearing witness to a moment.

This first road trip with Griest was followed by several more. In 2006, I traveled to eight cities across the country, inviting participants to send birthday cards to President George Bush for his sixtieth birthday and in 2008 I visited dozens of cities and college campuses across the country as I took "I Wish to Say" on the road one more time. Another tour is planned for Fall 2016.

This section concludes with an essay on *dissent* by Ricardo Dominguez, a San Diego-based artist, Associate Professor of Art at the University of California, San Diego, and co-founder of The Electronic Disturbance Theater, a group that developed virtual sit-in technologies in solidarity with the Zapatistas communities in Chiapas, Mexico. Dominguez writes, "Dissent is always about the location and dislocation of one's social sense or (ae)ffective condition in relation to the embedded reality one finds one's self in, that is the influence of where and when one is born or comes into being."

"I Wish to Say" came to life through connections to a national network of free speech activists, all working to protect our First Amendment rights. The typewriter offers an invitation to dissent, to speak one's mind. Taken together, the essays in this part of the book provide insight into my work and the "I Wish to Say" project, while also offering glimpses into a wide spectrum of creative practices that exist in conversation with the broader field of socially engaged art. The concept of polyphony, or a multitude of voices, lies at the root of my research interests, and the artists in this section represent a diverse sample of the richly varied work being made today.

# THE TYPEWRITER:

## An Ode to Its Smells, Sounds, and Tactile Responses

*Sarah Shun-lien Bynum*

I remember the smell of our typewriter more clearly than I can remember what it actually looked like. It was probably a Smith-Corona, although I can't say for certain, and its color was most likely gray or tan or maybe even a neutral shade of green. Was there a heavy cover that snapped over it for carrying purposes, or did it have its own special suitcase? Was its body made of some sort of lightly pebbled composite material? Its corners square or rounded? The truth is, I don't think I could identify this typewriter in a lineup. But I feel sure that I would know it by its smell. As soon as you turned it on, the machine let off a wonderful odor. I've heard this described as an "electric" smell or as a mixture of "ozone and ink" – and I suppose that the smell generated by the powerfully humming motor and the warming of the ink ribbon was largely what I was inhaling – but I will say that this particular typewriter did emit its own scent, distinct from that of other typewriters I have encountered since.

My theory is that there were hidden smells embedded in the machine, smells linked to its provenance as my mother's primary compositional tool throughout her years in graduate school – the smoke from her cigarettes, her Prell shampoo, the mineral smell of the radiator steam in her parents' Morningside Heights apartment, the residue of the cooking oil that her mother used freely when stir-frying – and that by turning on the power switch, I was releasing the olfactory evidence of this former life of hers. That, I believe, is what made our typewriter smell particularly good.

So there was its smell, also its hypnotizing warmth and vibration – and I haven't even gotten to the pleasure of the plastic keys yet, each one with an almost imperceptible dip in its center. Keys that would need to be only barely touched before they answered you with a muted clatter and a line of perfect letters on the page. Letters perfect both in their shape and their spacing, marvelous in their ability to turn my words into something excellent, unimpeachable, and entirely official-looking. For a child frustrated by the unprofessional appearance of handwriting, the typewriter seemed heaven-sent, a miracle of the water-into-wine variety. Suddenly my limericks

looked ready for publication. The same was true for the opening pages of my historical novel. Everything I wrote on our typewriter possessed a halo of authority, and I read and reread my words with detached appreciation, as if someone else were responsible for them.

All of which is why I submitted without protest to my mother's suggestion that I enroll in a summer typing course at the local high school. In the summer of 1984 I was twelve: too old for camp, too young for a job, and as for my mother, she was newly divorced, intent on instilling in her daughter the importance of *marketable skills*. Those long years spent writing art history papers had not equipped her with the marketable skills necessary to attain *financial independence* – another phrase she repeated urgently. That summer she studied for her real estate broker's license while I learned to touch type fifty-five words per minute, and it's a summer I remember as being a restful one, a period of relative calm before adolescence arrived and I became obsessed with asserting my tastes and opinions.

The typing class began at 9 a.m. sharp, as if to acclimate us to regular business hours, and was held in a first-floor classroom with enormous double-hung windows, propped open to let in the air before the day grew hot. We sat in rows, at compact desks, each with its own electric typewriter and a practice book held upright by a triangular cardboard stand. The room and its arrangement are still very palpable to me. About the instructor I recall absolutely nothing, which is unusual for me because at that age – in fact, at every age – I have wanted my teachers' approval above all else and thus made scrupulous note of them. But of the person who taught me how to type – a competence on which I depend daily – I cannot say whether this person was old or young, man or woman! The class seemed to run by itself. That was exactly what pleased me: how we operated in a dreamlike stupor, our minds blank, our fingers feeling their way over the keyboard, the room quiet except for the busy, soothing sound of metal rapidly hitting paper.

So little exertion was required of me, yet every day I was rewarded with signs of progress. Exercises completed, letters mastered. Nothing felt more gratifying than the ding of the bell and the carriage moving smoothly and heavily across the platen. In typing I had discovered a form of work perfectly suited to my temperament: neatness, accuracy, productivity, adherence to the rules, all performed in a state of drowsy relaxation. After I finished my exercises, I would walk home, eat lunch with my mother, then spend the rest of the day reading Agatha Christie mysteries in front of a box fan, with both of us satisfied that I was coming ever closer to acquiring a marketable skill.

As I write this now, it is hard not to feel unduly aware of its quaintness, its summoning of what must sound like a very distant past. And there is no getting around the fact that I do belong to the last generation of Americans who learned how to keyboard on typewriters rather than on computers. It's sobering to realize that in a relatively short lifetime I have witnessed the near-extinction of technologies that had endured for a good hundred years before I was even born, among them film photography, the record player, the landline telephone, and the typewriter.

Do I mourn the typewriter's passing? My senses certainly do – the computer cannot come close to matching its array of smells, sounds, and tactile responses – but to make any further claims of regret would be insincere: every story, essay, poem, term paper, and piece of cor-

respondence I have written since the age of fifteen I have composed directly on a computer. My early-acquired touch typing skills combined with the ease of word processing has completely obviated any other method of drafting. Now I can't imagine formulating sentences in my own handwriting, or on my mother's electric Smith-Corona. The computer's takeover has been total in its effects. But the ease with which I can write on a computer has not made the writing itself any less difficult, and it is during the most difficult moments that I find myself missing the typewriter.

What I miss is the feeling of purpose and clarity that the typewriter gave me, the sensation of being a smartly dressed assistant sitting at attention, fingers poised, in service of an important assignment. In this fantasy, I am not the generator of content but its conduit, whose only job is to deliver it as quickly, correctly, and elegantly as possible. I do not procrastinate or dither; I feel no sense of futility or misgiving or lost ability; I set out knowing that not only will I achieve what's been asked of me, but that I will be paid for it. This is not a retrograde fantasy but a beautiful dream. If at the computer, I am beset by distractions and often filled with despair, then at the typewriter, I work. I make the most of my marketable skill. Someone else is telling me what to write and I listen; I focus; I type.

# THE LOOK:
## Patty and Her Avatars

*Santiago Echeverry*

Back in 1993, the guard of the place where I used to work, the French Embassy in Bogotá, Colombia, told me how he had witnessed the murder of a transgender prostitute the previous night. He vividly described how she had been shot, and how no car would stop to take her to the hospital. She bled to death on the sidewalk. For him it was normal to see her die: she was "disposable," the social cleansing term used to define all the undesirable inhabitants of a large city. This incident revealed how all of us in the LGBT community were under the same category of "disposable people," simply because of the way we looked, talked, or behaved, or the places we visited.

This anonymous victim was just one of the most recognizable targets in our community, because of her look, her job, and the exposure the streets gave her. Her murder inspired me to create an avatar for myself, appearing publicly for the first time in a video art piece entitled *Last Night a Transvestite was Killed*, and allowing me to come out of the closet officially. After the 1991 Constitutional reform, it was finally legal to be homosexual in Colombia, and I was free to be in drag, to wear feminine clothes, a wig, and high heels. In one scene, my wig is torn, revealing that the narrator and the victim are the same. Then my earrings are snapped from my ears in the same way the stars are torn from a disgraced general in a humiliating, degrading ceremony. The night of the video's premiere, at the most important video art festival in Latin America, which was sponsored by the French Embassy, I attended the opening in drag, something totally unheard of in the art world. Everything I wore was borrowed, including the shoes. My head was bald, and as part of the performance I was wearing a purple beauty queen sash saying N.N. (no name), parading the room while putting my makeup on in front of everyone. The vast majority of people rejected me; even those who knew me did not say hello. But the supporters were amazingly encouraging and naturally created a supporting circle around me. The drag *uniform* was an empowering tool that allowed me to understand the tragedy of all of us who were being murdered, and who are still being targeted for being different. The first incarnation of Patty was born.

When I returned to Colombia from New York at the end of the 1990s, after I finished my studies, I encountered a transformed city. Drag queens were popping up everywhere, the party scene was exploding, and drugs had inundated every level of the entertainment and political worlds. The country was torn by a violent war between the paramilitaries, the guerrillas, and the official armed forces. Cities were crumbling, while our community was partying as if there were no tomorrow. The most outrageous expressions of a LGBT subculture made me think of the times right before National Socialism rose to power in Germany, moving Christopher Isherwood to document this specific period of time - writings that later inspired the musical *Cabaret*. After eating a tainted *ceviche* in Cartagena, I contracted Hepatitis A. While hallucinating during recovery, I saw the image of Patty as the perfect MC for times that were announcing a bigger war. Her last name was created: "E. Patétik." My former Colombian students became my biggest collaborators, donating makeup, clothes, wigs, and especially their talent to create this new character. Reused, upcycled, and transformed items helped me morph into this hybrid persona, usually being recreated every single time she appeared in public or virtually. Patty had seen the world and the likes of Lipsynka, Ru Paul, Lady Bunny, and Joey Arias, but she understood that her own role was different. Those drags in the first world were not fighting for their lives, for their own existence; they were entertainers, not witnesses of an endangered society – or at least they were not aware of it. Around this time, my mother had to escape from Colombia because her political enemies tried to murder her, and shortly after that my brother left the country too, knowing he would rather start from zero than face the kidnapping of his children. My mom left most of her belongings in Colombia, and in her wardrobe I found my grandmother's mink stoles and gloves, as well as her costume jewelry. Patty was a potpourri of vintage clothes, a custom-made male corset, and a beehive pink wig that acted as a lightning rod for all the surprised looks in the streets. She became increasingly elegant, handling fantastically tall high heels, proudly retrieving the genetic information I was carrying in my X chromosome. Instead of feminizing my male features, I was enhancing the natural masculine traits of my face, focusing mostly on the eyes. Patty was not pretending to be a woman: I am not transgender. Patty was a male in outstandingly non-traditional female clothes, never tucking and never adding fake boobs. The narrator and the victim of my video art piece had clearly merged.

Soon after this, I realized my career in Colombia had no future, and I accepted an invitation to teach in Maryland. It was my turn to leave the country, and I moved to the United States in 2003. I had the biggest welcome party anyone could expect: the FBI and the police at the Miami airport stopped and questioned me for hours because the ex-boyfriend of my now ex-partner accused me of being an international terrorist trying to bomb a federal building in Baltimore. I wish I had recorded the faces of the agents when I was showing them the pictures of Patty on the cover of *Arts International* magazine and the article that Sheryl Oring had written about my work: I could hear their brain cells popping, trying to understand what kind of evil creature I incarnated. Not only was I talking about interactive media and the future of digital tools during the questioning, but there I was, wearing the most fabulous quartz bracelet, in drag on the cover of a magazine. Patty came to my rescue in one of the most stressful moments of my life, proving I was nothing more than an innocuous "entertainer" (that's how they ended up describing me),

and we were allowed to enter my new life in America. But the blow of this event was too strong for Patty, and she didn't survive this ordeal: she disappeared in April 2004, closing the cabaret. Just as Man Ray was said to complain to Duchamp about Dada being unsuccessful in New York, there was no political reason for Patty to exist in the United States: her political purpose was gone. I needed to rebuild my life, I needed to understand this new society, and Patty was just a distraction.

After a few years in Tampa, a new avatar was born: Edwardo, an illegal gay Latino immigrant, fighting fascism in this world by channeling Dusty Springfield. Wearing his highly Anglicized name and the American flag on an orange shirt – reminiscent of those worn by inmates – he burns the swastika to perform a dramatic interpretation, of "You Don't Have to Say You Love Me." A very masculine man becomes a 1960s diva. Edwardo appeared in a fictional short video by Gregg Perkins titled *Patria o Muerte*, where he plans a socialist revolution with his Peruvian co-worker from a car garage, but sees his dream frustrated when a girl steals all their savings.

Fifteen years after the full creation of Patty E. Patétik, there is an entirely new generation of young Colombian artists that has rediscovered her and invited her to participate in their projects. They see Patty as one of the path openers that allowed the understanding of their "being different but fun" attitude. Patty has recently collaborated in Bogotá with a punk puppet band called Six Sex Six – punk being the ideal spawning ground for the kind of work drag can be – and with a talented queer photographer known by his professional name, Manu Mojito. These artists understand that both Patty and I are getting old, balder and furrier each day, and respect us for what we are. They actually motivate us to embrace our salt-and-pepper beard, making me realize that, as I get older, more of Patty is infiltrating my own persona, causing me to dye my whiskers blue and purple. Cabaret is not as dangerous as it was before, and it is more alive than ever. I can't wait to explore it again – this time not as an expression of a decaying world, but rather as a way to express our unique, fragile identities.

# THE QUESTION:
## The Door to What We Most Want to Know

*Chloë Bass*

I use questions to bring other people into my practice as quickly as possible. As a conceptual artist working in complex, often ephemeral forms – yet with a practice that undeniably requires the participation of other people – I have to walk the line between being totally approachable and completely confusing. Giving people a familiar strategy as a way to engage with a project is one way to be sure that someone *will* engage with the project. When someone asks you a question, you give an answer – even if the answer is that you don't know the answer. If a question is posed, a response follows. This is particularly great when you're exposing people to something new – from the simple "Do you have a moment for Greenpeace?" on a busy Manhattan street corner to the more surprising: visitors at a recent exhibit of mine were greeted by the question "How do you know when we are really together?" Whether or not the participant understands all the conceptual underpinnings of a project, its history, and its intended aesthetic impact is immaterial to me. What is important is that once the question is posed, the conversation can begin.

But questions are not just important for bringing others into my practice. I also find them helpful for myself. All of the questions around which I've structured my recent work are truly things with which I am grappling: How do I know when I'm a person? What does it mean to be with others? What does it mean to be somewhere? How does what we do build the place we inhabit? So far, I've found that if I want to know something, there's a good chance that others are curious about it as well. Even starting to get a sense of how other people think about or deal with these questions has been deeply helpful as I continue to form myself as a person, not to mention as an artist. This is a way of crowd-sourcing information that I need to know for my own life. And how better to form an audience than around mutual curiosity or shared, instinctive needs?

For my 2011–13 project, "The Bureau of Self Recognition," my central question concerned the development of the individual: Is self-recognition a moment, as science has long posited, or a process? Is who we are pre-determined, or are we shaped by what we do? Rather than framing this question with all of its philosophical baggage, I opted for a slightly smoother inquiry:

**45**

What are three things you do every day? I got answers ranging from the ridiculous ("triptychs, trinities, trigonometries") to the sublime ("Look at mirror. Become more flexible"). Even better was when I got other questions: "Every day? Like every single day?" "Do things like 'breathing' count?" Or the deeper, underlying concerns that came out through conversation: What does it actually mean to do something every day? Why do we do these things? How do daily activities build over time? While generating yet more questions is not necessarily the intended purpose of framing a work with a central question, I find these responses to be a good indication of how audiences are paying attention, or how seriously the project is being taken. The success of my question as an entry point, meant that participants joined the project both for the simple short-term benefits, and for much longer-term, deeper engagements. Through nine months of inter-actions with over twenty-five individuals, I collected seventeen hours of video and 240 slides, among other archival materials.

It is important to remember that the question is not something that exists alongside the work; rather, it is one of its crucial aesthetic elements. Questioning, and conversational forms more generally, are in themselves an important craft. As many realms of art push themselves towards the social, it is important to be mindful of the ways in which communications impact the overall success of a project. Artists have long been known for questioning the way the world works, finding creative solutions, and implementing them. But all too often, the myth is that we ask these questions alone, to ourselves, in our studios. The process of building a different world doesn't come to light until the (often finished) work is on view for a public. Moving work into a more social realm (through social practice, community engaged art, performance, or other inherently dialogic forms) means that we need to figure out whether the questions we ask our-selves in the sanctuary of the studio are sufficient and comprehensive when we turn outwards to others. What does it mean when questioning is an aspect of both process and product, private and public?

My work *Tea Will Be Served* (2011) is a performance that rests entirely on participants asking each other questions while brewing and sharing a pot of tea. In this project, wording is crucial. A question that's too simple ("Is tea for two?") can snarl up the works by lending itself to a cursory answer: yes, or no. "Why is tea for two?" results in a back-and-forth exchange that in-creases intimacy and understanding between participants. A question that's too complex ("What is the purpose of paired tea interactions within your culture?") can be a roadblock. Patient par-ticipants might take time to unpack all the potential meanings and then debate the answers, but a performance designed to work with anyone – intimate friends, casual acquaintances, or total strangers – can't assume that level of patience. Partnering questions with simple activities serves as a mnemonic device for the conversation. Each phase of action (brewing, pouring, sweetening, and finally sipping tea together) brings words into the body; future iterations of these same basic actions can then serve as triggers back to what was discussed.

What is it to question? For me, it's the process of building a work in paper-thin layers. The question is foundational: essential, eventually buried, perhaps never directly answered – but the place from which all else develops. The question opens the possibility that something will hap-pen here, together. All we need is to be open to the asking. What is it you most want to know?

# THE CAMERA:
## Coming to Terms with Photographing People

*Dhanraj Emanuel*

> I observed that a photograph can be the object of three practices (or of three emotions, or of three intentions): to do, to undergo, to look. The *Operator* is the Photographer. The *Spectator* is ourselves, all of us who glance through collections of photographs – in magazines and newspapers, in books, albums, archives … And the person or thing photographed is the target, the referent, a kind of little simulacrum …
>
> (Barthes 1981: 9)

For as long as I can remember, I have always been around cameras and cameras have been around me – I come from a family of photographers. And for as long as I can remember, I have been uncomfortable photographing people. Not just because of the awkward interaction between photographer and photographed or subject and subjectified, but because of the responsibility of representation. Am I unbiased in my representation of people sitting in front of my camera? They have just poured out their hearts to a stranger with a typewriter. Should I read their cards before making their portrait? Will it inform my interaction and elicit a response worthy of their vulnerability?

The prospect of crisscrossing the country, listening in on conversations of strangers and making their portraits seemed like a fitting way to end a three-year visit to the United States. But before embarking on such a journey with Sheryl Oring and her "I Wish to Say" project back in 2006, I had to come to terms with the idea of photographing people. I would be photographing a cross-section of American society whose faces might be printed or exhibited next to their words so readers or museum visitors could make the connection between person and opinion. Would it give the person context, or vice versa? Does this add a layer of authenticity to the text?

As I struggled to make sense of this assignment, I started to see myself as being there for the sitter as opposed to the sitter being there for me, the photographer. This shift in perspective is of utmost importance to the project and to the role of the camera within it. The portraits are taken in an aesthetic similar to that of the passport photograph (albeit stylized), but unlike the pass-

port photograph that serves to identify the person for a specific purpose, the role of the image is to give voice to the text. This isn't to say that the text is somehow inadequate. To the contrary: the text seen together as a series creates a sociological, political, and ethnological snapshot of a moment in recent American history – a snapshot of a whole in whose embrace the individuality of pieces are swept away.

The role of the camera in this project is to contextualize the participants within the larger public, thereby individualizing the public. Photography plays the crucial role of personalizing each person's message, distinguishing each message within the overall "I Wish to Say" project, which tells a larger story.

Another question I've grappled with is whether "I Wish to Say" is primarily a performative artwork or a process. For the participant, the performance is often a cathartic, empowering, fulfilling experience – period. That they are part of an artwork is of little – or at least secondary – concern. Take, for instance, Guillermo Gonzalez, from Valrico, Florida, who sat, shoulders hunched and weary eyed and demanded, "Help my Mexican people. Don't discriminate. They are not criminals. They're here because they want to work. They're human, just like you and me. HELP!" He added a PS: "Answer me!" And Maria Martinez of Albuquerque, who held three children on her lap as she said, "I hope that you fix the immigration situation, because it would be hard for me to live single with three kids if my husband is deported."

Just like the rubber stamps with messages such as "URGENT," "FINAL NOTICE," and "RUSH," that people add to their cards after dictating their messages, the camera further authenticates and makes official the voice of each participant. The presence of the camera makes it a participant in the performance and simultaneously a conduit for both the documentation of that experience and means for a new reading of it. The secondary reading of the performance via the postcards, rubber stamps, and photographs allow for the process to be contextualized as a performative work of art that has given, and continues to give, voice to the public, one by one.

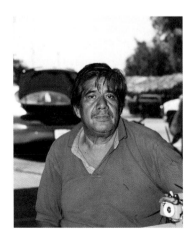

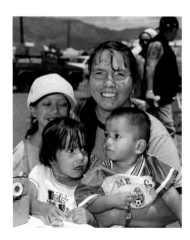

Guillermo Gonzalez.
*By Dhanraj Emanuel*

Maria Martinez.
*By Dhanraj Emanuel*

# THE DIGITAL ARCHIVE:

## Maintaining Privacy by Giving It All Away

*Hasan Elahi*

On June 19, 2002, I ran into a small problem that turned my life upside down. It happened at the Detroit Metropolitan Airport as I was on my way home to Florida via a rather convoluted route from West Africa. When I handed my passport to the immigration agent, I realized something wasn't right. After a few moments – which seemed to be an eternity then – he eventually got up and said, "Follow me please." I ended up at the Immigration and Naturalization Service detention office, a rather large room filled with people from all corners of the earth, with fear on their faces as this was their first day in the United States and things were not going well for them. The agent was just as confused as I was. Eventually, a man in a dark suit approached me and said, "I expected you to be older." I had no idea what he meant. At this point, I asked him to explain things and he responded, "Well, you have some explaining to do yourself." We then entered a barren, stark white interrogation room with a camera in the corner. There was an L-shaped desk with a computer on it and the man in the dark suit sat across from me. I still didn't know what was happening, but I realized that he was some type of government law enforcement officer and I was a suspect in something.

He asked me to retrace where I had been since I had left the United States, and he asked detailed questions about what I was doing, who I had met, who had financed all my travels, and so on for a good half an hour.

Then, out of nowhere, he asked: "Where were you September 12?"

Fortunately, I'm rather neurotic about record-keeping and my Palm PDA allowed me to look up Wednesday, September 12, 2001, on my calendar. I read him the contents: "Pay storage rent at 10, Meeting with Judith at 10:30, Intro Class from 12 to 3 and Advanced Class from 3 to 6." We read about six months of my calendar appointments, I don't think he was expecting me to have such detailed records.

He continued:

"You had a storage unit in Tampa, right?"

"Yes, near the university"

"What did you have in it?"

"Boxes of winter clothes, furniture that I can't fit in my apartment, some assorted junk and garage sale material."

"No explosives?"

"No, I'm certain I didn't have any explosives."

"Well, we received a report that you had explosives and had fled on September 12."

I think anyone who talks to me for more than a few minutes realizes that I'm no terrorist threat. He must have agreed I was no threat; after all, why else would he let me get on a plane home? But although he had the authority to let me go home, he couldn't just tell his supervisor: "Leave this guy alone. He's harmless." The system is built in such a way that it didn't trust him enough and it had to be escalated to higher levels of scrutiny.

A few weeks later, back in Tampa, my office phone rang and a man introduced himself and said he wanted to speak to me regarding my interview in Detroit. We entered an interrogation room, in which a rather large, imposing man with very short hair sat off to one side. I eventually realized that this was an FBI agent and the person with whom I had been dealing on the phone and earlier in the day was a deputy marshal with the Justice Department. The questions started as if I were in court. State your name, date of birth, occupation and such. The deputy marshal was expecting short one-line answers, not the long drawn-out essay-format answers complete with background information and such that a typical academic would give. He would begin reading the next question and after reading it out loud, realize that I had already answered it in my previous response. This game went on and the FBI agent watched quietly until he asked me about witnessing any acts that might be detrimental to the interests of the United States or a foreign country. So I started describing an incident that I had witnessed in Southern Mexico where Zapatista supporters were quite visible in the streets. Before I could get a full sentence out, the FBI agent cut me off by saying, "We're not interested in indigenous populations" and proceeded to ask me whether I had ever met anyone from Al Qaeda, the Taliban, the Islamic Jihad, Hamas, Hezbollah, and about half a dozen other groups that I had never even heard of before – and I consider myself pretty much on top of world affairs. He seemed to know things that were quite remarkable, little details that one simply could not just study and learn, like the statue of the person that was at the entrance of the American University in Beirut. Or routes that regular buses in that region took as opposed to Hezbollah buses. The things that he knew and the detail in which he knew them frightened me.

I could have contested the legality of the entire investigation and insisted on having a lawyer. But that would have made things messier and it was quite clear that they were the ones in power. It wasn't ever stated directly, but I realized that at any moment they could take me to Guantanamo and they would not have to explain to anyone what they were doing or why. When you're face to face with someone with that much power over life and death, you behave in a very unusual manner. You revert to your animalistic instincts and you do whatever that animal has to do for survival. In my case, it was to cooperate. And I cooperated to the point where I told them everything.

These questionings went on for the next six months and finally ended with a series of polygraph examinations. The agent who administered the tests was an older man, rather quiet in demeanor, who said he'd been doing this for years. As he hooked me up to the wires, we went through the questions. I'm assuming that questions such as, "Is today Tuesday?" or "Is your name Hasan?" were the control ones to compare with questions such as, "Have you ever met with any person from an intelligence agency of a foreign nation?" or, "Do you belong to any group that wishes to harm the United States?" I don't really remember most of the other questions as I pretty much went into a subconscious state while responding. When you're hooked up to that machine with all the wires coming out of you, it is actually quite easy to go into another mental state – something out of a sci-fi movie. Once it started, all I remember was that the test was repeated nine times. It ended three hours after I had entered the room. I remember the other agent coming into the room at the end and telling me that I had been cleared and everything was fine. I asked whether I could have a letter saying that, but he insisted that everything was okay and if I need anything, I should call him. I told him that I was planning on traveling in a couple of weeks and this was to be the first time since the investigation started, and that I was a little nervous about being let back into the country. All we needed was the last person not to get the latest memo and here we go all over again. He asked me to call him with the flight details and he would take care of everything.

Shortly after this meeting, right before my next trip, I called the FBI to report my whereabouts. It's not that I had to call, but I chose to. I wanted to make sure that they knew that I wasn't making any sudden moves or that I wasn't running off somewhere. I wanted them to know where I was and what I was doing at any given time. Then the phone calls turned to email … the emails turned to longer emails … with pictures … with websites that I would make. And then I wrote some clunky code for my old Nokia 6600 phone and basically turned it into a tracking device.

In the process of creating this project (which was hardly a project at first, but more of a practicality so I didn't get shipped off to Guantanamo), I started thinking about what else the FBI might know about me. I know I told them every little detail of my life and they probably have my flight records, so I created a list of every flight I've been on since birth. The more recent flights show not only exact flight numbers extracted from my frequent flyer accounts, but also photographs of the meals that I got fed on the flights. I collected all these pieces of information (or evidence of my activities in my particular case) and created a website for the FBI. It was a rather organic process, but eventually became "Tracking Transcience." There are various databases of images on the site: airports, food that I've eaten at home, food that I've eaten on the road, random hotel beds that I've slept in, various parking lots off of Interstate 80, empty train stations, and some even as specific as tacos eaten in Mexico City between July 5 and July 7, not to mention the toilets that I use. These images are all quite empty, and really could be anywhere, but they're extremely specific to the exact location where they were photographed.

Currently, there are 72,000 images on my site, and I trust that the FBI has seen all of them. Not unlike the Stasi files of East Germany, the FBI knows the stores that I've shopped in and

where I've bought my duck-flavored paste, or kimchi, or my laundry detergent, or my chitlins – because I told them everything. Along with these images are screenshots of my financial data, communication records, and transportation logs. It is here that one can cross-reference these records with my images, not unlike how the FBI had to cross-reference the very same databases. So not only am I providing my location and photographs, but there are now independent third parties (whether it be my bank, or my phone company, or other entities) verifying that I was indeed at these locations at the times and dates provided.

When one goes on my site, one shouldn't expect the information to be provided in a clear and concise manner. In fact, the interface is deliberately quite user-unfriendly and a lot of work is needed to thread together these thousands of points of information. By putting everything about me out there, I am simultaneously telling everything and nothing. With that barrage of information about me that is publicly available, I live a surprisingly private and anonymous life. I have decided that in an era where everything is archived and everything is tracked, the way you maintain privacy is to give it all away. Information agencies, regardless of who they are, all operate in an industry where their commodity is information. And the restricted access to the information is what makes it valuable. If I cut out the middleman and offer the information publicly and flood the market with my information, that information that the FBI has on me has no value, since everyone has access to it – and thus the overall currency is devalued. I realize that on an individual basis, it's a symbolic gesture, but if 300 million people started doing this, the government would potentially need to hire another 300 million people to keep up with the information. But more importantly, the entire system would have to be redesigned from the ground up as it would no longer be a matter of collecting the information, but more about the analysis of it.

After doing this for over a decade, I started asking myself, "What do I not share?" While I'm perfectly fine opening up every aspect of my personal life to the public, I'm still aware that I'm only telling one part of the story. I might post pictures of my cat all over my Facebook page, but he would never show up on "Tracking Transience." Instead, there are only little clues about his existence, such as a partially visible bag of cat litter. Otherwise, you'd never see him – or anyone else. Most of the images here are of empty, desolate, and, at times, outright depressing surroundings.

That is not to say that I am never around any people or that I don't have any fun. What the viewer doesn't see is what is happening on the other side of the camera – and that's a very deliberate decision on my part. Even in the most crowded airport, I'll seek out that one gate where no one is present. Or maybe I'll show the one lonely potted plant in the corner of a room in the middle of that lively party. It's a way to require an interpretation of the image and ask the viewer to place it in context. We often take photos of what we feel is important, but what if the photograph still captured the same important event, but turned the lens away from the subject? Is it still a photograph of the event? What if our cameras were automated and captured everything around us?

I still stand behind the idea that you protect your privacy by giving it up, but I also acknowledge that even in the years I've been tracking myself, our culture and opinions of surveil-

lance have changed. When I first started my project, people thought I was insane. Why would anyone tell everyone what they were doing at all times? Why would anyone want to share a photo of every place they visited? These days, we don't even think twice about doing this. We don't even notice that our smartphones are tracking us much more accurately than I ever could track myself. What I'm doing is no longer just art; creating our own digital archives has become so commonplace that we're all – or at least hundreds of millions of us – doing it all the time. Whether we know it or not, most of us are completely unaware of the archives that our phones and our browser searches and histories are creating. We have been incredibly adaptive and we learn quickly, but we cannot possibly expect the norms of yesterday to apply to tomorrow. It's not a matter of better or worse, but that things will be different – we need to acknowledge that and be ready to change. The challenge is finding common ground where the technology, culture, and policy all work in sync with each other. Far too often, the technology moves at a far greater speed than that at which our culture is able to adopt it into day-to-day use. And unfortunately, by the time our lawmakers get around to deciding what policies to implement in response to that technology, it has already evolved into a whole different thing.

I'm hopeful that we'll learn to adapt and will find common ground. For now, we're still in a transition between analog and digital, and for as long as we're in this state of flux, we'll develop a more sophisticated understanding of the consequences of living under constant surveillance. For now, at least, we still have control over what information we put forth publicly. Being mindful of how we do that feels like a good first step toward retaining control.

# THE PAPER, THE GAME, AND THE CITY PARK:

## Places for Things to Happen

*Lee Walton*

### Game On

I pinned up a brand new empty sheet of paper to the studio wall. I was an undergraduate, and it was the first day of class. I looked around and all my fellow students were drawing – with purpose, it seemed. I was perplexed. Confused. I asked my instructor, "What are we supposed to be drawing?" Casually, he told me as he walked away, "This is Advanced Drawing." I looked again at this empty, open field of paper. It had nothing. I had nothing. An overwhelming feeling of humility blanketed me. I realized, at that moment, I had so much to learn. Game on.

### *Musings About a Sheet of Paper*

The open space of the paper is a place for something to happen. The function is indeterminate and undefined. It is an event space full of potential. The emptiness is a structure without an author. It is receptive and can be changed. Like the wider end of a funnel, it is open to infinite possibilities. The author is the person who uses it.

The space is defined by its edges. The edges set this space apart from the rest of the world. This delineation is simply a shared agreement. It is an invented language. This space is not real, but artificial – "art" being the root of the word artificial.

Through desire, intention, and non-intention, things can happen within this space. Various elements can interact. This interaction can take shape and form. The organization of these shapes and forms can create meaning, re-create some notion of reality or be reality itself. When graphite travels across this space, a line is recorded. When a paintbrush is used to apply a field of pigment to this space, the energy changes. The drawing, or painting, becomes a record of these events. Historical documentation. Things that happen in this artificial space are inseparable from the things that happen in real life – and vice versa. At the core, it's social. John Cage described, "Art as sort of an experimental station in which one *tries out living*" (1961: 140). We are the authors and participants. We invent the systems, rules, and structures. We also break them, revive them, subvert them, dethrone them, and reinvent them.

Robert Rauschenberg's *White Painting,* 1952, turned on its side.

Ultimately, the drawing space is social and the power is vested in the artists. The world is changed in some way from our participation in this space. The game is changing too.

### Musings About Soccer Fields

Much like a sheet of paper, or freshly stretched canvas, a soccer field is an open, rectangular space. Its edges are often made of chalk or spray paint. These lines are specific. They are delineated on the basis of a set of agreed-upon rules. There is an inbounds and an out of bounds. A soccer field is set apart from the rest of the world. It can be anywhere. It is an event space. The field itself is completely empty. The goal posts are out of bounds, just barely, but still out of bounds.

The players activate the space. There are two teams, twenty-two players on the field. A soccer ball is kicked around. As the ball moves through the space, the players adjust accordingly – as a unit. The intention of kicking the ball is based on each team's opposing desires and shared goals. They work together. It is social. It is political.

There are rules. Referees help with this part of the game. Referees are responsible for maintaining order and enforcing rules.

When a player breaks a rule, the referee can issue a penalty and in some cases remove a player from the game entirely. Referees can "refer" to the official rulebook if necessary. Unfortunately, sometimes the referees use their authority to influence the game based on their own desires. This cannot be tolerated. This is unjust and unfair. The players and participants will not allow it. They will protest and eventually revolt. The game is too important. It means everything.

Camp Nou Soccer Field, Barcelona, Spain, 2015.

The soccer ball itself is meaningless. Interchangeable. It is just a tool. Its weight is regulated at 233 grams by a governing body. This has proven to be the best weight to facilitate a fair match. We all want a good game. Art, much like a soccer ball, is interchangeable and meaningless without the players. It is how we respond, change shape, and interact on the basis of its ever-changing context that counts. It's purely relational. Purely social. Art, like a soccer ball, can be replaced, pumped up, deflated, overly fetishized, lost, or eaten by a bulldog. It's about soccer. It has never really been about the soccer ball.

Spectators are also part of the game. They just watch and cheer supportively for the players who share their own desires, dreams and goals. They are safely distanced from the field and cannot directly affect the direction of the soccer ball. However, if coordinated properly, they can still influence the outcome of the game in strange ways.

Ultimately, the soccer field is social and the power is vested in the players. The world is changed in some way from our participation in this space. The game is changing too.

### Musings About City Parks

Much like a sheet of paper, freshly stretched canvas, or a soccer field, a public city park is an open space. A city park is a dedicated space, intentionally set aside from the hustle and bustle of the rest of the city. The function of a park is for recreation. Re-creation.

Socially, the park operates under and values a different system of exchange than the rest of the city. A functioning park is a shared space. It has edges. These edges are defined in different ways, such as sidewalks, walls, landscaping, or other architectural elements. They take on many shapes. Many of them are rectangular. You are either inside the park or outside the park.

Parks are designed and built by people. Structures, such as benches, walkways, plantings, fountains, playgrounds, and more, are built into the space to create opportunities for various things to happen – such as conversation, a game of chess, a rest in the shade, a picnic, a drum circle, or a leisurely stroll. You can walk across a park in the same way that you can draw a line across a piece of paper. If enough people take this same walk, a path will emerge. The park is not fixed, it changes constantly, based on the movements and actions of the people who use it.

The public city park is not a real space, but an artificial one. It's an open and flexible structure amidst the controlled, rigid, privately controlled, functional spaces of the rest of the city. Parks transfer their authority to the public – much like the way Robert Rauschenberg's *White Painting* (1952) is an open and flexible structure that transfers power to the viewers, allowing them to become the authors themselves.

Central Park, New York, New York, 2015.

**59**

Public parks are free social spaces, and anyone can use them. However, they do have rules. The public park, a citizen-funded space, is governed by our city officials. These officials are responsible for keeping order and enforcing rules. This ensures that citizens can experience and use the park safely and justly. Essentially, it's about fairness and maintaining a good park! When a person breaks a rule, a police officer can give a penalty and in some case remove a person from the park entirely. Police officers follow official "policy." Unfortunately, sometime they use their authority to influence the activities of the park based on their own desires. This cannot be tolerated. The public will not allow it. They will protest and eventually revolt. The park is too important. It means everything.

Ultimately, the park is social and the power is vested in the people. The world is changed in some way from our participation in this space. The game is changing too.

# THE STREET:

## Fleeting Situations and Doings

*Ed Woodham*

I've chosen to write these musings about 14th Street in Manhattan inspired by the structure of haibun – a prosimetric literary form combining prose and haiku. The form seemed perfect for writing about the street as it lends itself to experimentation and could be viewed as a form of word photography. Imagine that the haiku is the snapshot of a block on 14th Street – the moment a photograph is taken. The prose is the framing of the shot with all the ambiguity of suggestion of past and present.

I have a long and ongoing history with 14th Street. I've collaborated with hundreds of artists and thousands of passersby every October since 2008 (at this location) to create the project "Art in Odd Places" to reclaim our public space by setting visual and performance art along this major thoroughfare without permission.

14th Street is my adopted studio-laboratory, employed as an open and free performative space to study communication in the public sphere. I've walked 14th Street over the past four decades absorbing visceral notes of how a particular magic happens only in the democracy of the street. I've checked out the ever-changing nooks and crannies between the buildings and observed the varied rhythms of the crowd. I continue to search for serendipitous moments of urban poetry.

From east to west…

**Avenue C**
electricity juice
pedro campos housing
pollinate vision(s)

Con Edison generating plant looms over shuttered businesses. Ominous presence of surveillance. North: a behemoth eighty acre village of *upstate* red bricks. South: Pedro Albizu Campos

Plaza connects towering NYCHA apartment buildings. Limestone electronics. Everything stops still as a young voice sings "Firework." Navigating the dynamics of possibilities. A giant 10 foot red pillow wobbles on the sidewalk.

**Avenue B**
otto's shrunken head
shops old school dollar stores and
stretches of upgrowth

Blue construction walls. Tikki rock & roll. Ninety-nine cent dreams. Closed/out of business. An old-school Irish pub. Someone sitting in a yellow square plastic crate with wheels propelled by jerking movements across the sidewalk. He stops and climbs on two more crates and speak/sings, "Sometimes. Sometimes. Sometimes. I feel like a mother. Sometimes. Sometimes. I feel. Sometimes I feel like a mother. Sometimes. Sometimes I feel motherless." (repeats) He stops. And walks west.

**Avenue A**
allen ginsberg's loft
tall priced stuytown brickments
conceived immaculate

A woman sitting at a small white table placing textured blue and gray papier mâché of real estate price headlines over her face. Church bell. The writing is on the sidewalk. A bearded man with a sparkly one-piece twirls a baton on the corner to an R&B song.

**First Avenue**
williamsburg subhub
house of worship nowhere bar
artichoke pizzas

With his eyes and ears covered, a businessman with a metal suitcase sleeps upright on a vertical bed connected to a subway grate. Personal space caution tape is wrapped around four grocery shopping carts. A siren sounds for a long time. Nighttime. Entire apartment buildings' windows reveal images of the street's past. Red lipstick kisses cover trunks of trees.

**Second Avenue**
ear and eye clinic
wigs, russian gifts, cuisinemash
beauty bar music

Passersby tie blue ribbons onto a chain link fence on an empty lot. Someone asks us both to slow dance – suspending time. Car horns. A woman wearing a white wedding dress leads a group of dancing girls dressed in white – all wearing the number zero.

**Third Avenue**
disco donut and
palladium memories
private parking lot

Trash bags have personalities and relationships. Gilded obsolete fireboxes. "What the hell is going on today?" A man in a gold helmet and a cape has landed on a row of newspaper boxes. He was flying? Swarms of crowds hypnotized by small screens move in-sync round us. Crochet in the round razor wire on a fence.

**Irving Place**
box appliance sale
con edison tower light
university

Inside a small coffee cart for an intimate cup of tea to share stories. A man in a suit sprays the anarchist symbol on a nearby wall. It disappears. Wind from the passing of a crosstown bus catches large white underwear and bras hanging from a laundry line between two light poles.

**Fourth Avenue/Union Square East**
washington stature
subway riders pound millions
cacophony space

Two painters duel face-to-face. A miniature summer shift on a tiny hanger. A naked muscular man wearing an animal skull over his swimsuit area spits rum and throws colored powder. The handshake of a trader after an exchange. A large circular red ladder rolls by. George Washington is a tourist!

**Broadway**
politics engaged
the steaming clock numbers flash
spontaneous drive

Smiley face portraiture. Wash and dry the feet of strangers cloaked in black cloth. A long line of women wearing traditional white gowns walks in unison carrying glass jars with their braids inside. A blessing from a priestess with a six foot wig activating all of our twelve senses. A request for adoration.

**University Place/Union Square West**
opposing streets meet
a green market beginning
chess players inner

Transported to the past, a newsboy with a flatcap chants, "Get your newspaper right here! Read all about it!" An empress eats lobster. Construction workers distress their new jeans by rubbing them on the sidewalk for hours. A financial corporation races by, followed by an iceberg. Life is not easy for any of us.

**Fifth Avenue**
remnant of macy's
party city graffiti
union nervequarters

A group of officials collect random data. What's the first thing you thought of when you woke up this morning? "Top o' the morning to you!" says a gentleman in a top hat and morning suit. A siren. Neon skinned figures contort inside and around scaffolding. A dandy poses in the middle of the street.

**Sixth Avenue**
mattress emporium
newish school aluminum
desco vacuum neon

A man on his hands and knees scrapes up black gum from the sidewalk. An operator helps us to make a phone call using a phone number from the past. A dada stoop sale. Repeating infinity Busby Berkeley tap numbers. Good stuff meetings.

**Seventh Avenue**
tunnel passunder
doughnut pub rags a go go
statue of jeanne

Reimagine the street. Architectural chalk blueprint of an apartment on the sidewalk. A tsa-tsa in a cubby, lichen on a building. Head-to-toe camouflaged delegates hold signs of other languages. Loss of the vibrant character that made NYC. Monty Burns for mayor.

**Eighth Avenue**
our bank of duane reade
lady of guadalupe
village idiot

A gay love letter from the past tucked in a telephone booth. A woman wearing cans and lids of cans clanks across the intersection in circles. A feather floats down from the sky with a private message. Angelina Jolie saunters with an entourage of bodyguards and paparazzi in a reality.

**Hudson Street**
triangle breakthrough
the manhole before hellfire
triangulo tango

Sounds of brass instruments from each corner. Love prescription = your openness will be rewarded in unexpected ways. Information about where we are going. A respite in two of the twelve white chairs. Glimmer of glitz where are you?

**Ninth Avenue**
meatpacking apple
the toilet gay sex club
crossdressing corner

Edward Snowden stands nine feet tall. An unwavering drag bride promenades west. A rolled up five dollar bill in an iron gate. The drone asks for a memory. The hidden inaudible pollution is revealed.

**Washington Street**
mother, jackie 60
alexander mcqueen beef
crème de cobblestone

Fashionistas strut sarcasm with drummers. *Found on a circuit box:* a little graffitied iconic New York white delivery truck. Someone is trying to move something that they cannot.

**Tenth Avenue**
cuts through the border
elevated railroad park
hour liberty

A path of rose petals. Oil and water mix dreamy absurdities on a gas station window. Liberty Inn augmented reality. A compliment dispenser: "Your eyes are pretty." Two mothers eat their babies. Multiple clocks on a fence.

**Eleventh Avenue**
walk west forever
transoceanic fairies
float hudson river

A person with a yoke carrying two buckets of water walks toward the river. Flags wave on the pier posts nubs. Two people lower a device, another dips cards into the holy Hudson. Listen to the sounds. Carrying one another and the burdens embodied can rest here.

# THE CITY:
## The Political Equator and the Radicalization of the Local

*Teddy Cruz*

The forces of control across the Tijuana/San Diego border, the most trafficked checkpoint in the world, have provoked the small immigrant border neighborhoods to construct alternative urbanisms of alteration and adaptation through a series of two-way invisible trans-border flows. These are physically manifested by the informal land use patterns and economies produced by migrant workers flowing from Tijuana into San Diego in one direction, altering the homogeneity of San Diego's neighborhoods. In the opposite direction, the "infrastructural waste" from San Diego moves into Tijuana, as this city recycles the urban waste of Southern California to construct an insurgent, cross-border urbanism of emergency across the many slums that dot its periphery. This suggests a double urbanization of retrofit by which the recycling of fragments, resources, and situations from these two cities can trigger different meanings of urban policy, housing, and public infrastructure.

These geographies of conflict serve as complex environments from which to recontextualize the abstraction of globalization by engaging the specificity of the political inscribed in physical territories: a *radicalization of the local.* Therefore, this border region has been one of the most productive zones for my research in the last few years, where the conditions that have produced the current universal institutional crisis have enabled the recoding of a practice of intervention by engaging the spatial, territorial, and environmental collisions across critical thresholds, whether global border zones or the local sectors of conflict generated by discriminating politics of zoning and economic development in the contemporary city.

Seeking to problematize these local–global correspondences, and imagine new conceptual frameworks to further engage geographic conflict as an operational artistic tool, I coined the term *Political Equator* as a practice diagram for my work at the border. Considering the Tijuana/San Diego border region as a point of departure, the Political Equator traces an imaginary line along the United States–Mexico continental border and extends directly across a world atlas, forming a corridor of global conflict between the 30th and 35th parallels north. Along

this imaginary border encircling the globe lie some of the world's most contested thresholds, including the United States–Mexico border at Tijuana/San Diego, the most intensified portal for immigration from Latin America to the United States; the Strait of Gibraltar, where waves of migration flow from North Africa into Europe; and the Israeli–Palestinian border that divides the Middle East.

This global border, forming a necklace of some of the most contested checkpoints in the world, is ultimately not a flat line but an operative critical threshold that bends, fragments and stretches to reveal other sites of conflict worldwide, where invisible trans-hemispheric socio-political, economic, and environmental crises are manifested at regional and local scales. The Political Equator has been our point of entry into many of these radical localities, other marginal communities and neighborhoods distributed across the continents from which to imagine new forms of governance and urbanization. It could be argued that some of the most relevant projects forwarding socio-economic inclusion and artistic experimentation will not emerge from sites of economic abundance but from sites of scarcity, in the midst of the conflicts between geopolitical borders, natural resources, and marginal communities.

### Trans-border Itinerant Dialogues

The Political Equator was conceptualized in 2005 and has taken the form of nomadic urban actions and debates involving institutions and communities, oscillating across diverse sites and stations between Tijuana and San Diego. These conversations on the move have proposed that the interdisciplinary debate takes place outside the institutions and inside the actual sites of conflict, enabling the audience to be both witness and participant. The meetings unfold around a series of public works, performances, and walks traversing these conflicting territories, and they serve as evidentiary platforms to recontextualize debates and conversations among diverse publics. The main focus has been to link two activist neighborhoods adjacent to the checkpoint but divided by the border wall, which have been the sites for my research and practice in the last years: San Ysidro, on the U.S. side, which is the first immigrant neighborhood in the United States, and Laureles Canyon in Mexico, the last slum from Latin America towards the United States, and an informal settlement that is home to approximately 85,000 people, literally crashing against the border wall.

While the global city has become dependent on a top-down urbanization of *consumption* in recent years, many local neighborhoods in the margins of such centers of economic power have unfolded as bottom-up urbanizations of cultural and socio-economic *production*. It is within these marginalized, under-represented communities that people themselves, pressed by socio-economic injustice, are pushed to imagine and produce "other" arrangements, "other" spaces and institutional protocols, "other" citizenships. It is at the periphery where conditions of social emergency are transforming our ways of thinking about urban matters, and matters of concern about the city. A series of Political Equator meetings therefore have been focused on the specificity of these two border communities, generating a series of cultural and knowledge exchanges, co-produced in collaboration with the two main local community-based NGOs that

represent these neighborhoods, Casa Familiar in San Ysidro and Alter Terra in Laureles Canyon.

Social justice today cannot be only about the redistribution of resources, but must also engage the redistribution of knowledge. One of the most pressing problems today, in fact, pertains to a crisis of knowledge-transfer between institutions, fields of specialization, and publics. The Political Equator takes the shape of an urban-pedagogical research project, producing corridors of knowledge-exchange linking the specialized knowledge of institutions and the political intelligence embedded whithin communities. This implies transforming the generic conference format into an experimental platform to research new forms of knowledge, pedagogy, and public participation, whose point of departure is the visualization of environmental and political conflict.

### The Political Equator 3: Border–Drain–Crossing

The most recent of these meetings, the Political Equator 3 (PE3), took place over two days, June 3–4, 2011. This time, the itinerant conversation mobilized the audience from San Ysidro into Laureles Canyon through the Tijuana River Estuary, which is adjacent to these neighborhoods, the checkpoint, and the border wall. The environmental performance of this sensitive zone at the edge of the border wall, as it sinks into the Pacific Ocean, has been compromised in recent years by the presence of Homeland Security militarization, as the United States has been building the third border wall, and other infrastructure of control. This includes the construction of a new highway of surveillance that runs parallel to the border wall along a 150 foot-wide linear corridor that Homeland Security claimed as its own jurisdiction after 9/11. Along this corridor, Border Patrol has systematically been building a series of dirt dams and drains, which truncate the many canyons that are part of the trans-border watershed system, accelerating the flow of waste from the informal settlement of Los Laureles into the estuary.

The most emblematic public action during PE3 was an unprecedented public border crossing through an existing drain, recently built by Homeland Security at the intersection of the wall, the informal settlement, and the estuary – enabling the audience to slip uninterrupted from the Tijuana River Estuary on the U.S. side into the Los Laureles Canyon in Tijuana. This public performance was embedded inside this site of exception, encroaching into official institutional protocols and jurisdictional zones – a fundamental part of the curatorial dimension of the event.

This act of crossing resulted from a long process of discussions and negotiations with both Homeland Security and Mexican immigration, requesting the recoding of this specific generic drain beneath one of those dirt berms as a temporary but official port of entry for 24 hours. A significant part of this strategy was to camouflage this happening as an artistic performance, while implicitly orchestrating the visualization of the collision between environmental zone, surveillance infrastructure, and informal settlement, and bringing together local, national, and international activists, scholars, and researchers, artists, architects, and urbanists, politicians, Border Patrol, and other community stakeholders who represented the many institutions that have an antagonistic role around this site of conflict.

As the audience moved south against the natural flow of wastewater coming from the slum

and contaminating the estuary, it reached the Mexican immigration officers who had set up an improvisational tent on the south side of the drain inside Mexican territory, immediately adjacent to the flowing murky water. The strange juxtaposition of pollution seeping into the environmental zone, the stamping of passports inside this liminal space, and the passage from estuary to slum under a culvert amplified the contradictions between national security, environmentalism, and the construction of citizenship. Can border regions be the laboratories to reimagine citizenship beyond the nation-state?

By enabling the physical passage across this odd section of the bi-national territory, PE3 not only exposed the dramatic collision between informal urbanization, militarization, and environmental zones, but it also articulated the urgency for strategies of coexistence between these two border communities. Can we shift our gaze and resources from the border wall itself and into the slum? Can this poor Mexican informal settlement be the protector of the rich Tijuana River Estuary in the United States?

The need to reimagine the border through the logic of natural and social systems is the foremost challenge for the future of this bi-national region, and of many other border regions across the globe. A community is always in dialogue with its immediate social and ecological environment; this is what defines its political nature. But when this relationship is disrupted and its productive capacity is splintered by the very way in which jurisdictional power is instituted, it is necessary to find a means of recuperating its agency, and this is the space of intervention in which art and architectural practice need to engage today. Can architects intervene in the reorganization of political institutions, new forms of governance, economic systems, research and pedagogy, and new conceptions of cultural and economic production? This cannot occur without expanding and recoding our conventional modalities of practice, making architecture both a political field and a cognitive system that can enable the public to access urban complexity, building collective capacity for political agency and action at local scales, and also be generative of new experimental spaces and social programs for the city.

# THE ROAD:

## Stories from the Navajo Nation

*Stephanie Elizondo Griest*

Sheryl Oring and I hadn't known each other long before we decided to drive across America together. But what our friendship lacked in shared memory, we made up for in united purpose. We had both started our careers as journalists but then pursued artsier paths – she as a visual artist and me as a creative writer. As single women in our thirties, we were striving to produce work that mattered while still paying the rent (which, in New York City, was no small feat). A perk of not yet having spouses or houses or children was our freedom to chase impulse. When we realized that our latest projects (a new book for me, an inaugural performance for her) would be better served on the open road than in our cramped Brooklyn apartments, we flew out to Texas – where my 1992 Mazda awaited – and ventured off.

Those first few days, we indulged in everything you should on a road trip, gorging on po-tato-and-egg taquitos from a street stand in Albuquerque, downing cold beer at a honky-tonk in Flagstaff, and splurging on red cowboy boots in El Paso. The demands of our Palm Pilots evaporated in the hot mineral baths of Truth or Consequences, New Mexico. Our frantic New Yorker pace slackened as we wandered through the orange stone castles of Bryce Canyon. Every morning, the road unfurled before us, glimmering with possibility.

Americans have long reveled in the pleasures of our nation's byways. The poet Walt Whit-man composed his famous ode to "the open road" in the 1850s. A doctor, a biker, and a dog named Bud made history's first transcontinental U.S. road trip in 1903, when they accepted a fifty-dollar bar bet to drive a cherry red Winton Touring Car from San Francisco to New York City in ninety days or less. (It only took them sixty-three, but cost them nearly $8,000 in the process.) Until the interstate highway system was launched in the late 1950s, road-tripping was considered a recreation of the rich, but writers like Jack Kerouac (*On the Road*) and John Steinbeck (*Travels with Charley*) gave it a more rugged connotation. By the 1970s, road-tripping had become our most attainable American Dream, open to anyone with a set of wheels and a little spunk.

But Sheryl and I were road-tripping in post-9/11 America. Our nation had been embroiled in an unjust war in Iraq for a year by that point; in seven months, we would determine whether or not to halt the presidency of the man who had declared it. As former journalists, we knew the importance of bearing witness to a moment. So these were the things we carried: a 1950s Erika typewriter Sheryl collected while living in East Berlin; a suitcase full of vintage suits and beaded cardigans; five bricks of 4" x 6" index cards; a Polaroid camera; an assortment of notebooks; and a collection of rubber stamps that said things like: "IMPOPRTANT," "COPY," "AIRMAIL," or "RETURN RECEIPT REQUESTED."

By the time we reached the Navajo Nation, we had been traveling for a week. That morning we'd taken our finest drive yet through the badlands of the Painted Desert, a riot of lavender, orange, gray, and blue. Our destination was Tuba City, purportedly the Navajo's largest community – though its streets seemed bereft of people. Finally we came upon Toh Nanees Dizi Shopping Center, home to a supermarket, a cinema, a pizza parlor, and a laundromat. Parking at the last establishment, we stepped into a whir of mothers, spin cycles, and Sun Triple Clean Tropical Breeze detergent.

While everyone seemed aware of our presence, only the children acknowledged it. They stared with unblinking eyes as Sheryl set up her office atop a dryer. First she removed the Erika from its leather carrying case and wiped off its enameled keys. Then she unwrapped a fresh brick of index cards and slid two into the typewriter with a piece of carbon paper in-between. As she started arranging her rubber stamp collection, I approached a middle-aged woman who was folding towels. She had wispy bangs and a moon-shaped face and greeted me with suspicion. I explained that we were traveling across the nation to record how people felt about it and then mailing the responses back to the president – yes, the Oval Office-holder himself – via postcards. Yes, right here, right now. Completely free of charge.

Soon there was no need for me to speak anymore. She was ready to do so herself. "Dear Mr. President," she said, shaking out a pair of hot jeans. "We've been wanting electricity for over thirty years."

Her name was Virginia and she had been living off batteries since she was a kid. She had the funds to buy her family a home computer but lacked a working outlet to plug it in. "You help people in Iraq when they need it," she dictated. "Over here, we've needed help ever since I can remember and we're not getting help."

Six-year-old Trevor wished to go next, tackling his postcard like a Santa list: "I want a playground. I want paper. I want shoes. I want pants, shirts and, and …" – he scrunched his face in contemplation – "… and a door."

This was when Sheryl's "I Wish to Say" project truly began to resonate within me. For years, I had been wrestling with the guilt of leaving newspaper journalism to "make art." Weren't artistic pursuits just an intellectual indulgence? What purpose did they serve in the world, hanging from a nail in a gallery or collecting dust on a shelf?

But then I watched a young mother named Tonya tell Sheryl how her family had blown through three generators already, and how expensive it was to drive into town to refill them. Two teenagers, Teshia and Marquetta, told her their only employment options here were the grocery

store and the pizza place. A young man named Mori told her how they "have hardly no dumpsters here" and how his aunt went to Iraq but didn't make it back for Christmas.

Sheryl didn't summarize or contextualize their voices. She didn't interrupt with pesky questions. Rather, she listened without judgment and transcribed exactly what was said, word for word. Then she encouraged the speakers to transform their dicta into artworks by offering up her rubber stamp collection. Some made collages of scarlet "URGENT"s and "CONFIDENTIALS"'s. Others signed off with an ominous "FINAL NOTICE." Saving a copy for her archive, Sheryl pasted a postage stamp on the original and gave it to the speaker to mail or keep, as they pleased. For "I Wish to Say" wasn't just about bearing witness; it was about empowering people to create their own acts of witness.

That evening, we merged off the I-15 onto the Las Vegas Strip, thus transitioning from one of America's most impoverished communities to one of its ritziest. Our hotel, The Luxor, featured a thirty-story pyramid topped by the world's brightest ray of light. Known as "Sky Beam," its glow could be detected up to 275 miles away—not all the way from Tuba City, but close. The Luxor rationalized its use of thirty-nine xenon lights with 700-watt bulbs as a tribute to the ancient Egyptian belief that the souls of the dead travel skyward in gleams of light. We saw it as a testimony to our nation's extremes and hurried to record it. Sheryl set up the Erika in an abandoned concession stand while I intercepted gamblers gravitating from one casino to the next. They lowered their daiquiris long enough to drawl out their own dicta: "Dear President, Gas prices are too high. Let me use my SUV again." "Dear Mr. President, Just finish bombing Iraq." "Dear Mr. President, I like you but you need to get your shit together. Thank you."

All told, Sheryl typed up 100 postcards during our journey – at a college campus in west Texas; at a book festival in New Mexico; at a truck stop in Utah; on Skid Row in Los Angeles. Time and again, she urged me to compose a card of my own, but I never did. After so many days of so many Americas, that 4" x 6" canvas felt too scant to fill – or too vast. This never seemed to stump anyone else, however. On the contrary, the people we encountered were eloquent on command, articulating their thoughts as if they had long been raring to do so.

It has been a decade since that glorious road trip. Sheryl has now held "I Wish to Say" performances in dozens of locations around the United States, mailing off more than 2,500 postcards to the White House and getting anointed "The People's Secretary" by ABC World News along the way. Some of her recent performances have showcased up to twenty typewriters operated by a parade of smartly dressed secretaries. Yet her premise remains as it has since that first trip long ago: a speaker, a postcard, and an empathetic ear communing along the open road.

# DISSENT:

## American Style

*Ricardo Dominguez*

dissent (v.)

> early 15c., from Latin *dissentire* "differ in sentiments, disagree, be at odds, contra-dict, quarrel," from *dis-*"differently" (see **_dis-_**) + *sentire* "to feel, think" (see sense (n.)). Related: *Dissented*; *dissenting*. The noun is 1580s, from the verb.

**0.0** Dissent is always about the location and dislocation of one's social sense or (ae)ffective con-dition in relation to the embedded reality in which one finds oneself; that is the influence of where and when one is born or comes into being. My dissenting being emerges from the convo-lute of being from Vegas, Las Vegas, Nevada. My dis+sense/dis-(scent) about the world was full of bright burning neon nukes going off down the road, casino capitalism playing the odds 24/7, strange alien areas run by military groups for unknown purposes, and the pragmatic platonic prayers of the Mormons running the state. I found myself under a simple formula that would soon run the whole neoliberal world:

Money+Mafia+Military+Mormons(+ a Mexican me)=equaled the ruins yet to come.

**0.1** I was a screenal child. The performative matrix of screenality became the site of learning dissent. It was on the screen that I witnessed assassination after assassination in the 1960s, the battle for civil rights, U.S. presidents commit crimes, Vietnam, the Pentagon Papers … the list is endless. The screenal condition also offered me the potential to feel otherwise, to see otherwise, to imagine otherwise, to act otherwise: by watching endless monsters created by ground zero politics destroy the world, by watching Black power take down the man in *The Spook Who Sat by the Door*, by watching hippies dance into other worlds in countless groovy flicks – I could sense another world was possible. One could dissent otherwise. One could watch the watchers.

**0.2** I saw our dissenting sisters and brothers in the 1960s and 1970s driven insane by the surveillance state on TV. Many groups – the Black Panthers, the Brown Berets, the Yellow Pearl – were all under extreme surveillance. They had no proof at first, but it became overwhelmingly self-evident due to COINTELPRO and many other actions that there indeed was a nation-state force aggressively seeking to keep track of them. So in the 1980s, there was a sense of accepting that, "Yep, sure, they are surveying us – so what?."

**0.3** ACTUP (AIDS Coalition to Unleash Power) was basically the on-the-ground dissent training for me and many others, where we tried to meld notions of media with notions of direct action to perform aggressive acts against the therapeutic state. I and other members of ACTUP/Tallahassee felt that our data bodies and real bodies had to manifest themselves in a radically transparent manner, without fear of what it might mean to be surveilled. Because often surveillance aggressively tried to bring you down because of your sexuality: "We're going to out this person now because we now have a letter he sent to his lover, who was a male or female or whatever." And thus the individual was broken because of this knowledge getting out. Obviously, when you're entering into queer spaces, where issues of sexuality are at the forefront, that begins to shift some of the oneness of what is available to the surveillance state to break you. Again, there was this move toward a certain level of acceptance of surveillance, an acceptance that one could counter surveillance by disallowing it to aggregate around what the surveillance state imagined to be sites of personal trespass that on a social scale could be used against one or one's community to disentangle it. I remember being the mediator for our local ACTUP/Tallahassee, and the very first question that we were trained to ask was, "Hello, welcome. If there are any undercover agents, please raise your hands, or FBI or journalists, you're welcome to be here with us. Don't be afraid to come out."

**0.4** I think I took a lot of that history with me when we started to assemble Electronic Disturbance Theater 1.0 in the 1990s, in terms of our choice to engage in radical transparency. Some of the actions that happened during that time were the jam ECHELON actions. ECHELON was a well-known global surveillance system established by the NSA. Remember, I grew up in the 1970s, during the Watergate scandal, the leaking of the Pentagon Papers and, at the end of that period, the 1982 publication of James Bamford's famous book, *The Puzzle Palace*. We knew the NSA had the ECHELON system, so in the 1990s we asked, "How can we imagine ECHELON's functions?" So we said, "Well, it probably picks up words and targets certain words: blow up, bomb, whatever." So, for Jam ECHELON Day, we asked all the communities who were involved with us on a global scale to take fifty words and paste them on every email that they sent out. In theory, we would jam ECHELON because it would be tracing all of these systems. The outcome was that the United Kingdom and other countries began to question the United States regarding where the ECHELON bases or stations were located in Europe.

**0.5** Thus there was an awareness of the way in which surveillance would function within the paradigm of data body/real body. Our response was to be transparent, to have the code available to anybody who wanted to look at it, and also to enunciate what we were going to do, how we were going to do it, why we were doing it, and so on. This really became part of a larger aesthetics of disturbance that manipulated the operations of surveillance by encompassing the

surveillance state as part of its performative matrix. It wasn't that we were going to do something secretly because we didn't want to be surveilled, but our gesture was to have the surveillance state participate in – to help amplify – the gesture of disturbance.

**0.6** Within the surveillance state, there is this kind of Roman empiricism of the law: "You are breaking this law [whatever law they say you are breaking] because your technology is effectively functioning within the paradigm of the law that we have established, and we have now aggressively gathered your emails, gathered your photographs, and we see you stating that you are going to use this technological add-on." To this we would respond, as part of the gesture of disturbance, "Yes, welcome surveillance state to the performance. We understood how the technological empiricism of law, which you are seeking to establish against us, works. But the technological aspect is on your side, in terms of breaking the law of trespass. On our side, nothing is happening. There is no weight of empirical technology on our end. We are less than script kitties [the lowest level of hackers]. Nothing about anything we do works. It does not function. So you are all in this performative matrix that allows us to make visible the infrastructures of technology and the social structures of surveillance at play."

**0.7** Part of the aesthetics is one in which the surveillance state and the hackers become confused – in what we in the Critical Art Ensemble in the 1980s called the "aesthetics of confusion." This then allowed us to have a different conversation with those entities on a different scale, and that scale would be the field of aesthetics of art production. Often you would have encounters where lawyers or FBI agents or others would say, "Are we part of the performance? Are we part of the artwork?" To which we would respond, "Yes, you are." I think that allowed us then to create an a/effective, visceral response around the theater of code and the empiricism of utilitarianism-effective society that condition the state's logics of surveillance and technology. It allowed for our dissenting gestures to bloom otherwise.

"I WISH TO SAY:" 2008

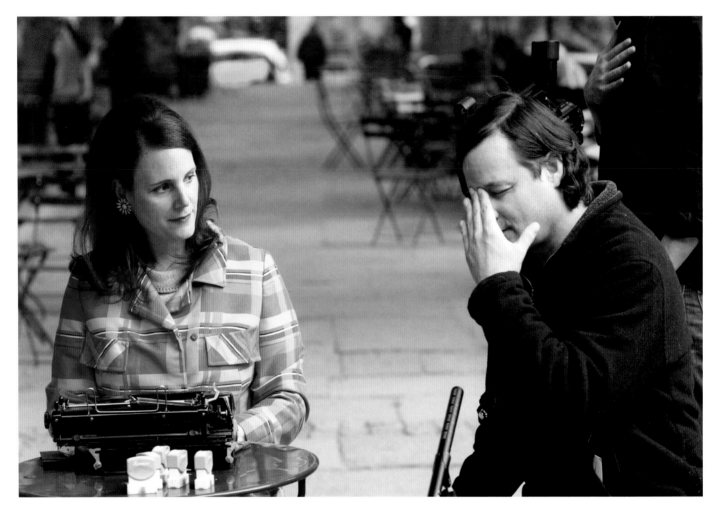

During a 2008 show at Bryant Park in New York, Alex
Candelaria considers what he'd like to say to the president.
*By Dhanraj Emanuel*

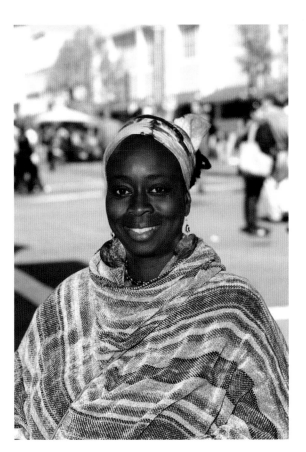

By Dhanraj Emanuel

APR 1 8 2008

Congratulations President Obama!
This is an acknowledgement that
I always knew would happen in
my lifetime. There is so much
to do, and I realize that it
will take more than just one
man to do it. However, it's a
job that can be done. And I
now feel proud to be an American.
Sincerely,

Amatula Jacobs
Oakland

**PAST DUE**

Dear President,
I don't like war. Many peopple
are being killed and I don't
like that. I'm a refugee here,
 I came here three years ago.
 I was born in Burma. I didn't
like the dictatorship in my
cou ntry. I'm a Buddhist monk
and participated in peaceful
demonstrations. I was hiding
in  Thailand and then applied
to come here. I would like
all countries to live ꭗꭗꭗꭗ
 peacefully.
Sincerely,

Ashin Kovida
Oakland

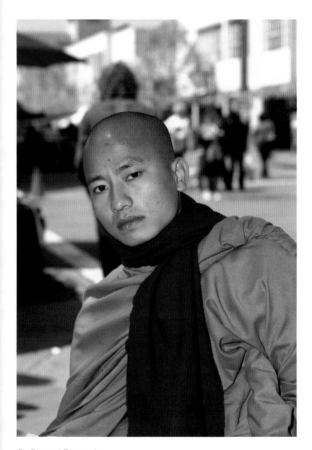

*By Dhanraj Emanuel*

By Dhanraj Emanuel

# IMPORTANT

Dear Sir or Lady,
I am a full-time graduate
student and if I get cancer,
I will h ave to rob a bank
to get treatment. Please
make it so that I can afford
healthcare and also pay off
100 grand in student loans.
Good luck with that.
Love,

*Jill*

Jill
Dallas, Texas
Feb. 22, 2008

APR 2 2 2008

Dear Mr. or Mrs. President,
While I have many things to
say, I will only be proud to
call myself an American  when
there is equality for all,
including the right to marry
whomever I love and when poverty
is abolished in our country.
Until then, I wish you the
best of luck and I pray that
you use your office to
relieve this country of all
its injustices. I pray that
one day I'll be proud to call
myself an American. So the
question is, will you be the
one to let me do that?
Sincerely,

Vince Sison
St. Mary's College

PAST DUE

By Dhanraj Emanuel

*By Dhanraj Emanuel*

APR 2 2 2008

Dear President,
Please don't let my boyfriend
get deployed. Also, please
don't allow a draft. I-m
deeply afraid for my 10-year-old
and 13-year-old brothers.
No World War III.

Sincerely,

Chelsea Ulloa
St. Mary's College

**CONFIDENTIAL**

APR 1 3 2008

Dear Mr. or Ms. President,
I want you to know the war in
Afghanistan and Iraq is going
really well for the civilian
contractors. If you would pay
the military as much as you
are paying  them you wouldn't
have to worry about looking for
volunteers. Just a suggestion
from a veteran.
Sincerely,
OEF Vet
in San Francisco

URGENT

*By Dhanraj Emanuel*

*By Dhanraj Emanuel*

2 9

APR 1 8 2008

Immigration Legislation

Dear President,
My main concern is immigration
policy. It's 2008 and we don't
have a decent immigration
policy – get a grip! Apparently
the presidents do not know their
history. The Latino or indiginous
people have been here for
thousands of years.  We didn't
create the borders or divide up
the states – it was open
 territory. xx They allowed
 us to cross the border when
they needed us for cheap labor
txxx and they kicked us out
when they didn't. Th is has been
 going on for 500 years  –
 since the European arrival.
 Sincerely,
  Lorenzo Garcia
  Oakland

Lorenzo Garcia

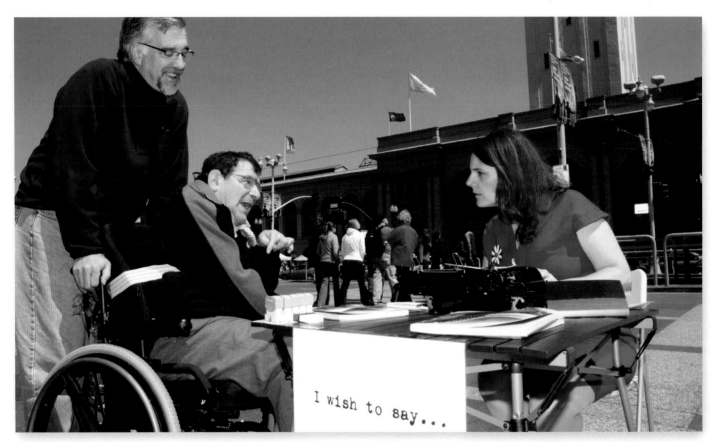

In April 2008, Sheryl Oring returned to the Bay Area for
a series of shows in San Francisco and Oakland, where
the project began.
*By Dhanraj Emanuel*

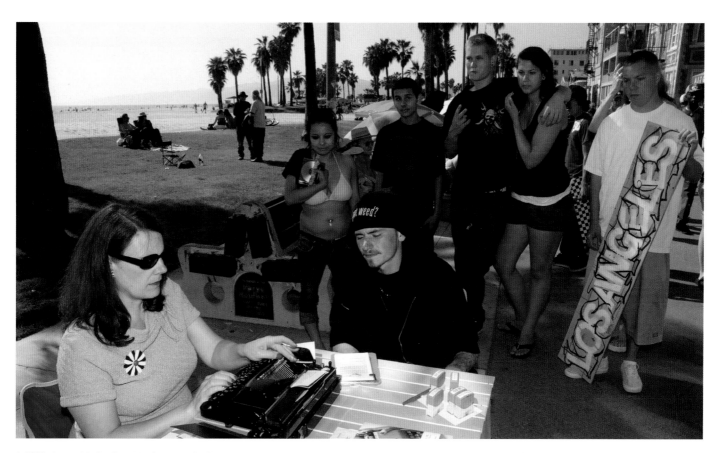

A 2008 show at Venice Beach in Southern California.
*By Dhanraj Emanuel*

MAY 1 9 2008

Dear Mr. or Mrs. President,
We must end corporate domination
of America! It is killing us!!
From the acquiescence to
purely profit driven pharma-
  ceutical companies (spoken
as a former consultant) to
supplication to big oil.
Corporate rule leads to death
of the nation.
Sincerely,

Hans Tester
New York City

By Dhanraj Emanuel

*By Dhanraj Emanuel*

MAY 1 9 2008

Dearest next President,
It is with great hope and
passion that I write to you
and request thatx you bring
this country to a safer, better
level. As a 53-year-old Latin
woman, my desire is to see
a president fulfill many of
the wishes that women in this
country have held dear to our
hearts. I believe that these
wishes are the same that our
mothers held dear to their
heart. So as I go to work, I
pray that you willgo to work
swiftly to bring us forward.
God be with you.
Mucho gracias,

Maria Elena Alvarez
MSW, New York City

MAY 2 0 2008

Dear President of the United
                          States,

Time for correction by America,
for Americans and the world.

Peace,

*[signature]*

Susan Lane
New York City

**PAST DUE**

*By Dhanraj Emanuel*

*By Dhanraj Emanuel*

**IMPORTANT** JUN 07 2008

Dear President,
I am truly excited about your new title. It is really exciting to have our first African-American as president of the United States of America.
I remember you when we worked in Chicago. You were my representative when I lived in Hyde Park. I look forward to all the great work that I know you will do.

On June 18, the U.S. Senate will be compiling an appology for slavery, and in this appology it should be a real appology. By that I mean, it should include restitution. It is my hope that you will be in the Senate that day to help facilitate this important part of our new history.
Sincerely,

Barbara J. Baker, Chicago

SEP 2 5 2008

Dear Mr. President,
My name is Ash and I'm a guy.
That sounds like a strange way
to start a letter because you're
not here so you can't hear my
voice, which is a low alto on
a good day. But I'm used to
explaining myself. I don't mind
that, but I'm not often allowed
to. My driver's license has an
F on it. My passport has an F
on it. And I can't change that
without surgery I can't afford.
I can't even change my female
name because I'm already unsafe
in airports and police stations.
 I know there's only so much you
can do. You're not the one making
the laws after all. But any
help you could offer would be
appreciated.
Best,
 Asher James
 Wichita

*Asher James*

*By Dhanraj Emanuel*

By Dhanraj Emanuel

From Bert Orphious Jones,
Wichita

SEP 2 5 2008

To the next President of the
United States,

Your honor, there are a couple
of things I wish to cover. With
the current state of the economy
the cost of college is really
high for most middle-class and
lower-class citizens. And I
was wondering if you have it
planned to lower the cost of
college by adding governmental
assistance that helps more than
what it does now or by funding
the schools a little more? Also,
I wish to cover healthcare and
how it should be universal.
Most people might think that this
is is a Communistic view but
it would be a wonderful blessing
to the country if everybody was
treated the same by the
insurance providers. Reason being
why I say this is because at a
younger age, I had my own near-
death experience and 4 other kids
had the same problem and didn't
make it. Please consider these
options ＋ please make the right decisions
for this country.

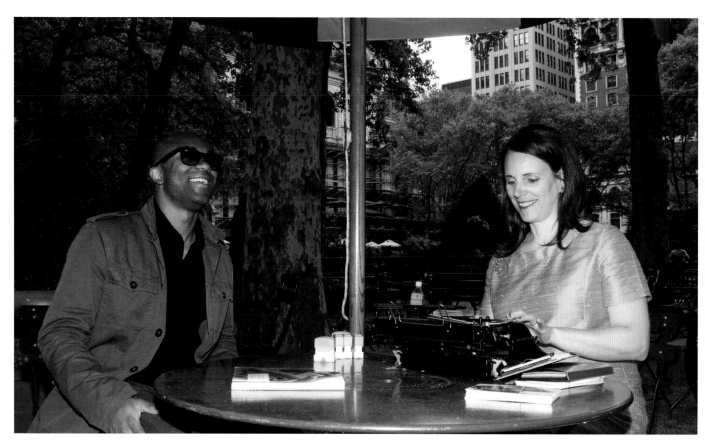

Sam Riddick shares his thoughts during a show at New York's Bryant Park.
*By Dhanraj Emanuel*

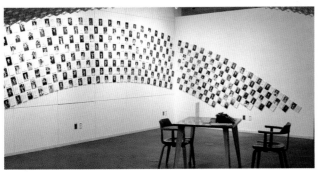

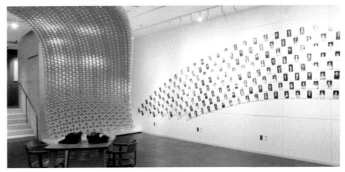

Messages to the president and portraits of the people
who sent them were exhibited at the McCormick Freedom
Museum in Chicago, in Fall 2008. The exhibition design
was done in collaboration with architects Neil Katz, Ajmal
Aqtash, and Richard Sarrach.

*By Dhanraj Emanuel*

# Frameworks: Scholarly Views

# FRAMEWORKS: SCHOLARLY VIEWS

*Sheryl Oring*

Whereas the previous section, "Ruminations: The Artist's Perspective," put "I Wish to Say" into conversation with a number of artists' individual practices, "Frameworks: Scholarly Views" examines some of the theoretical frameworks and histories with which the "I Wish to Say" project – and many other socially engaged works of art – are in dialogue. Writers ranging from art historians and a book artist to an attorney specializing in First Amendment rights and a political scientist discuss histories and ask questions that many artists address in their work. The breadth of academic fields featured in this section reflects the interdisciplinary nature of socially engaged art. And this is just a start.

To begin, art historian Edward Sterrett, a research assistant at the Getty Research Institute, discusses the role of the object in socially engaged art. In his essay, "Toward a Sociability of Objects," Sterrett examines current theoretical debates about the relation of aesthetics and politics in socially engaged art practices, and proposes some of the ways in which my work troubles the terms of these debates by reconsidering how the social engaged by it might be operated by myriad emergent aesthetics.

In the next essay, "Socially Engaged Art, Photography, and Art History," art historian Bill Anthes, contributing author to the textbook *Reframing Photography: Theory and Practice*, by Rebekah Modrak (Routledge, 2011), and Professor in the Art Field Group at Pitzer College in Claremont, California, discusses the connections between today's socially engaged art and its ties to the social movements of the 1960s and 1970s, as well as performance and activist art from those decades. Photographic documentation of time-based and performance works gave artists such as Yoko Ono and Allan Kaprow a place in art history. Today, socially engaged artists rely on photography to document their work for inclusion in exhibitions, essays, and curricula. Photography, says Anthes, "has transformed the canon, bringing new themes and perspectives into conversation with established media and aesthetic."

In "Activism's Art: A (Very) Brief History of Social Practice and Artist Books," Miriam Schaer, a Brooklyn-based multimedia book artist and a Lecturer in the Interdisciplinary MFA Program in Book and Paper at Columbia College, Chicago, provides a broad overview of the role played by artists' books in the field of socially engaged art. Starting with the pamphleteers who began publishing essays in the form of unbound booklets in the 1500s and continuing through to today, Schaer makes a compelling argument about the power of handmade books in activist practices in the United States and abroad.

In "Free Speech in a Digital Era," First Amendment rights attorney David Greene examines the complex ways in which free speech is impacted by the pervasiveness of the Internet. Greene, Senior Staff Attorney and Civil Liberties Director at the Electronic Frontier Foundation in San Francisco, outlines the way our expectations about digital free expression have evolved over the past two decades.

The section concludes with the essay "Efficacy, Trust and the Future of Civic Engagement," by David B. Holian, Associate Professor of Political Science at the University of North Carolina at Greensboro. Holian examines "political efficacy," which can be defined as the degree to which citizens feel confident enough to engage in the political process and, by their engagement, influence that process.

The varied frameworks in this section reflect my belief that hope lies in the conversations generated by this sometimes complex and ongoing dialogue among artists, historians, theorists, thinkers, writers, and makers. Together, we work across disciplines toward making changes in neighborhoods and communities across the country and beyond.

# TOWARD A SOCIABILITY OF OBJECTS

*Edward Sterrett*

### The Object in Theory

Socially engaged art practices have been defined largely against the conventional forms of production and appreciation of aesthetic objects. Whether focused on critiques of the ideological framework of the gallery space, the underlying elitism of avant-garde formulations of artistic identity and spectatorship, or the complicity of market oriented artistic production within a broader project of hegemonic cultural and economic forms, the turn towards engaging the social as the material of aesthetic production seems to have resolutely abandoned engaging with objects. It is as though turning away from objects will somehow get us closer to the increasingly embattled and impoverished social fabric. In part, this is because the object – with all its solicitations to post-facto contemplative aesthetic appreciation – is an insistent reminder of the well-worn role of the artist as heroic agent of transformation, but also because this reminder catalyzes the slippery complicity of art's objecthood with the dirty hands of market capital. Social engagement is its own kind of promise about where aesthetic experience takes place, what kinds of value it generates, and the resolutely collective and participatory nature of its protocols.

Rick Lowe's transformation from a painter of political messages to the founder of "Project Row Houses" presents a neat example of this turn. As the story goes, a young boy from Houston's 3rd ward visiting Lowe's studio on a school field trip suggested to him that making paintings about social problems does little to fix them. For Lowe, this became a challenge: not to leave behind his life as an artist, but to engage his artistic practice in the transformation of social forms. Thus what began as a painterly investigation of the row house stoop became a cultural reclamation project in which that social form was given new life through the literal reconstruction of a row house community. The creative resources of the artist, not only specifically Lowe's material and intellectual skill set, but also the more diffuse or ideological forms of cultural capital that have accrued around artistic identity, were put to the task of negotiating between local residents, business owners, banks, city planners, social services organizations - in short, any and

every node in the infrastructural network of the neighborhood whose interests or agency had some bearing on the situation (Lowe 2009; see also Finkelpearl 2013: 132–52). Lowe credits his artistic training with allowing him to recognize and engage effectively with the complex web of constituencies and protocols already at work in local communities, as well as with the ability to reframe entrenched polarities and to open new spaces for negotiation and renewal (Lowe and Cruz 2009).

In describing "Project Row Houses" Lowe has often invoked Joseph Beuys' concept of *social sculpture*. This is particularly useful for thinking about the ways in which socially engaged art practices reposition the locus of creative activity from art objects to social forms. In Beuys' concept, sculpture is not an object, but rather a process that takes the social world as its material. It is an inversion of the conventional definition of public sculpture (now sometimes cleverly referred to as *plop art*), in which an aesthetic object is crafted in the private space of the artist's studio and displayed in a predetermined public space. Social sculpture reorients the syntax of the terms "public sculpture" in much the same way that the work it describes reorients the agency and material of aesthetic production. Rather than offering sculpture to the public, it invites the public to sculpt itself – which is to say that the relational, reciprocal, and ritual forms of exchange that comprise the social world are ushered into the process of aesthetic transformation. In this way, social sculpture also underscores the stakes of displacing the object from its privileged position in aesthetic production. It returns us to that young boy in Lowe's studio, whose assertion that painting can't do anything gets directly (however naively) to a question that was central to Beuys' project: What are the politics of the production and reception of art – in other words, what can art do to transform the social world?

The promise that aesthetic experience will work to counteract the progressive and increasingly inescapable instrumentalization of the material and social world is perhaps the core feature linking contemporary socially engaged artistic practices with the aesthetic avant-gardisms that precede them. But questions about what constitutes aesthetic experience, how it produces its counter-actions, and what the scale or scope of such counter-actions might be, have generated a rich and often contentious array of theoretical approaches to describing and defining socially engaged art practices, and in turn these have been instrumental in developing socially engaged art practice as an institutionally stable category of contemporary art, complete with graduate programs, peer-reviewed journals, and symposia. The repudiation of the art object in the production of socially engaged aesthetic experience has been central to these theoretical efforts. But while it seems to occupy a generally agreed upon point of exclusion, the object returns insistently to the scene of both practical and theoretical consideration.

We could begin, for example, with Claire Bishop's extensive work toward theorizing what she prefers to call "participatory art practices." She describes these as generally being "organized around a definition of participation in which people constitute the central artistic medium and material," and in which "the artist is conceived less as an individual producer of discrete objects, than as a collaborator and producer of *situations*" (Bishop 2012: 2). Thus, along with the center of creative agency shifting from individual artist to collaborative group, its destination shifts

from object to situation. Bishop draws her criteria for evaluating these practices from Rancière's theories on aesthetics and politics. According to Rancière, the politically effective role of the aesthetic is to leverage sensible forms in order to suspend categorical judgment in a state of perpetual undecidability, which incites critical reflection on the inevitable contradictions and complexities of any encounter between self and other (Bishop 2006a: 178–83, 2006b: 3). Here, aesthetics ostensibly operates politically by transforming the patterns of subjective and intersubjective experience that underpin social forms. This kind of production of self-reflexive criticality requires that the work of art remain on some level inappropriable, and thus oppositional with respect to its audience. It must take the form of a kind of shocking rupture of communication, with this incommunicable excess positioned in such a way as to unseat the rigid stability of conventional subjectivity and open it to new forms of alterity.

The difficulty for Bishop is that the inherently participatory nature of socially engaged art practices – their tendency towards ameliorative acts of collectivity – makes this oppositionality very difficult to achieve. Participation tends to dissipate the simple opposition of artist/audience that a conventional art object holds neatly in place, and Bishop is forced to work against this dissipation to sustain the critical distance that allows her to view the work as a symbolic form, arranged to produce the appropriate ruptures into uncertainty. Her approach ultimately requires her to objectify the work, or to seek out works that have addressed their own objectification with sufficient criticality to make them visible as properly aesthetic and political. For all of its eschewal of aesthetic objects, under this critical apparatus the socially engaged work must remain, in a certain respect, bounded as an object, and the author's hand legible as such. Bishop's treatment of Santiago Sierra might be one of the more literal examples of this tendency (Bishop 2012: 222–34; see also Kester 2011: 61–2).

The most strident, as well as the most theoretically comprehensive, response to this kind of approach is Grant Kester's theorization of what he calls *dialogical aesthetics*. Kester has undertaken a vast reconsideration of the canons of aesthetic theory in order to better address the material realities of socially engaged art practices, and the complex imbrications of aesthetics and politics produced by them (2004, 2005). In this effort, he has historicized the rise of poststructuralist theory in critical discourse, linking the retreat of revolutionary politics into an aesthetic of textual undecidability to a line of aesthetic theory that begins with Kant and Schiller's circumscription of the art object in a field of disinterestedness, and extends through Greenberg's concept of formal autonomy.[1] In all of these cases, the art object takes a position of resistance to the broader, ostensibly hegemonic, instrumentalizing forms of culture. Within this tradition, Kester identifies an insistent reliance on the art object as an uncontaminated zone of hermeneutic labor (coded by artist and decoded by audience), whose political efficacy is contingent precisely on its freedom from all other forms of social and cultural exchange. This textual model of the relationship between aesthetics and politics is distinctly problematic for socially engaged art practices – particularly for those that take on overtly political activism – but Kester is by no means entirely dismissive of the tradition from which it emerges. A crucial aspect of the convergence of revolutionary politics and avant-garde aesthetics remains resolutely at the center of his

concerns: the idea that aesthetic experience can and should contribute to what Kester calls "the transformation of human consciousness in a way that enhances our capacity for the compassionate recognition of difference, both within ourselves and in others." (2011: 185).

This is partly why he returns to Enlightenment philosophy in order to formulate the concept of dialogical aesthetics. For both Kant and Schiller, the charge of somatic pleasure associated with a disinterested aesthetic experience was a necessary precursor to enlightened dialogue. The beauty of the object (which in Kester's analysis is interchangeable with its "criticality" in the later avant-garde aspects of the aesthetic tradition) primes the subject to encounter difference in social discourse and to generate an appropriately enlightened response. In formulating a theoretical foundation for a dialogical aesthetic, rather than positioning aesthetic experience as a formative process of subjectivity, which is distinct from and precedes social discourse, Kester situates it *within* the process of dialogue itself. Here, aesthetic experience is a co-created state of empathic insight, which allows participants in a dialogical exchange to transcend those entrenched formations of subjective myopia that separate them.[2] This effectively bypasses the prototypical role of the object in conventional aesthetic theory, and opens the way for a reformulation of aesthetic experience as a cooperative, intersubjective transformation.

The result, while theoretically robust, is an approach to socially engaged art practices that tends to underplay the role of aesthetic experience outside the strict confines of discursive exchange. Recall one of Kester's primary examples in *Conversation Pieces*, Wochenklausur's "boat colloquies." The artists organized a series of conversations in Zurich among local politicians, activists, sex workers, and representatives of various social service organizations, in an attempt to break the political deadlock that had been preventing efforts to provide shelter and social services for the homeless drug-addicted prostitutes of the city. The conversations took place on small tourist boats out on Lake Zurich, which provided a unique atmosphere that allowed the participants to leave many of their more rigidly oppositional stances on shore, and ultimately to successfully facilitate the establishment of a women's shelter. Kester mentions in passing the effectiveness of "the ritual and isolation of the boat trip" in generating this atmosphere, but he largely focuses on that isolation as an opportunity for voices, otherwise constrained to representing their constituencies in public forums, to engage in a more fluid state of dialogue. We are left to wonder about all of the somatic effects of the boating ritual, and how their poetic resonances might have contributed to the dialogical aesthetic of the event. Perhaps such considerations threaten to let too much of the conventional aesthetic in through the back door. Given the specific distinction that Kester draws from Enlightenment aesthetics, a prelude of somatic pleasure is precisely not what dialogue needs if it is to be its own source of aesthetic value. But surely the boat, its rhythms and its scents, and its deep historical romance with casting away, lent itself on any number of levels to the more explicitly discursive acts of empathic insight that made this project a success.[3] Can we jettison Kant without casting off the object?

### An Object Lesson

I first encountered Sheryl Oring's "I Wish to Say" project in December 2008 on Library Walk at the University of Calilfornia, San Diego (UCSD), I was immediately struck by the careful

choreography of the work. Here was a project that proposed, in very straightforward terms, an opportunity for any and every passerby to say something to the president of the United States. Yet for all of its guileless appeal to civic virtue, at the same time it was coursing with a peculiarly exuberant nostalgia. In neatly pressed vintage suit and impeccably coiffed hair, Oring sat at a table behind a glistening vintage typewriter, dutifully taking dictation onto fine 4" x 6" index cards, which were then hand stamped and signed by the participants for postal delivery to the White House. Clearly this was the least techno-savvy form of direct democracy one could propose. I'm not sure whether the president had a twitter feed in 2008, but Web 2.0 was certainly all the rage, and the promise of retooling the user feedback systems developed by Google or Amazon for governmental purposes was in the wings. So what was a politically and technologically savvy artist like Oring doing taking dictation with a vintage typewriter?

Two years later, in March 2010, Oring staged another iteration of "I Wish to Say" at UCSD, this time generating letters to University of California President Mark Yudof in the wake of the tremendous tuition hikes that had recently been implemented across the University of California system. Rather than working as a lone secretary, she deployed almost a dozen stand-ins, each appropriately dressed and coiffed, each perched behind a sleek mechanical typewriter along a row of tables, which took up a substantial portion of the central corridor of campus foot traffic. The scene certainly drew attention in a way that a kiosk of touchscreens or a downloadable app would not have done, and more often than not participants began by remarking on the typewriters. Either they had a story about their own long since passed experiences, or they appreciated the retro-modernist chic of the design, or they remarked on how difficult it is to type on "those old things." One way or another, the attention that was drawn in by the typewriter would spill over into an exchange that might lead to a simple explanation of the project, an invitation to sit down, and the beginning of a session of dictation. These sessions always followed a certain kind of staccato rhythm, as participants were forced to slow down and to repeat themselves for the women sitting across from them, who were, as gracefully as possible, wrestling letters out of these beautiful but somewhat quirky machines.

Dictation is something that no one is used to anymore, and the resistance to the seamlessness of user experience produced by this clunky apparatus gave traction to something seemingly superfluous to the explicit task of saying something to the president. Because, for all of their charming getup, the typists were clearly not secretaries trained to take dictation, the exchange was never simply a one-sided delivery of what a given person *wished to say*. To make up for their deficiencies, the typists were constantly interrupting the dictation, reading things back, and at all times reminding the speakers – for technical reasons that were transparent to everyone involved – that they were profoundly concerned with hearing what it was they had to say. These interruptions would sometimes spontaneously transform into editing sessions when participants, hearing back fragments of their thoughts, would reconsider how something might best be phrased. And all of this interpersonal hubbub inevitably drew in further interest, so that the general idea that a kind of collective action was underway became an understated but unmistakable sign of what it means for a space to be public – or, perhaps more accurately, what it means for a space to *become* public.

Is this a statement about technology, or even about nostalgia? Not really. It has more to do with a certain kind of understanding of sociability, of its role in the formation of constituencies that do not always appear on the technocratic or demographic scope, and of its inevitability in the sphere of democratic political action. For whatever it is worth, the typewriter finds itself peculiarly active in the production of this particular field of sociability. It lends part of its historical context to the scenario; it asserts a specific aesthetic presence, and it participates in an event that is simultaneously political speech, social exchange, and artistic production. The idea that speaking about politics is a social act that forms its own constituencies, regardless of the content of that speech, is of course the foundational spirit of a democratic state, and precisely the kind of celebration of dialogue in the public sphere that brings political philosophy into aesthetic debates about socially engaged art practices. But how to account for the features and actors of a social form and what role the aesthetic plays in vivifying that engagement?

Rather than turning directly to more theory, of which there is plenty worth considering (Latour 2005), I would now like to deviate into the work of an artist who I think has never entered the conversation on socially engaged art practice, but whose sharply sociological eye for objecthood might suggest another approach to thinking about what the social is and how it might be engaged.

In May 2000 at the Neuer Berliner Kunstverein, Haim Steinbach opened a show titled "North East South West." To anyone casually aware of his work, the show would not at first have seemed much of a departure. It offered the recognizable framework of rigorously formal arrangements of shelving, displaying careful clusters of objects. It also characteristically deployed a nuanced iteration of a reduced set of conceptual maneuvers. The shelves were built from construction scaffolding and glass panels, a technique that he had explored in a number of shows over the previous five years to reflect on the construction of the aesthetics of display. The objects were borrowed from other people's collections, and this too was a repetition of a previous gesture that stretches back as far as his work of the late 1970s, and has consistently linked his practice to the legacy of Marcel Duchamp and to what has been called *appropriation art*. This kind of finely grained reworking of carefully formulated procedures aimed at attuning and attenuating attention into a flurry of perceptual and contextual considerations is the hallmark of a certain brand of contemporary art practice, which takes the gallery as its most suitable, even if consistently troubled, home. In this sense, it might seem very far afield from what is commonly taken to fall under the rubric of socially engaged art practice. But the inclusion in "North East South West" of a series of video monitors arranged along the periphery of the gallery, which showed footage that was shot during the field research Steinbach conducted leading up to the show, brought an aspect of Steinbach's object fascination to light in a way which had remained decidedly occulted in his earlier work.

When Steinbach set out in search of the objects that he would include in the exhibition, he was invited into the homes of a wide range of participants across the city of Berlin: "workers, technicians, students, secretaries, directors, architects, and children" are listed among them (see Kunstverein and Tolnay 2001). His visits would generally begin with a cup of tea or coffee, and eventually Steinbach would turn the conversation toward whatever arrangement of objects

might be on display – on a side table, a television set, a desk, or a shelf. Steinbach was not immediately interested in what the objects were, but rather in how they were arranged – why this one was next to that one, or this one above and that one below. The participants almost always began by suggesting that there was no particular answer to such questions, but with a bit of persistence on the part of Steinbach, a whole field of personal associations, formal correspondences, and semantic connotations would emerge from what had at first been excused as a simple matter of chance (Kunstverein and Tolnay 2001: 73). These relationships were psychological and personal as well as aesthetic and symbolic. They were what Steinbach has called "an art game," and this kind of play with object relations is not, in Steinbach's view, reserved for the privileged context of art works; it is a continuous field of relations that is fundamentally social and aesthetic.

By bringing these very personal arrangements of objects into the gallery, and distributing them in a transparent and non-hierarchical display, he invited the participants to reconsider the sociability of their private play, and to see themselves as part of a collective act of expression that transcends the narrow class identifications and prestige functions associated with sociological critiques of taste and commodity culture (Kunstverein and Tolnay 2001: 72). It is not that these associations were not present at all, but rather that the complexity of relations into which they were cast by the arrangements themselves was far more nuanced, poetic, and personal, and at the same time more broadly collective than a rigidly sociological perspective might offer. In the immediate aftermath of the show, Steinbach described this collective as a *neighborhood*:

> What is a neighborhood but a layout of streets, a location of homes, a temple of worship, and a museum, etc. The substructure consists of apartments, rooms, cabinets and shelves with things arranged. Maybe it is possible to find an architectural plan for a new neighborhood. In this neighborhood the aesthetic experience is no longer fixed on the attribution of value to objects themselves, but rather to the total experience of the space of objects. (Steinbach 2000: n.p.)

It is a peculiarly whimsical and populist vision of the aesthetic, and one that breaks substantially from the oppositionality of avant-gardisms without foregoing the entrance into a richly hermeneutical exploration of objecthood. While Steinbach's architectural plan is conspicuously empty of people, it nonetheless signals the broadest possible distribution of both aesthetic experience and aesthetic production. Indeed, the aesthetic in Steinbach's neighborhood is not the fragile, enclosed sphere, constantly fending off contamination by the insidiously instrumentalizing forces of capital, or ideology, or any of the other seemingly inescapable features of modernity against which avant-garde aesthetics must raise the barricades. Instead, it is its own exuberant and unpredictable force, permeating objects and our interactions with and through them towards uncertain ends.

While Steinbach may be interested in revealing the aesthetic in the  interconnectedness of object relations and social relations, he is not in the business of unmasking ideological formations for a purportedly unaware audience, or of shocking them into some kind of political consciousness. On the contrary, he works from a position of deep respect for other people's art games. Indeed, in Steinbach's world, objects inevitably complicate their commodity status as

**109**

they pass through the peculiar psychic life of domestic and social space. They take on more associations, more relations to other objects and people. Far from the impenetrable gleam of mass ornament that terrorized avant-garde critics of popular culture, Steinbach's "total experience of the space of objects" can't help but manifest a perpetual accrual of shifting relations – sensual, psychic, and semantic, but also personal, historical, and political. This accrual constitutes the material of play for art games, and if there is something unlimited or 'free' about this play, it is not the free play that evacuates the world from objects in Enlightenment aesthetics. It is the messy metonymy of contextual accretions that make objecthood deeply social, and that leave the social world inevitably permeated with objects.

# SOCIALLY ENGAGED ART, PHOTOGRAPHY, AND ART HISTORY

*Bill Anthes*

Contemporary art practice today takes the entire social realm as its purview, imagining the sphere of human relations as an aesthetic form, instead of presenting a corpus of precious and autonomous objects. For artists working in the social realm, photography is fundamental to the experience of the artwork. Even when the direct experience of, or participation in, the situation initiated, enabled, or orchestrated by the artist is understood to comprise the artwork, photographs document the artwork and allow an understanding of the artwork to circulate and appear in exhibitions, essays, and curricula: Rirkrit Tiravanija serving noodle curry to a small gathering in a commercial gallery; William Pope.L traversing the entire twenty-two-mile length of Broadway in Manhattan on hands and knees while wearing a tattered Superman costume; a line of 500 volunteers recruited by Francis Alÿs, Cuauhtemoc Medina, and Rafael Ortega displacing a sand dune outside Lima, Peru, a distance of ten centimeters with shovels; Teresa Margolles dragging length of fabric soaked in the blood of victims murdered in Mexico's drug wars across a public beach in Venice, Italy. Tino Seghal refuses to allow the constructed situations he orchestrates to be photographed. (They also lack a written script.) While it might be possible to construct a history of contemporary social practice art that relies solely on verbal description, the exception of Seghal seems to prove the rule: As socially engaged artworks are made into images, they become part of art history.

The means for making photographic documents of socially engaged artworks ranges from the humble and mundane point-and-shoot camera (or, more recently, a smartphone linked to an Instagram account or other social media) to artists who produce carefully considered and crafted objects that suggest a conversation with art history. Nikki S. Lee's projects, in which the Korean artist passes for White, Black, or Latino, or as a punk teenager or a senior citizen, were

documented with a simple 35mm film camera. The resulting enlargements are exhibited with the electronic date stamp still visible in the lower right corner of the image. Santiago Sierra's performances include day laborers engaged in manual tasks that are exhausting and often dehumanizing and demeaning. Sierra's deliberately staged and shot, and carefully printed, black and white photographs are more austere. They seem to recall now iconic images of body and performance artworks of the 1960s and 1970s. Both artists produce striking and memorable images that contain within them the means to recount the original moment, and to contextualize the event in relation to the social, as well as the history of contemporary art.

As artists have engaged with social issues – in the 1960s and 1970s, most notably with the antiwar movement and feminism, and in the post-civil rights era of the 1970s and 1980s, with the still unresolved legacies of racism and sexism – those issues have become part of the discourse of art history. Suzanne Lacy and Leslie Labowitz's performance *In Mourning and in Rage* (1977), a vigil for victims of the notorious Hillside Strangler, staged on the plaza of the Los Angeles City Hall, brought a critical focus on sexual violence and its representation in mass media into the art world and art history. In *Artifact Piece* (1987), James Luna's uncanny silent and motionless presence alongside archaeological materials in a vitrine in a San Diego, California, museum of anthropology foregrounded a revisionist perspective on representations of indigenous peoples in science and culture. Adrian Piper's performances as a menacing dark-skinned male at large in Cambridge, Massachusetts, in her *Mythic Being* (1973–75) continue to provoke discussion of the raced and gendered body in public spaces. Such works, as important as they have become for a history of contemporary art, gain much of their power from having been photographed and reproduced, thereby extending their impact beyond the initial moment of the performative act and the immediate physical context – whether the steps of a government building, a public museum, or a city street. Indeed, it is entirely likely that the import of the interventions made by Lacy and Labowitz, Luna, and Piper were not apparent to those who experienced these works in the first instance as confusing or threatening, rather than as occasions for critical reflection.

Of course, this is the point of unsettling art work – that it not be immediately assimilable as "art," and thus disregarded too quickly. But such works' currency grows as they enter into dialogue with past art and prompt critical reflection and exchange, extending their initial impact from a momentary puncture in the social fabric of a specific time and place to an intervention into the larger arc of art history and into dialogue with larger social and political movements and processes. While radical artists and critics might take exception to the incorporation in the history of art radical works produced in contexts beyond the confines of the gallery or museum in which art is traditionally experienced and contemplated, the continued dissemination of and circulation of such works broadens their critical purchase (see, for example, Jones 2012).

As proxy for the artwork, photographic documentation afforded works in emerging performance, time-based, and installation media a place in art history. To be sure, artists have made works that are imagined such that photographic documentation is an integral aspect of the aesthetic consideration of the work itself; works of socially engaged art are, in effect, made to be documented. This idea has its precedent in the history of art as well, as critics argue that in the modern era works of art are conceived with an eye towards their inclusion in the museum and archive, in relation to the arc of the history of the contemporary. An artist's education today prominently includes the goal

that an emerging artist will be able to position their work in conversation with art historical precedent and contemporary practice. Nothing is produced in an historical or social vacuum. Artists today make work in dialogue with a history of performance art and spatial practice: for example, iconic images of gallery visitors squeezing between the nude bodies of Marina Abramović and Ulay facing each other in a narrow passageway in *Imponderabilia* (1977). Artists including Allan Kaprow, Carolee Schneeman, Joseph Beuys, Yves Klein, Bas Jan Ader, and Tehching Hsieh are indispensible to understanding the socially engaged art of the present, yet their works are known primarily through photographic reproduction. Christo and Jeanne-Claude's temporary public installations are in many ways precursors to the social practice art of today, as the artist foregrounded on-the-ground local political processes necessitated by mounting their works. Photographs, film and video documentation, and sundry preparatory materials are all that remain of Christo and Jeanne-Claude's monumental art works, and the sale of photographs, concept drawings, and the like were a key part of the funding structure that supported their practice. Influential artist-collectives including the Judson Dance Group in New York, the Gutai Art Association in Japan, Fluxus on an international stage, the Collective Actions Group in Moscow, and the artists in Beijing's East Village art colony are known almost exclusively through photographs. All the above are key touchstones in an art history that includes not just painting and sculpture (and also photographs as such as works of art, although that is another story altogether), but actions in real time and space.

Photographs have facilitated the recuperation and incorporation of time-based, performative artworks and site-specific installation art – as well as activist interventions – into an emerging canon of contemporary art history. Radical artists and critics, for their part, might describe this as a coopting and neutralizing maneuver on the part of the institutions of the art world, the academy, and the art market. Nevertheless, bringing time-based, site-specific and activist works into art history has significantly impacted the shape and character of the canon. Photography has thus had the effect of bringing radical work into art history and the market for contemporary art. In so doing, it has transformed the canon, bringing new themes and perspectives into conversation with established media and aesthetic. As much socially engaged art practice occurs outside the white cube of the gallery, these works have brought the world back into those insulated and rarified spaces. Works of institutional critique, social practice art, and relational aesthetics are now standard programming at major institutions, and figure prominently in published historical surveys, as well as studio art education.

Because of photography, a key work such as Yoko Ono's *Cut Piece* (1964) can be included in the same chapter of a history of contemporary art as a welded steel sculpture by Anthony Caro (Crow 2005). Modernist Michael Fried (1967) was concerned that works that "included the beholder" and existed in mundane "literalist" time were antithetical to art. But Ono's work – in which the artist knelt impassively on stage as audience members, participants in her performance, snipped away her clothing – shares printed space with Caro's late modernist masterwork, which Fried's criticism heralded for its transcendent timelessness. *Cut Piece* changes the terms of the discussion from art as aloof, self-sufficient, and otherworldly (as Fried famously wrote, "presentness is grace") to a focus on institutions and social identities and movements. Institutions, social movements, and the range of human interactions in social space are the concerns of today's socially engaged artists. And concerns with the physical location of artworks, as well as questions of embodied perception (and the way that bodies are marked socially), duration, and social and economic positionalities are now, to be sure,

a key part of the discourse of contemporary art, just as the social and political movements of the 1960s and 1970s – civil rights, feminism, antiwar activism, student uprisings, and urban insurrection – are important as context, subject matter, and terrain for understanding the art history of the period. Such powerful images also find themselves in conversation with a history of media images, as images are part of a collective memory in an age of media. The social movements of the 1960s and 1970s are remembered in iconic images, and these artworks become part of that history as well.

Moreover, artists today produce artworks to occupy the spaces of social media. Contemporary social media enable photo sharing and microblogging, and have proven efficacious as a platform for organizing and activism, as was demonstrated by the importance of a digital public sphere – beyond the reach of police and state surveillance, at least to a degree, in the Arab Spring of 2010 and the Black Lives Matter movement of 2014. Artists including Ai Wei Wei have exploited social media as a form of activist journalism – for example documenting a pattern of government neglect and inaction around the devastating 2008 Sichuan earthquake – and have used various blogging and photo-sharing platforms as venues for a kind of virtual public art practice, and a means for international artistic collaboration. Emma Sulkowicz, a Columbia University art student, produced the year-long *Mattress Performance (Carry That Weight)* in 2014–15 as a senior project that called attention to a pattern of institutional inaction in instances of sexual assault. Sulkowicz's grueling work of performance art transpired as much online as it did in the physical spaces of the university campus.

In the case of the Ai Wei Wei, social media are the vehicle as well as the venue for a new form of public art. Social media have had salutary effects as regards affording artists a means of connection with broader publics – on a global scale – beyond the confines of the contemporary art world, but they also can also have the effect of reducing complex artworks to fodder for trolls and cyber-bullies. Wafaa Bilal, an Iraqi-born artist, created an online artwork, *Domestic Tension* (2007), in which the artist lived in a Chicago gallery under 24-hour online surveillance, during which online viewers were invited to "shoot an Iraqi" with a remote-controlled paintball gun. Internet traffic from unpredicted numbers of would-be shooters crashed the server on the first night of the performance. Bilal's internet work is a chilling contemporary echo of Ono's *Cut Piece*. We might also be reminded of Chris Burden staggering out of a gallery as blood streams from the entry and exit wound made by a bullet in the aftermath of his performance *Shoot* (1971).

More recently, the Swiss "naked performance artist" Milo Moiré has caused a stir at art world events such as the Basel Art Fair (2015) and at tourist sites such as the Eiffel Tower. Moiré's performances comprise the artist, nude and hearkening back to an earlier generation of feminist body art performances of the 1960s and 1970s, but reduced to social media spectacle as audiences become participants, posting "selfies" with the naked artist to photo-sharing platforms such as Instagram. Moiré has been arrested and briefly jailed, charged with public indecency, but she seems disinclined to stop. Moiré's artwork seems to be little more than a trivial meme for an age of social media (as museums and gallery attempt to curtail the proliferation of self-promoting visitors armed with smartphones mounted in "selfie sticks"). But her project, such as it is, demonstrates that the work of socially engaged artists cannot be confined to the spaces of the art world or the discourses of contemporary art. Socially engaged artists have always sought to breach those sanctioned spaces and discourses. Photography – in all its forms – has been a means and a method to achieve that end.

# ACTIVISM'S ART:

## A (Very) Brief History of Social Practice and Artist Books

*Miriam Schaer*

Socially engaged art – trending now in art circles around the world – is generally understood to be art that creates a relationship with its audience, that aims to influence social policy and that is collaborative, participatory, and provocative. But socially engaged art has a history that goes back to a time before the word "artist" was coined. The Aboriginal people who stained the Djulirri rock complex in Australia; Aristophanes, whose ancient Greek comedies skewered gods and politicians alike; the scribes who illuminated medieval manuscripts – none of these people could have been more socially engaged.

A simple glance through Mr. Peabody's Wayback Machine shows that art has always been collaborative and participatory. Consider the book: clay tablets and papyrus scrolls at the start, evolving into sheepskin, palm leaf, and paper pages. From the early Middle Ages to the earliest incunabula, books were the collective products of writers, printers, binders, paper-makers, tanners, chemists, and a host of others. Most dealt with business, philosophy, or religion. But sometimes they were provocative, acts of defiance, calls to action.

Around 1450, when Johannes Gutenberg's printing press first enabled anyone who was literate to read the Bible, the religious establishment disapproved. Yet within about a decade artists were decorating printed devotionals in Rome and Germany with intricate woodcuts (Thompson 2000). These were the first illustrated books, church-commissioned tracts to enforce the laws and customs of the time.

Gutenberg's system – efficient, effective, low-cost – spread rapidly through Europe and across the globe. Authors everywhere emerged, with many discovering individual as well as institutional voices. The life of the mind was profoundly transformed. Documents in a widening array of formats – books, booklets, broadsides, periodicals – covering an expanding catalog of contents – politics, history, etiquette, power, and humor among hundreds more subjects – appeared and spread. Early authors not only wrote: many also helped to design, print, bind, and distribute their works.

We may today consider some of what appeared at that time to be "social practice." In 1517, for example, Martin Luther hand-penned what became known as his *Ninety-Five Theses*, protesting a variety of clerical abuses, especially the sale of indulgences (a kind of "Get Into Heaven" pass for the wealthy). Within two months, printed copies of the *Theses* had spread throughout Europe, triggering the Protestant Reformation, Europe's centuries-long explosion of radicalism, nationalism, and sectarian fury. It is doubtful that there has ever been a single more powerful instrument of social provocation.

### The Pamphleteers

Luther was hardly alone. Pamphleteers began publishing essays in the form of unbound booklets in the 1500s. Their pamphlets often had far-reaching effects, creating vital conversations between their authors and the public. Although many published anonymously (fearing retribution), the early pamphleteers included John Milton, Daniel Defoe, and Jonathan Swift.

Many a famous text first appeared in pamphlet form, including, in 1729, Swift's *A Modest Proposal … For Preventing the Children of Poor People From being a Burthen to Their Parents or Country; And for Making them Beneficial to the Publick* (Oliver 2010: 35) – in which he recommends the poor sell their children to the wealthy for food. Deadpan details like "A young healthy child well nursed, is, at a year old, a most delicious nourishing and wholesome food, whether stewed, roasted, baked, or boiled" have made the phrase "*A Modest Proposal*" a s ynonym for satire.

On the U.S. side of the pond, Thomas Paine's 1776 *cri de coeur, Common Sense* (Kaye 2006: 43) helped incite the American Revolution by explaining in clear, persuasive language the need for independence. A collaboration between Paine, founding father Benjamin Rush and printer Robert Bell, it appeared as an anonymous 48-page pamphlet, and was an immediate sensation, selling an incredible (for the era) 500,000 copies in its first year. It also included what we might today call a "performative" aspect, as it was read aloud in pubs, churches, and town halls. Washington even had it read to his troops.

Some provocations achieved their impact only in the course of time. Writer Mary Wollstonecraft's twin pamphlets, A *Vindication of the Rights of Man* (1790) and A *Vindication of the Rights of Woman* (1792), savaged the virtues of monarchy and hereditary privilege, and argued that women deserve the same fundamental rights as men, especially regarding education (Oliver 2010: 121).

The years leading to the violent eruption of the French revolution in 1789 were a breeding ground for incendiary, even scabrous, publications, many of them including cartoons. A genre known as *libelles* – political pamphlets or books slandering public figures – proliferated, especially in the run-up to the revolution. Mocking and subversive, they made a sport of thrashing the royals, with Marie Antoinette, Louis XVI's Austrian-born wife, a particular symbol of all that was wrong with the ruling class. Graphically illustrated *libelles,* like *The Royal Dildo, The Royal Orgy*, and *The List of All the People with Whom the Queen Has Had Depraved Relations* (1792), accused Marie of adultery, lesbianism, pedophilia, public masturbation, bestiality, and treason.

In 1791, the feminist playwright Olympe de Gouges countered 1789's *Declaration of the*

*Rights of Man and the Citizen*, a core statement of the French revolution, with her *Declaration of the Rights of Woman and the Female Citizen.* "Woman is born free and lives equal to man in her rights," de Gouges declared. She demanded full political rights for women, noting that since "woman has the right to mount the scaffold … she must equally have the right to mount the rostrum." But no one cared. De Gouges herself mounted the scaffold two years later, guillotined for attacking the revolutionary regime.

Eighteenth-century pamphleteers were provocative, collaborative, and socially engaged – deeply so. The best established high bars for both activism and impact. Many are the spiritual ancestors of *Charlie Hebdo*, the mercilessly satirical French weekly whose editors were slaughtered for their cartoons of the prophet Mohammed.

William Blake, the eighteenth-century poet, painter, and printmaker, was socially engaged in a different way. Considered the first "book artist," he wrote, illustrated, printed, and bound his own books and also worked for others. His contemporaries thought him mad, even as his creativity was admired. His eccentricity, in fact, makes Blake hard to pin down. He loved the Bible but hated organized religion, sympathized with early feminists, supported the French revolution until its descent into terror, and developed a personal mythology that reinforced opinions of him as a mad visionary.

*Visions of the Daughters of Albion*, a 1793 book-length poem filled with Blake's illustrations, condemned enforced chastity for women and marriage without love. Blake also defended the right of women to self-fulfillment. His watercolors for a version of Dante's *Divine Comedy*, left incomplete by his death in 1827, highlighted his belief that materialism had corrupted the world.

### Birth of the Modern

Skipping ahead, we come to the rise of constructivism. Constructivism was an art and architectural philosophy that emerged in 1919 from Russian Futurism and the cauldron of the Russian revolution. It preached an art indistinguishable from social engagement, and preferably in the service of revolution. Constructivism's angular, industrial, geometrically abstract style first expressed itself in three-dimensional works, but soon expanded to include books, posters, photography, film, and graphic and textile design.

Artists like Alexander Rodchenko, El Lissitzky, Solomon Telingater, and Anton Lavinsky designed books that proved to be major inspirations for radical designers in the West. Russian constructivism's influence was vast. Its philosophy influenced the German Bauhaus and Dutch *De Stijl* movements, and spread throughout Europe and Latin America, inspiring generations of artists.

One of them was Franz Masereel, a Belgian who worked in France (Beronä 2003). Masereel created *Passionate Journey*, an unexpected bestseller in 1919, and several other "wordless novels" that told stories using caption-free woodcuts. Predecessors of today's graphic novels, and widely imitated at the time, they employed dramatic black-and-white images, usually to express feelings of anxiety and fear in an atmosphere of social injustice. Masereel's influence can still be seen in the work of artists like Art Speiglman, author of *Maus*, and Alison Bechtel, author of *Fun Home.*

John Heartfield (née Herzfeld), a contemporary of Masereel, pioneered the use of pho-

tomontage as a medium of political protest (Selz et al. 1977: 7). He published biting anti-war, anti-Nazi montages on the cover of *Arbeiter-Illustrierte-Zeitung* or *AIZ* (*The Workers Pictorial Newspaper*) (1977: 27). Images like a swastika made from blood-drenched hatchets, a dove impaled on a bayonet, and Hitler as both a puppet and a butcher had a huge impact, and led Hitler to shut down *AIZ* in Berlin as soon as he came to power in 1933 (1977: 28).

Heartfield's brother, Wieland Herzfelde, founded a small but influential collective, Malik-Verlag, that published Heartfield's works as well as those of artists and writers like George Groz, Berthold Brecht, Kathe Kollwitz, Maxim Gorki, and George Bernard Shaw, among others. Books by the socially critical collective were censored, condemned in courtrooms, and used as fuel for Nazi book burnings. Founded in Berlin, Malik-Verlag moved to Prague after Hitler's ascent, then to London, and finally to New York.

After the war, artists struggled to make sense of the world around them. One important group, Fluxus, took off in Europe and the United States as an avant-garde movement devoted to the subversion of earlier art traditions. Fluxus's anti-art, Dada-influenced artists, composers, and designers were active in a broad spectrum of artistic pursuits, including books. Founder George Maciunas declared Fluxus a movement to "PROMOTE A REVOLUTIONARY FLOOD AND TIDE IN ART" that would "FUSE the cadres of cultural, social & political revolutionaries into united front & action."

Maciunas and early members like Allison Knowles and Dick Higgins worked collaboratively on books and printed projects with Nam Jun Paik, Yoko Ono, John Cage, and dozens of other artists who would go on to become art world luminaries. The idea that artists could produce work in large numbers (including cheap, democratic multiples) gained currency in the 1960s, thanks in part to Fluxus.

Books produced by Fluxus artists coincided with an increasing ability to produce all sorts of printed matter more easily and inexpensively. Fluxus artists reveled in the publishing freedom conveyed by offset printing, Xerography, collage, 35mm photography, rubber stamps, and innovative forms of printmaking. A new world of do-it-yourself publishing morphed into a culture of chapbooks, alternative weeklies, zines, and other forms of down and dirty publishing. Socially engaged art by individuals and groups became commonplace.

Fluxus was also unusual because of the large number of participating women artists. However, feminism, a philosophy predicated on social engagement, did not gain a serious art-world foothold until 1973 when artist Judy Chicago, art historian Arlene Raven, and graphic designer Sheila Levrant de Bretteville established the Women's Building in Los Angeles as the first public center in the United States devoted to feminist art (Gaulke 2011: 11–17). The Women's Building nurtured such female-oriented art organizations as the Feminist Studio Workshop (its primary tenant) and the Women's Graphic Center.

A year later, Ann Kalmbach, Tatana Kellner, Anita Wetzel, and Barbara Leoff Burge founded the Women's Studio Workshop, a feminist-informed organization providing studio space and funding for artists' projects and books, which it publishes under the WSW imprint. Housed in Rosendale, New York, the Workshop continues to thrive, and publishes a number of artists

whose work takes on various social and political issues. New York artist Sharon Gilbert, for instance, focuses on nuclear and environmental issues in such works as *Poison America*, *Action Poses* and *Green: The Fragile*. Her work is simply produced, often on a Xerox machine, and small in scale, but with a raw, proto-punk, anti-design aesthetic in its typography and layout. *A Nuclear Atlas* (1982) still has the frantic avalanche of information Gilbert amassed to persuade readers of the urgency of her message.

### Action Art

In the 1980s, artist books played a crucial role in the activist art that developed as a response to three overlapping trends: the rise of the Reagan era, the AIDS crisis, and gay rights.

Activist art collectives like Bullet Space, Collaborative Projects, Inc. (Colab), the Art Workers Coalition, Heresies, and Group Material seemed to be everywhere in the 1980s and 1990s. Their arsenals included a vast number of inexpensive, widely distributed artist books and multiples. The goal of the New York-based Political Art Documentation/Distribution Project, for example, was "to demonstrate the political effectiveness of image making, and to provide a framework within which progressive artists can discuss and develop alternatives to the mainstream art system" (Sholette n.d.). PAD/D and like-minded groups began meeting at the Printed Matter Artist Book Store in Manhattan, then at the nearby Franklin Furnace, a hub for avant-garde artists.

PAD/D projects emphasized public participation and performance. In 1981, *Death & Taxes* invited New York artists to produce public works protesting the use of federal taxes for the military instead of social programs. One responding artist was arrested for impaling a human dummy on the bayonet of a World War II memorial at an armory. The same year, *Image War on the Pentagon* consisted of dozens of cardboard picket signs actually used by demonstrators during a Washington, D.C., demonstration to protest budget cuts and U.S. involvement in El Salvador and Nicaragua (Sholette n.d.: 7).

By the mid-1980s, with AIDS a full-blown epidemic, the LGBT community was gaining unprecedented visibility, in part through its activist artists. The art collective Gran Fury launched its pivotal Silence=Death campaign amid a growing outpouring of socially engaged, gay-themed art and agitation. The AIDS Project Los Angeles published *Corpus*, an exceptionally beautiful art journal edited and designed by George Ayala, Jaime Cortez, and Pato Hebert. *Corpus* was filled with journalism, memoirs, art, and fiction by and for the HIV-afflicted, and was distributed free through service organizations, hormone clinics, prisons, libraries, universities, bars, clubs, PRIDE events, queer bookstores, drop-in centers, shelters, and at other AIDS-related locations.

The reaction against Reaganism and AIDS spawned a generation of artist provocateurs. One such, A.A. Bronson, created a series of provocative organizations, publications and installations while supporting the work of other artists and presses. An essayist and curator, Bronson co-founded the artists' groups General Idea and Group Material, and *FILE Magazine*. He presided over Printed Matter, and started the annual New York Book Fair, which hosts over 200 independent presses, booksellers, artists, and publishers from some twenty countries. Based now in

Berlin, Bronson remains a prolific artistic resource.

Ed Hutchins, another independent book artist, founded a craft fair called the Book Arts Jamboree. From a perch in Mt. Vernon, New York, Hutchins publishes ingenious entertainments through his independent Editions Press. His *Gay Myths*, written after the 1993 March on Washington for Lesbian, Gay, and Bi Equal Rights, illustrates such so-called truisms as "You can pick us out! … We all love opera! … We hate straights!" with directness and humor, engaging both those who have and those who have not thought about gay issues. Thousands of copies have been distributed.

From her New York base, Clarissa Sligh's *Reading Dick and Jane with Me* (1989) expressed the discomfort of African-American children learning to read using a national primer starring a White, blond-haired family. *Reading Dick and Jane* decoded what *Dick and Jane* was really communicating. Her *Wrongly Bodied* in 2009 was one of the first photographic artist books to tell the story of a transgender man. In *Wrongly Bodied Two* (2011), Sligh tells the stories of Jake, a twenty-first-century White woman transitioning from female to male, and Ellen Craft, a nineteenth-century Black woman who escapes slavery by passing as a White man.

With *Motherisms* (2014), Chicago-based artist Lise Halle Baggesson challenges the notion that motherhood and creative practice are incompatible. Baggesson argues that women are often summarily dismissed from the art world when they become mothers, creating "a mother-shaped hole in contemporary art." Organized as letters to Baggesson's mother, daughter, and sister, *Motherisms* proposes the radical notion that motherhood is the artistic practice that informs all others.

Artists – "antennae of the race," as Ezra Pound (Pound and Fenollosa 1967) called them – have long labored to free audiences from the alienation of dominant ideologies. Today's socially engaged artists rest on the shoulders of their cranky, artistic, book-making ancestors. They work in a chaotic arena vastly expanded by the Internet, DIY publishing, social media, the fragmentation of conventional publishing, a revival of printed artist books, and a variety of other still unsettled forces. Yet they persist.

# FREE SPEECH IN A DIGITAL ERA

*David Greene*

The advent of digital communication and its rapid and expansive adoption world-wide has been a boon for the freedom of speech.

I first wrote a similar statement well over a decade ago. And now over two decades into the "digital era," the statement seems so obvious that it doesn't require a citation or even much explanation. Digital information, and perhaps the Internet and the rise of social media in particular, have made it easy for anyone almost anywhere in the world to identify and reach an international audience with their thoughts (about the pressing issues of the day, or their personal stories, or their daily mundanities, or their vitriolic jibes, or really anything). One no longer needs the backing of a major media organization to publish widely. It is now exceedingly easy to "petition one's government for a redress of grievances" – the very acts encouraged and enabled by "I Wish to Say" – by emailing one's legislators, commenting on their Facebook page, or mentioning them in a Twitter post, all without having to leaves one's own house – or one's pajamas. (I fear naming specific applications and platforms in this article. Surely this will render the article obsolete and quaintly dated in the near future! But I am confident that these platforms will only be replaced by others that provide the citizenry with greater, not less, access to governmental officials.) Dissidents can make their plights known to human rights organizations. Whistleblowers can expose government wrongdoing to an international audience with ease. Everyone has a voice and the easy means to speak loudly at their disposal – all again, while in one's pajamas.

In fact, in many ways, the pajamas paradigm is definitional of a digital era. Digital communications are certainly faster than paper communications. But the most significant innovation was the elimination of the gatekeepers – the publishers, networks, recording labels. In the paper/analog era, without these gatekeepers it was very difficult for a speaker to spread their message without leaving home. But in this digital era, a person need not even leave their bedroom to take part in and influence an international conversation.

Of course, once one gets just a little beneath the surface, the picture is much more complex.

Before we dig beneath that surface, though, it is worth remembering that at the dawn of this digital era, we were not so sure it would work out this way. All new communications media seem to have ridden a similar arc in their relationship with the government. When a new medium is first introduced and is used mostly by its early adopters, there is a complete lack of regulation. Radio communications, for example, were not regulated by the U.S. government until 1928 (and only then, the story goes, because the *Titanic*'s distress signals were interfered with by others using the same frequencies). Then, when the urge to regulate comes, it comes on strong. Later, as the medium becomes routine and embedded in people's everyday lives, the need for regulation seems like a relic of a more naïve time. And then sometimes – though not always – the regulations are rolled back.

This same progression occurs in the law. The U.S. Supreme Court has said that courts should look at each new communications medium as it is adopted, to determine what level of legal protection should be given to speech on that medium.[1] But when that analysis is actually undertaken, there are only rare examples of a medium being treated any differently than the default of unqualified First Amendment protection for speech.[2] In fact, in the case in which the Supreme Court first stated that there may be new rules for new media, the court actually reversed an earlier decision and found that it was wrong to have ruled (thirty-seven years earlier) that movies were not entitled to full and unqualified First Amendment protection.[3] Currently, for a variety of reasons, only over-the-air radio and television broadcast media get a diminished level of First Amendment protection.[4] Given the way we all consume similar media without any restrictions, that regulation seems very much like a quaint relic.

Digital communications, and particularly the Internet, followed that same arc in the United States. In 1996, the U.S. government attempted to subject Internet communications to the same type of regulation that applied to over-the-air broadcast radio and television. Chief among these regulations were those prohibiting the publication of "indecent" materials that might be inappropriate for minors on sites that might be accessible to minors. Had that effort been successful, the Internet would have had, among other restrictions, the same restrictions on language and sexual material as daytime and prime-time television. The government argued that it should regulate the Internet for the same reasons as it regulates the broadcast media: the medium is "pervasive" in that it has the ability to enter people's homes and their most intimate interactions, and that there is special concern about shielding children from inappropriate material published online. In 1997, in *Reno v. ACLU*, the Supreme Court rejected that argument, setting forth what many read as the foundational proclamation of free speech in the new digital world. The Supreme Court said that the Internet

> provides relatively unlimited, low cost capacity for communication of all kinds
> . . . This dynamic, multifaceted category of communication includes not only
> traditional print and news services, but also audio, video, and still images, as
> well as interactive, real time dialogue. Through the use of chat rooms, any person

with a phone line can become a town crier with a voice that resonates farther than it could from any soapbox. Through the use of web pages, mail exploders, and newsgroups, the same individual can become a pamphleteer. As the District Court found, "the content on the Internet is as diverse as human thought."[5]

As I write this in August 2015, some of the tools mentioned by Justice John Paul Stevens in that portion of his opinion in *ACLU v. Reno* are already obsolete and no longer pertinent. But those tools that have replaced them have only served to magnify the democratizing force of digital communications that he championed. (While readers in future years may find my references to Facebook and Twitter no longer specifically pertinent, hopefully my reasoning will still be relevant.) And I believe that all of the principles laid out by Justice Stevens remain correct and are even more potent than in 1997. But I do share the concern of others that the Internet has not fulfilled its full potential as a democratizing medium, and that much work remains to be done.

The promise of the Internet was – and remains – the elimination of gatekeepers to individual global communications. Standing in the way of fulfilling that promise (perhaps not unexpectedly) is the emergence of new gatekeepers. Internet service providers, mobile communications companies, and other entities that provide the portals to digital communications have consolidated and now wield great power. A service provider could, for example, choose to only transmit certain content to its subscribers rather than everything available online. It could choose to omit (or slow down) the delivery of the content of a competitor or impose costs on disfavored content. This abuse of power has been exacerbated by the quasi-monopoly that has developed over the provision of Internet access.

Recently, this problem has resulted in something that some considered antithetical to the basic principles of the Internet when *Reno v. ACLU* was decided. In 2015, the Federal Communications Commission (FCC) assumed some regulatory authority over the Internet in the interest of "net neutrality." This is the concept that Internet service providers should not discriminate among Internet content-providers – that is, be "neutral" in delivering to their subscribers the information that those subscribers request. So every Internet user should have the ability to gain access without gatekeeper Internet service providers discriminating with respect to content, speakers, or applications to the same content as any other. Toward this end, the FCC has sharply restricted the blocking of legal content, applications, or services, has prohibited broadband providers from impairing or degrading lawful Internet traffic on the basis of content, and has barred broadband providers from favoring some Internet traffic over other traffic in exchange for payment. This very limited degree of regulation on the gatekeepers of the Internet was deemed necessary to preserve the medium as the democratic forum for its users and to encourage continued innovation. Still, the idea that the government could regulate the Internet at all was so repugnant to some advocates that the issue of net neutrality divided the Internet rights community. The legality of the FCC's net neutrality rules has been challenged and, at the time of this writing, remains an open question.

While net neutrality was an issue in the United States, the new gatekeepers problem is even more pronounced in nations where the digital communications providers are arms of

the state, or controlled by oligarchs. In these areas, repressive regimes can control both the inflow and outflow of digital communications. Twenty-first century authoritarian regimes now recognize that, just as seizing control of radio and television stations lets them control mass media, control of telecommunication providers gives them an unparalleled ability to restrict online communication.

The "Great Firewall of China" is the most famous example of this problem. But other examples abound. In Ethiopia, the government maintains a monopoly on landline, mobile, and broadband communications through Ethio Telecom, allowing it to use its own infrastructure to simultaneously censor and spy on its population. Most other countries offer a choice of telecommunication providers, especially in the mobile telecommunications sectors. But the handful of companies offering mobile services are tied to government spectrum contracts, and have been swift to respond to requests to control content. The day after Thailand's 2014 military coup, for instance, the junta leaders publicly summoned representatives of the country's Internet service providers to ensure their cooperation in blocking content. When a representative of one provider, Norwegian company Telenor, said it had been instructed to block Facebook by the junta, the government regulator denied the order, then called for an investigation into whether Telenor would be able to participate in a 4G license auction later that year.

Virtual private networks can sometimes provide an end-around such restrictions. But they are not always available to those who need them most. Similarly, the physical architecture of the Internet in some areas gives the state great power to cut off the flow of information. Internet "kill switches" can cut off all access at times when the government feels threatened by digital communications. Egypt famously did this during the Tahrir Square demonstrations in 2013.

That the freedom of the Internet may unintentionally result in less speech for some is a concern that also arises in the context of online harassment. Just as the Internet provides those who wish to speak with an international audience, the Internet also makes it easy for those speakers to be targeted by those who disagree with their views. Speakers may then be targeted with hateful messages and threats, or the revelation of their private (non-digital) contact information (known as "doxxing"). The ability to disseminate speech around the world instantly also means that one's intimately private information may be disseminated around the world instantly as well. For these reasons, there have been calls for new laws that would place penalties on these types of Internet speech in the name of making sure the medium remains available for everyone. We have learned from history that such efforts frequently, if not always, end up including a lot of important and harmless speech; it is exceedingly difficult to write such laws in a way that means they only penalize the speech that is targeted. And it is important to make sure that existing laws cannot address such harms before new laws are passed.

There are other unintended consequences of the digital revolution for which we must remain watchful as well. As the Internet has greatly diminished the role of traditional news media as gatekeepers for global communications, and as the Internet has greatly disturbed the classified advertising paradigm that provided the financial model for such media entities to exist, U.S. media entities have far fewer resources to devote to ensuring government transparency. When news print publications were highly profitable, they funded a great proportion of the lawsuits

that made sure that state, local, and federal governments were complying with their open government laws. Media entities routinely filed lawsuits to enforce laws that grant the press and the public access to government records, meetings, and court records and proceedings. But we are seeing far fewer of these important legal actions now. Just as major news media entities are figuring out how to restructure their business models, we must try to figure out how to restructure our models for making sure that this vitally important work still gets done.

When I was the executive director of the First Amendment Project, we decided to commission performances of Sheryl Oring's "I Wish to Say" project in San Francisco and Oakland, California. What appealed to us at that time – and the reason I think it continues to appeal to communities around the world where Oring presents her work – was the very idea of using a supposedly obsolete medium of communication – manual typewriter! mailed postcards! – to inspire people to do something. Talking to their president and others in positions of power and influence would actually be quite easy for people to do with their digital toolbox. But for some reason it wasn't getting done. Maybe sometimes it takes the appeal or novelty of an old technology to remind us of the promise and potential of the ones we have.

# EFFICACY, TRUST, AND THE FUTURE OF CIVIC ENGAGEMENT

*David B. Holian*

Engaging citizens with the opportunity to send a message to the president touches on numerous concepts that political scientists have found to be critical factors in determining the health of democracies around the world. Consider, for example, the following three such concepts:

- *Participation:* Citizens vary in terms of the degree to which they are willing to spend their scarce time on politics. Their choices can range from not participating at all, to voting for the president once every four years, to taking part in politics more routinely by displaying yard signs, discussing politics with friends and family, contributing money and time to campaigns, and protesting close to home or in Washington.
- *Agenda setting:* Political scientists have long noted the agenda-setting power of presidents and mass publics. Issues considered most important to Americans at any given time – those concerns they have foremost on their minds, ready to share upon being asked – tend to be the issues on which political elites focus. Moreover – especially where the president is concerned – causality can travel in both directions in the sense that presidential rhetoric not only responds to what a critical mass of Americans think is important, but can also influence the prominence that Americans attach to particular issues.
- *Political efficacy:* I believe this concept to be the most relevant connection between Sheryl Oring's work and political science research. The measurement of Americans' feelings of political efficacy coincides with the path-breaking voting studies of the 1940s, 1950s, and 1960s. *The Voter Decides* (Campbell, Gurin, and Miller 1954) was based on the first iterations of the American National Election Study (ANES), a survey of American voters taken in the months leading up to and in the immediate aftermath of every presidential election since 1948.[1] The ANES remains crucial to voting behavior studies in political science because it has allowed us to track the politically relevant opinions, attitudes and behavior of Americans for over six decades.

Originally, the authors of *The Voter Decides* defined political efficacy as the degree to which citizens felt confident enough to engage in the political process and, by their engagement, to influence that process. In other words, a politically efficacious person participates in politics in a variety of ways and believes that American political elites are responsive to citizen participation. This is precisely what is being communicated by "I Wish to Say" participants. First, there is the confidence to send a message to the president by discussing politically important issues with a stranger. Second, there is the expectation that this is not an empty exercise – that public opinion can be consequential even to those in the White House.

In the concept's early days, researchers measured political efficacy by recording survey respondents' agreement or disagreement with such statements as: (1) "Sometimes politics and government seem so complicated that a person like me can't really understand what's going on"; (2) "People like me don't have any say about what the government does"; and (3) "I don't think public officials care much what people like me think." A survey respondent with high political efficacy would disagree with all three statements.

As time passed, a consensus emerged among political scientists that this very broad measure of efficacy actually obscured distinct concepts. In *Political Life: Why People Get Involved in Politics*, Robert Lane (1959) argued for distinguishing internal from external efficacy. In this theoretical development, statement 1 above can be understood as a measure of internal political efficacy, a respondent's confidence in his or her ability to understand and participate in politics. Statements 2 and 3, on the other hand, measure external political efficacy, a respondent's confidence that those in positions of power care about and are responsive to the issues that ordinary people think are important. While each type of efficacy continues to have important ramifications for the overall health of a democracy, the concepts are clearly distinguishable in the sense that one can self-confidently participate in discussions regarding the issues of the day, yet believe that political elites, from the president down, will pay nothing more than lip service to public opinion. Conversely, someone with little faith in their own political attitudes may still trust that the system compels elites to heed the people.

The three figures below illustrate trends in the political efficacy of Americans across the last sixteen presidential elections.[2] Figure 17.1 presents change over time in a measure of internal efficacy. Agreement with the statement, "Sometimes politics and government seem so complicated that a person like me can't really understand what's going on" suggests a lack of confidence in one's ability to understand important political and public policy issues. At least 54 percent of respondents communicated low political efficacy in each year of the survey. After a consistent decline in the percentage agreeing with the statement through the 1960 election, the measure of low efficacy begins a steady increase that reaches into the 1970s and stabilizes in the 1980s. The increase through the 1960s and the plateau reached in the 1970s coincides with a tumultuous time in the United States that encompassed a series of political assassinations reaching the Kennedys, Medgar Evers, Malcolm X, and Martin Luther King Jr.; declining popular support for the Vietnam War, which drove President Lyndon Johnson into retirement; and the cover up of crimes related to the Watergate scandal, which caused President Richard Nixon to resign his office. Beginning in 1988, the trend in the percentage of Americans communicating low internal

efficacy is clearly downward.[3] However, this decline is interrupted in 2008. This could be partly because of issues related to the Great Recession. However, post-9/11 politics may also have led more Americans to admit confusion regarding politics. Given the absence of this measure from the 2004 survey, it is impossible to say with these data which explanation is more likely.

Figure 17.1

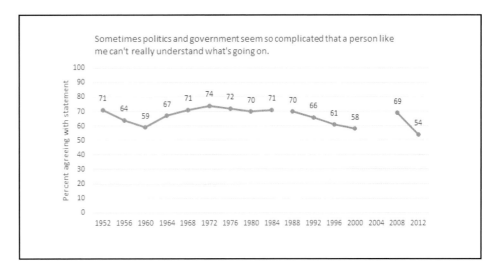

Either way, low internal efficacy responses decreased substantially from 2008 to 2012. In the most recent presidential election year, the percentage of Americans claiming an inability to understand politics reached a low point across the six-decade time span. There is preliminary evidence to suggest that the emergence of the Internet as a politically consequential tool is related to the uptick in internal efficacy. More specifically, social media usage, online political engagement, and the expanding opportunities to interact with government online are all correlated with political efficacy, suggesting that as Internet use continues to expand, citizens' political engagement may expand as well (Sharoni 2012).

Figures 17.2 and 17.3 present measures of external efficacy, each of which suggests an increase over time in the percentage of Americans who believe that their opinions do not matter to those in power. Moreover, the amount of this increase is understated because of the change in the responses available to respondents beginning in 1988 (see note 2). In other words, Americans have become even less confident since 1988 in their ability to hold the political system accountable than the figures indicate, and the public officials who work within the system are seen as less accountable as well. As with internal efficacy, the measures of external efficacy seem to be quite responsive to highly charged crises that drain people's confidence, both in their ability to understand politics and in the system's responsiveness to public opinion.

In Figure 17.2, respondents' lack of confidence in public officials climbs steadily through the turbulent 1960s and 1970s, while in Figure 17.3, negative views of the overall system spike

in 1968 and remain in the 40 percent range through 1980. Both figures suggest a slight upward trend in the percentage of respondents exhibiting low external efficacy since 1988.

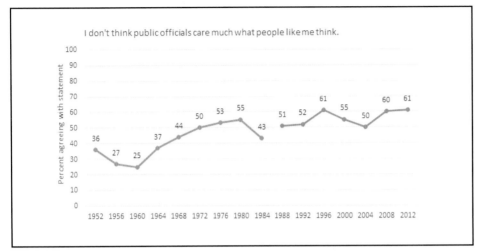

Figure 17.2

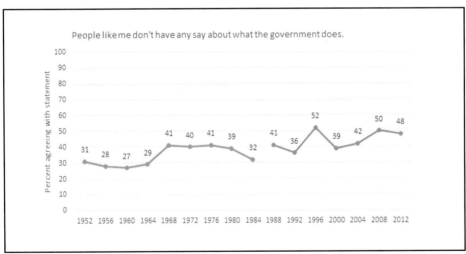

Figure 17.3

Both overall trends and contemporary levels of internal and external political efficacy are consequential because each has been linked repeatedly to public support for democratic systems, the stability of these systems, and a variety of worthy acts of democratic citizenship, including voting and other, even more demanding, forms of political participation. Take voting, for example. To political scientists, especially those who come to the discipline from the economically oriented, rational choice perspective, the act of voting – more specifically, explaining why people take the time to cast a ballot – is something of a mystery. Why do rational citizens vote? A simple

cost–benefit analysis suggests that doing so is, if anything, irrational. After all, strictly speaking, the potential benefit derived from voting is a citizen's assessment of the probability of casting the decisive ballot in any given election. Even in local elections where voters may be numbered in the hundreds, this probability is infinitesimally small. On the other hand, the tasks associated with voting can be quite costly. This is particularly true in the United States, where the burden of registering and keeping one's registration current falls on the citizen and not, as in most Western democracies, on the state. Such considerations are especially relevant during an era in which state governments across the country have seen fit to erect ever more daunting obstacles between citizens and the voting booth, such as onerous voter identification requirements, reduced early voting opportunities, and the repudiation of same-day voter registration.

Beyond registering to vote, the actual act is costly in terms of time spent and opportunities foregone. Voting locations can be changed, lines can be long, and the ballot itself can be confusing. In addition to these hurdles, the sheer number of elections in the United States, from primaries to general elections to, in some cases, run-offs, at the city, county, state, and federal levels, make voting even less enticing. Moreover, the nation's idiosyncratic electoral rules, such as the Electoral College and single-member congressional districts, which are often – quite legally – gerrymandered for partisan advantage, place even greater downward pressure on turnout. With regard to the Electoral College, forty-eight of fifty states confer all of their electoral votes on the candidate who receives the most statewide popular votes. Yet in 2012, millions of Mitt Romney voters in Democratic California, where President Obama amassed 55 of the 270 electoral votes necessary for victory, as well as Obama voters in Republican Texas (thirty-eight electoral votes) trudged to the polls knowing full well that the rules of the game would convert their popular votes for the sure loser in their states into electoral votes for the winner, the very candidate they opposed (Edwards 2011).

Viewed in this light, the approximately 58 percent of eligible United States voters who cast ballots in 2012, while quite low compared with most other Western democracies, is less an indictment of the political engagement of the average American than it is of the institutional and systemic barriers discussed above.[4] Importantly, the concept of political efficacy helps solve the puzzle presented by voting and its associated costs. Voters are, of course, not solely rationally dispassionate economic actors. The decision to vote is also influenced by psychological dispositions, which include feelings of political efficacy (Harder and Krosnick 2008). People who score highly on both internal and external political efficacy are more likely to vote (Abramson and Aldrich 1982) and more likely to participate in general (Verba and Nie 1987). But these relationships do not end here. Voting in general, and voting for the winner in particular, may also increase feelings of efficacy, which then leads, in a virtuous cycle, to a higher probability of turning out to vote in the next election. Furthermore, the added benefit of voting can be generalized to the larger universe of political activities. Working in a campaign, attending a rally, writing a check, or sending a postcard to the president can all lead to increased feelings of efficacy, and therefore more political engagement in the future.

Finally, political efficacy is important, given its close correlation with another measure of democratic health: trust in government. Just as Americans' feelings of external efficacy have declined over time, so has the faith placed by citizens in government to deal with the issues of the

day. According to the ANES, in 1964 just over three-quarters of Americans trusted the federal government to do what was right "most of the time" (62 percent) or "just about always" (14 percent). By 2012, in a massive shift in public opinion with far-reaching implications, nearly three-quarters of Americans said they trusted the federal government only "some of the time," while another 2 percent volunteered that they *never* trusted government under any circumstances. When trust in government is low, so is political efficacy. When these attitudes weaken, civic and social participation decline as well, while their opposites – political dissatisfaction, apathy, and alienation – increase. Clearly, the current state of American democracy is troubling. However, expanding opportunities for highly engaged "e-citizenship," not to mention long lines where citizens gather to send a postcard to their president, allow some hope that the United States has reached a low point in popular trust and efficacy from which a steady climb will soon begin.

"I WISH TO SAY:" 2010 TO 2016

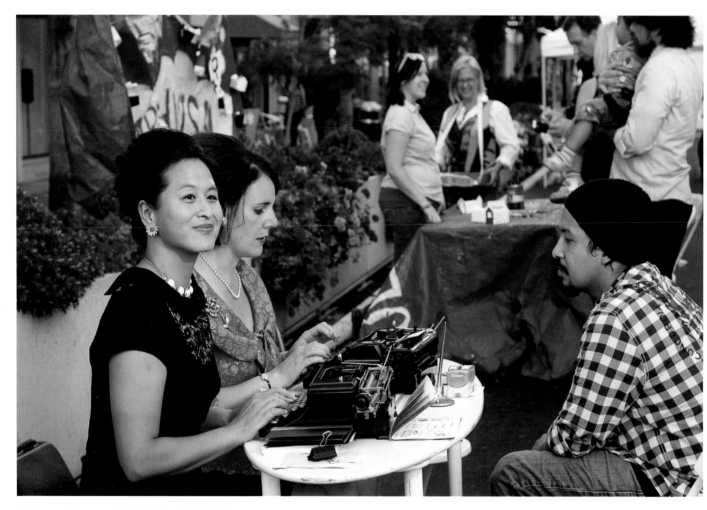

During a performance at the 01SJ Biennial in San Jose,
California, Stephanie Lie (left) joined Sheryl Oring at the
typing desk.
*By Dhanraj Emanuel*

SEP 1 7 2010

Dear Mr. President,
We just finished getting
health insurance for our family
after I lost my job and I know
what a hard job you have to fix.
It is like walking into a
used car lot in the sleazy part
of the town. You can't fix it.
You'll have to destroy it and
start all over again. My
daughter's insurance was denied
because she saw a doctor for a
cream for her skin.
Sincerely,
Unemployed engineer, Sujit Saha

**RUSH**

SEP 1 7 2010

Mr. President,
Dream like a child and reflect
like the elderly. Then maybe
more change will come.

Sincerely,

Jamie Hernandez

**IMPORTANT**

Dear Mr. President,

I need my family here with me.

~~Sincere~~
Alicia Perez
an Diego, CA

URGENT

MAY 0 1 201

Dear President Obama,
I want you to know ~~xxxxxx~~ me and
my family are victims of your
fal se promises. My father
came during the bracero program
in 1942. He brought my brother,
who at that time was 4 years
old. At that time, when you
came under the bracero program,
your family was recognized
as American citizens. 66 years
later, America deported my
brother. He's 70 years old
now and has never lived in
Mexico before. His wife lives
here, his children and his
great grandchildren. All his
brothers and sisters also
live here. You deported my
brother into a war zone in
Juarez, a war zone of cartels.
He is living in fear and in
shock, alone without his
family and daily he hears
guns ots, daily he finds bullet
shells outside his door with
no support from his family.

MAY 0 1 20

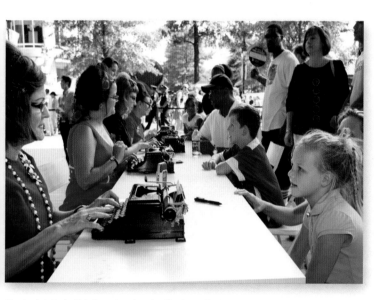

Five typists took dictation at a show in Charlotte, North Carolina, during the Democratic National Convention in 2012.
*By Dhanraj Emanuel*

SEP 0 3 2012

Dear Mr. President,

We are lucky that you are president. I want to be the first girl president.

Sincerely,

Kate Lawson, age 8

I WISH TO SAY
2012
CHARLOTTE

**IMPORTANT**

Kate Lawson

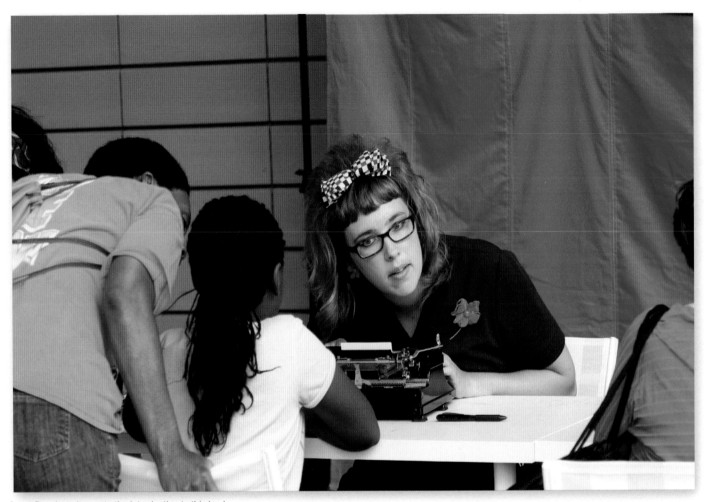

Corey Dzenko, who wrote the introduction to this book,
joined the typing pool in Charlotte, North Carolina.
*By Dhanraj Emanuel*

SEP 0 3 2012

Dear Mr. President,

I would like you to bring my son
home safely from Afghanistan !!

Karen Huskisson
Charlotte, NC
Sept 2012

I WISH TO SAY
2012
CHARLOTTE

**URGENT**

SEP 0 3 2012

Mr. President,

I am a 46 year old native
Charlottean with roots in the
great state of Illinois.  I am
begging that you continue with
your push for health care for
this country.  fax  My husband
and I are both college graduates
and cannot afford health insur-
ance.  He is a small business
owner in construction.  We have
two boys and YOU ARE OUR HOPE
FOR THE FUTURE.  Please stay
true to who you are and fight
for us.  We believe in you.

With great admiration,  Love
to you and your family

I WISH TO SAY
2012
CHARLOTTE

Connie McNeely

**FINAL NOTICE** HOPE!

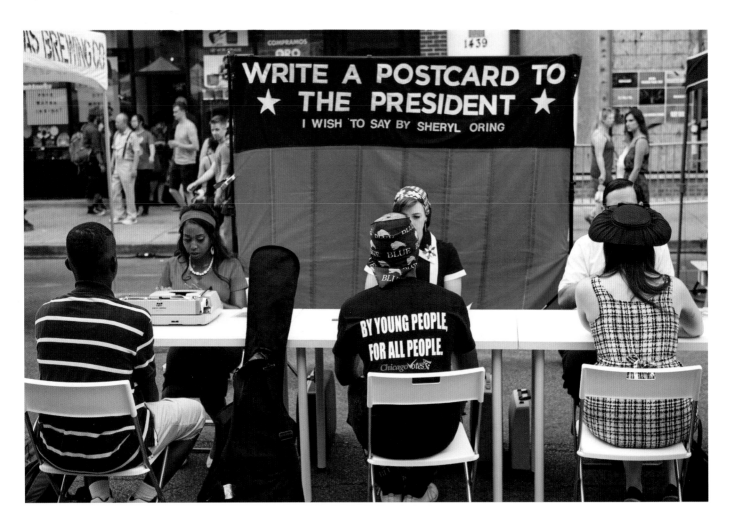

Five typists took dictation in Chicago during
performances at the Out of Site festival in July 2015.
*By Dhanraj Emanuel*

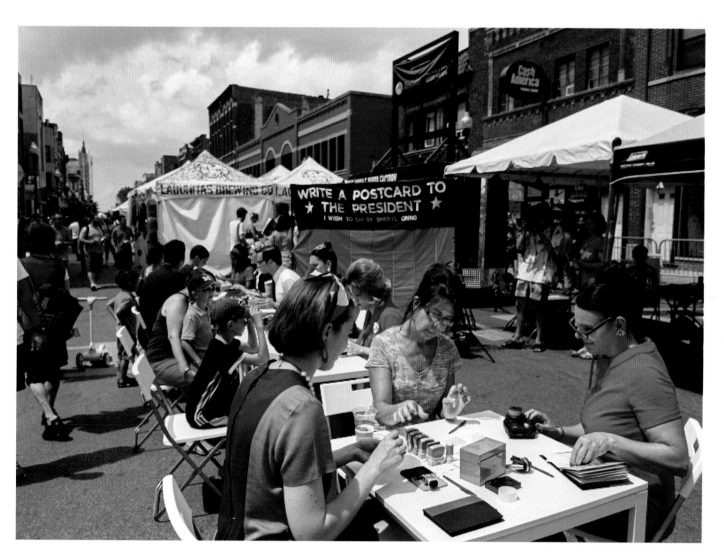

*By Dhanraj Emanuel*

By Sheryl Oring

JUL 2 6 2015

Dear Mr. President,
 I would like to thank you for including
ordinary people like myself in your
agenda. Thank you specifically for
normalising marriage for LGBT couples
across all states and for health care.
Both of those legislations bring us closer
to being united as a country.

From,
Mickey

APPROVED

# PAST DUE

JUL 2 5 2015

Dear President Obama,

xe& We're really concerned about maternaland pate nal benefits in this country. The benefit of caring for children when they're young will pay off in future economic savings--tenfold. In comparison to other countries, we're lagging far behind. If you're trying to help people at the end of their lives, I would strongly urge you to pay attention to the beginning of life. Put families first.

Sincerely,

Rachel and Rakhee, Chicago

*By Sheryl Oring*

*By Sheryl Oring*

JUL 2 6 2015

Dear Mr. President,

Your office looks great.

I like kindergarten. Please do not cut funding for schools. There are a lot of kids that need child-care and after-school programs.

I like your grey hair.

Sophia Guzman

ORIGINAL

JUL 2 6 2015

D

Dear President,

Thank you for your leadership. We are keeping you in our prayers.

Sincerely,
Teresa Sathuri

ORIGINAL

*By Sheryl Oring*

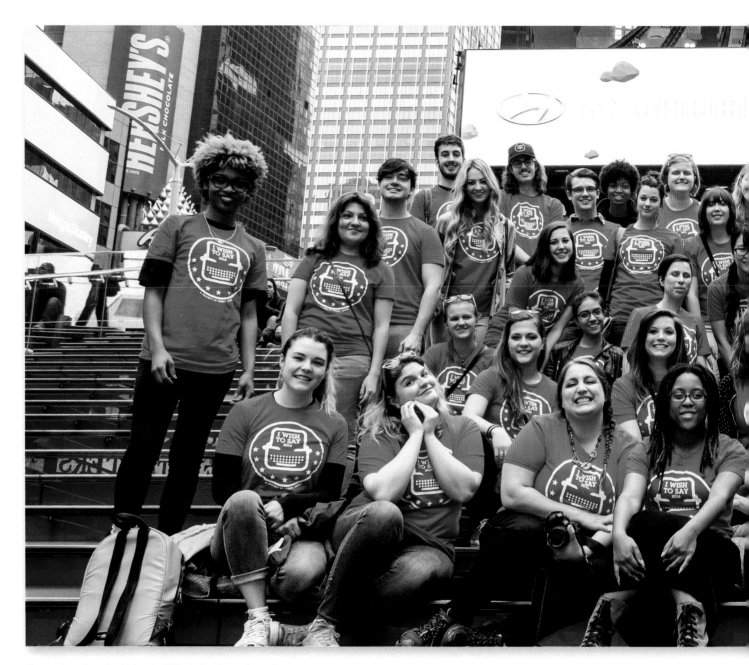

Sixty students from the University of North Carolina at Greensboro
traveled to New York for a performance at Bryant Park in April 2016.
*By Jiyoung Park*

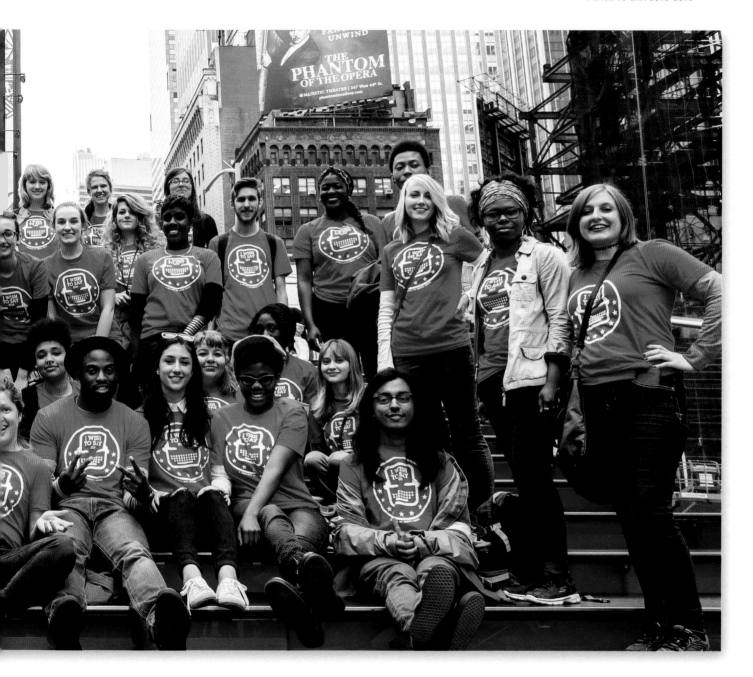

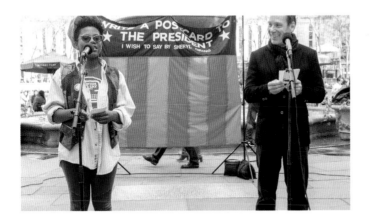

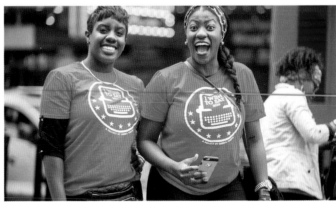

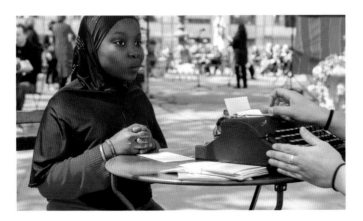

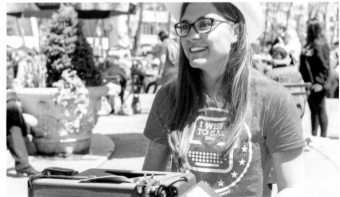

The April 2016 show at Bryant Park in New York was
presented in conjunction with the PEN World Voices
Festival.
*By Christian Carter-Ross*

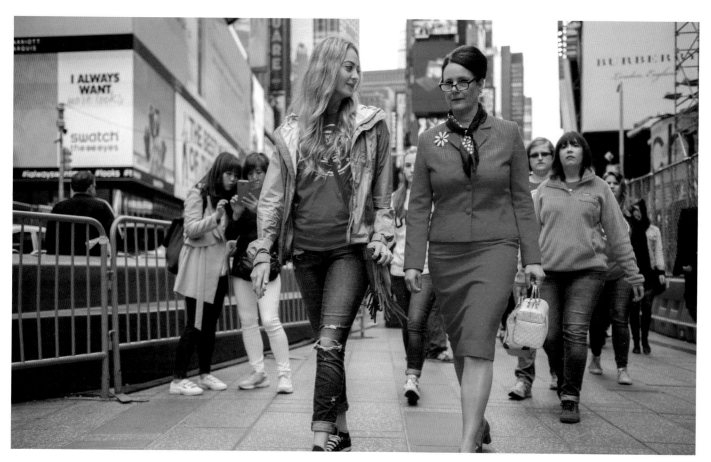

By Christian Carter-Ross

*Courtesy of Sheryl Oring*

APR 2 7 2016

Dear Mr. Sanders,
My name is Andres and I am
a 22 year old, New Yorker
I would like to personally
thank you for reigniting
the youths presence in
politics. After seeing you
in the South Bronkes this
year I was inspxired by
your ability to get great
people together. Never befo
-re have I been in such a
grand secular audiencethat
all strives for a better
future. You give me hope
that people with our mind
set still exist. Your
impact is greater than you
know. The mental revomlutio
n you started has just
begun.
Your Brother,

APR 2 7 2016

Dear Trum p,

 I know alot of americans doubt your

 ability because you are a buisness

 man however, if you can do fora

 America what you have done for your

 own buisnesses then I have no doubt

 of my own th t you will make

 America great again.

Sincerely,

Olivia Gemarro

# PAST DUE

*Courtesy of Sheryl Oring*

*Courtesy of Sheryl Oring*

APR 2 7 2016

Dear Candidates,

From New Yorksxx melting pot *-
Lets build bridges not walls. The
Brooklyn bridge is a great example.

Tony from New York

**PAST DUE**

APR 2 7 2016

To the Future President,

It's time for economic justice, par-
ticularly for those who work the hard-
est and are paid the least. It's
time to repay the debt to those whose
ancestors have built this country.
As you know and may or may not
acknowledge economic injustice dis-
proportionately affects black and
brown people who live in this nation.
It's time to strive for equity, reach-
ing the deepest for those whose need
is the deepest.

This cannot wait.

Henry Murphy II

*Courtesy of Sheryl Oring*

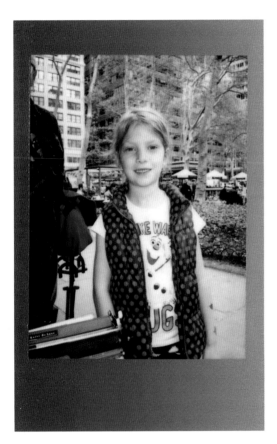

Courtesy of Sheryl Oring

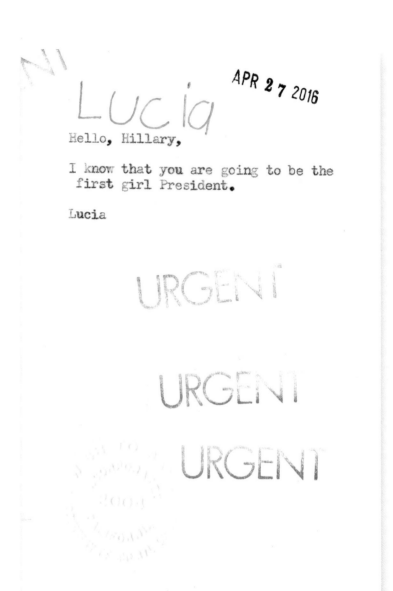

Lucia

APR 2 7 2016

Hello, Hillary,

I know that you are going to be the first girl President.

Lucia

URGENT

URGENT

URGENT

APR **2 7** 2016

Dear soon-to-be-president Clinton,

I am an ardent Bernie supporter who

will be voting and canvassing in the

general election.

I'm excited for your presidency

but i want to say that maintaining

Obama's legacy is not enough.

We need deep and drastic change

and a leaderwilling to stand up to
cpmpeting interests to make that
change.

The middle of the road is no longer
enough.

Please re-join us on the left

Sincerely,
Ricardo Pérez González

# URGENT

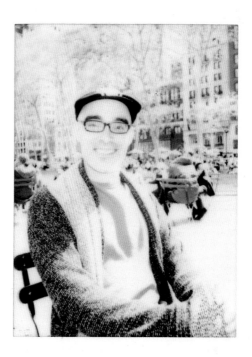

*Courtesy of Sheryl Oring*

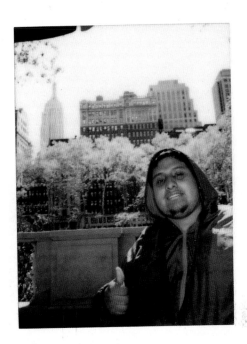

*Courtesy of Sheryl Oring*

APR 2 7 2016

Dear Mr. Trump,
 I don't believe in your very ignorant
mindset. I don't like the way you discri
minate against hard-working immigrants,
my parents came here to work, they
work hard, never raped, neve r stole.
If you want tomake America great againt,
you should do it by changing yourself
and the way you think. I love America
and I wish for the best outcome for
this country and the kids who come after
me. I sincerely hope that you will
reconsider your viewpoints and I believe
that building a wall between Mexico and
the US is a waste of money, you should
be building schools. Not every Muslim
is a terrorist. They too, like everybody
hope for a better life. Thank you, and
good luck.
                              Sincerely,

                        Luis Martinez

FFINAL NOTICE

APR 2 7 2016

Dear Mr. Trump,

I am a fellow citizen. I would
like to speak to you with all my
heart. I have been living in the
US for over 35 years and I am
proud to be an American for I5
years. I just want to continue to
be proud of this country after th
is year. This is a concern to me
and my immigrant community. i
 want to scream out: God bless
America!

        Sincerely,

        Man Mee Lai

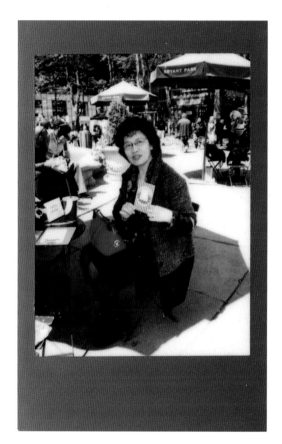

*Courtesy of Sheryl Oring*

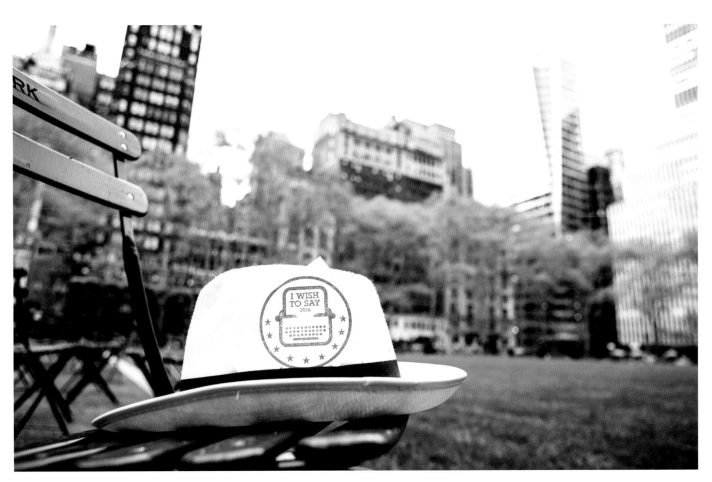

*By Jiyoung Park*

# Conclusion: Listening and the Power of Small Acts

★ ★ ★

# CONCLUSION: LISTENING AND THE POWER OF SMALL ACTS

*Sheryl Oring*

John O'Neal, co-founder of the Free Southern Theater, the theater wing of the Student Nonviolent Organizing Committee, talks about his work in the civil rights movement in a 2011 book by the Arts & Democracy Project:

> I soon discovered that the struggle that we had chosen to engage was not going to be straightened out in three to five weeks, three to five months, three to five years. Indeed, I had joined a struggle that was going to take at least one lifetime. Normal lifetime, because lifetimes were being cut short there by all kinds of means. So, I made a decision then that this would be my life's work. Since then, I've come to understand that it may be three to five lifetimes of work in the lifetime of an average human being.
>
> (Atlas and Turner 2011: 180)

The civil rights era led to real and significant social change. But so much more is needed. When I moved to the South five years ago, my father, who grew up outside Washington, D.C., in Greenbelt, Maryland, had one piece of advice. "You can change things, but it will take time."

Beyond persistence, what "I Wish to Say" has taught me is that small things can and do matter. Above all, active listening plays a crucial role in collaborative work. In this final section, three people who present work as arts administrators and curators discuss some of the challenges faced by artists and curators, as well as some of the lessons they have learned along the way.

Kemi Ilesanmi, Executive Director of The Laundromat Project, a New York City-based organization that brings arts, artists, and arts programming into community spaces in predominantly Black diaspora neighborhoods such as Bedford-Stuyvesant in Brooklyn, believes in arts and culture "as key ingredients for building stronger communities grounded in listening and

trust. But boy is this hard work, and slow too!" Ilesanmi continues, "Being visible and open while meeting people where they are and on their own terms rather than pushing one's own fully predetermined art agenda is essential."

More than a decade ago, George Scheer and some friends began transforming his grandmother's former thrift store in downtown Greensboro, North Carolina, into a living museum and residency that invites artists to use the collection to create site-specific artworks that become part of the ever-transforming museum. In a way, Scheer says, "we chose to let things linger, to not presuppose their purpose or value, to resist inserting our ideas of what could be in place of what already was." In conclusion, Sheer comments on the power of lingering and its role in social change. "Lingering," he says, "is a mode of waiting that allows power to transform."

This section ends with an essay by Radhika Subramaniam, Director and Chief Curator of the Sheila C. Johnson Design Center at the Parsons School of Design/The New School, where she teaches. Subramaniam posits:

> Small acts have big mythologies. Despite their scale, they're accompanied by enduring beliefs in their capacity to have sustained and meaningful impact. The accumulation of small acts, across time and space, repeated and determined, can multiply and grow enough to topple the largest bastion. Individual pulsating energies can overcome their solitary directions to stand side by side, shoulder to shoulder, to fill the largest Tahrir or Taksim Square with a vast, almost invulnerable, force.

The hardest step in a creative act is often the first step: the first word on an empty page, the first brush stroke on a blank canvas, the first call to ask a friend to help you collect hundreds of typewriters. After that initial step, the work becomes just that: labor in the service of an idea – an idea that may linger around for a while before its time has come. And then one day, there you are, standing amid a crowd that has gathered to help you take another step forward. And this time it's a leap. A leap into the abyss that could lead you to a different place, a different world.

# TURNING STRANGERS INTO NEIGHBORS

*Kemi Ilesanmi*

What makes a neighborhood? One might ask this in the context of rapidly changing neighborhoods from New York to Minneapolis to San Francisco, where shifts in race, class, local norms, and accessibility of leisure comforts are moving at lightning speed in once familiar locales.

One such historic and storied Black diaspora neighborhood is Bedford-Stuyvesant in central Brooklyn. It has been home to Jackie Robinson, Lena Horne, Jay-Z, and numerous less famous Black people, often emigrated from the American South, the Caribbean, or other parts of New York City. From 2000 until 2010, Bed-Stuy, as it is affectionately known, saw its White residents increase more than sixfold while the Black population dropped from 75 percent to 60 percent of the population (Roberts 2011). And, at least from anecdotal reports, a new upscale coffee shop seems to pop up every month; however, while the newcomers relax with $4 mochas, the old-timers wonder what to make of it all.

What makes a neighborhood? The answer is simple: people make a neighborhood. People who talk to one another and share stories and experiences. People who face common challenges and come up with solutions together. People who know each other's names, and maybe even share a meal now and again. People who listen to one another. In other words, neighbors make thriving neighborhoods.

Increasingly rapid neighborhood change (sometimes known by the g-word – "gentrification") forces not only shifts in neighborhood character, but also frays the social ties that bind residents together in common cause and shared vision, even across diversities.

The Laundromat Project (The LP), the New York City based organization that I lead, believes in arts and culture as key ingredients for building stronger communities grounded in listening and trust. But boy is this hard work, and slow too!

Bed-Stuy is one of our anchor neighborhoods, somewhere we have worked for over a decade, with easily another decade of deepening our work there on the horizon (e.g. more artist projects, community arts education, and local partnerships, as well as one day hiring a community

organizer). One of the ways we currently do this is by commissioning artists of color who are also local residents to make community-engaged projects in laundromats, parks, libraries, and other communal spaces. The artists are already grounded in the neighborhood when they begin, but nonetheless learn something intensely new while creating projects that help to knit together disparate neighbors, ideas, and experiences in real time.

Artist Aisha Cousins, who was born in 1978, moved to the neighborhood as a child. She and her mother lived at the corner of Marcus Garvey Boulevard, just a few blocks from Reid Avenue, which was renamed Malcolm X Boulevard in 1985. In her 2013 LP project "Mapping Soulville: The BedSty Remixes," she created a series of performance art scores with her neighbors to reflect on the life and legacy of Malcolm X as an iconic African American figure, while also engaging their own legacy touchpoints by asking them to rename Malcolm X Boulevard as they saw fit. As they waited between wash and dry laundry cycles at Marmy Laundromat, they also engaged in the power of naming: discussing how "Black Power Drive" might intersect with "Death of the Prison Complex Way" or more light-hearted suggestions such as "MJ Street" and historical entries such as "Nelson Mandela Road" and "Cesar Chavez Drive."

In a predominantly Black neighborhood with several streets still named after long-dead White slave owners as well as abolitionists, revolutionary heroes, and rich farmers, it is powerful to be invited to step out of our everyday routines to engage the complex legacy and history captured by a functional object such as a street sign. After all, who gets to name a street, and when do we know it is time for a new name? "Mapping Soulville" sparked fascinating conversations between residents new and old, allowing a reason to engage with a stranger in a conversation that was both easy and packed with historical weight. Those conversations planted seeds for future conversations about the shared space of their one neighborhood.

That thread was picked up again in 2015 by local artist Rasu Jilani, of Cruzian-Antiguan descent, in his LP project "Griots in the Stuy." *Griot* is a West African term for a community's storyteller, and Bed-Stuy has long held the stories of a Black diaspora seeking a bit of that American Dream. He has thus far conducted nearly three dozen interviews of neighborhood residents as he attempts to bridge the gap between what he calls "traditional" Bed-Stuy and "new" Bed-Stuy. His collaborator, Kwesi Abensetts, a Guyanese-born photographer, then captured each storyteller's portrait. They ranged from local business owners and politicians to homeowners, police officers, and others with deep as well as more recent ties to the neighborhood. But capturing individual stories does not necessarily engender cross-connections, so Jilani and Abensetts also held a public wheatpasting party to install the images on the side of a local business, Sincerely, Tommy. The excited storytellers came out with friends and family in tow and, because it was part of an annual LP festival called Field Day, other local residents and art lovers joined in the festivities as well. Strangers had a chance to become neighbors.

But remember how I remarked that this kind of work is often slow and hard? This is where The LP steps in with a rigorous and tested curriculum of professional development training that equips artists with the information and tools to listen in community and build local partnerships with authenticity and respect. Both Cousins and Jilani spoke of the importance of time when listening, gathering, and building trust with and between their neighbors. And they have both

lived in the neighborhood for a very long time – a lifetime in the case of Cousins. First, they showed up at the laundromat or the street corner again and again for weeks. Their presence and willingness to simply listen and have conversations even if the person did not want to officially participate in the project, constitute a key type of "sweat equity" that is needed for a truly successful socially engaged project. Being visible and open while meeting people where they are and on their own terms, rather than pushing one's own fully predetermined art agenda, is essential. The artists also employed simple techniques of games and inquiry-driven conversation to disarm residents and then connect them with others to help build communal ties. Nonetheless, it took months for Jilani to convince certain elders in the community to share their personal stories with him, and thus the world. Seeing the loving and respectful way in which early project participants were treated bought him needed credibility, as did seeing him working on the project in public week after week. Building trust is everyday work for artists and people in any community.

Cousins, Jilani, and the many other artists with whom The LP works in Bed-Stuy and across New York City are striving to build an authentic and deeply held community of neighbors, bridging divides of old and new residents, rich and less-rich, as well as Dunkin' Donut loving folk and French patisserie addicts. Creating space for art, conversation, debate, legacy-sharing, and unexpected shared experience in public spaces is key to our goal of shifting strangers into neighbors.

# LET IT LINGER

*George Scheer*

I have a fantasy of chaining myself to a busted old filling station awning at the corner of South Elm and West Lewis streets. It's hardly a landmark in downtown Greensboro, North Carolina, a city of 300,000 people that was once the world's largest producer of denim and home to the Woolworth's that sparked the sit-in movement across the South. But if a city's downtown is any measure of a place, urban renewal efforts and years of post-industrial decline have voided much of the economic and social vitality at Greensboro's core, including this old gas station. For more than sixty years, those pumps have been gone and nothing more than a large sheet metal awning has loomed over a cement lot beside a used appliance store. Now that efforts are underway to reinvest in downtown, the old-timers at the appliance shop are trying to sell out for $1.6 million with the lot advertised as parking. Set back and hovering without crowding the space, the awning is a striking and relatable street feature; well scaled to maintain a soft, pedestrian-friendly streetscape, its rust color tones are a bit nostalgic and a tad junky. No one would think twice about tearing down this aging infrastructure. Except in my mind, surrounded by bulldozers, contractors, and angry city officials, I'm yelling (totally coherently and convincingly, by the way), "This piece of trash is why we are here, it is why we are where we are, it is a sign of what we were and holds an important place for what we can become, and it is through its lingering, not despite its lingering, that we have grown toward our potential as a city!"

But the city's economic fantasies are stirred by the very same authenticity proposed in this architecture and its memory. History is everywhere, in fact and in plaque, from the tin ceilings of retail and coffee shops to the once segregated balcony of the local theater. Digestible modes of remembrance remain to salute an idea of progress that sets the stage for further gentrification. The common sentiment becomes that a city once composed by tremendous industry and historical action must have a legacy worthy of an urban future.

In that light, even an awning – a lingering piece of trash – must mean something. It is a monument for underdevelopment, a marker of a failed economy, a last vestige of a wild land-

scape facing further erasure. But speculators aim to obscure the power implicit in divestment – wash their collective hands of sixty years where we watched "paradise" slowly turn into parking lots. We let our downtown linger until just that moment when its most authentic beauty started to become visible and property values dipped low enough to inspire prospecting on an increasingly valuable social landscape. At the moment when beauty intersects decay and potential intersects depreciation, it becomes glaringly clear that the investors have us wrapped around their fingers, and a chorus of capital sings, "how junky," "how blighted," "how chic," "how bohemian," and how much parking is *still* needed.

Kitty corner from the extinct gas station is my grandmother's former store, which she ran from 1939 until 1997. It lived through the boom and bust of this downtown. Once an active surplus and workware store with a national mail-order business, it eventually became the junk store in an antique district that emerged in the late 1970s. Rather than compete with the antique sellers by moving inventory, my grandmother allowed her ever-increasing collection of things to pile high across all three floors. As a child, I hardly remember anything changing at the store. Everything pretty much lingered where it was from day to day, year to year. The immutable inertia of her store was constructed over decades of accumulation, absorption, and resistance to progress and commerce. For six years after her death, everything remained inside – just as she had left it.

In 2003, a group of artists and I began to transform the store into something else. Where most people saw a quagmire of trash, we saw a beautiful adventure, and the resources and space for further creation. We were prospectors, in a way. For us, the things were a necessary starting place rather than an impediment, a puzzle to be pieced together rather than a space to be cleared, a network of related artifacts rather than materials to be mined. Some of the original artist team argued that we should sell the objects, clear the building, place what we couldn't sell in boxes, store them away, and make *space* for artists to make work. They imagined studios, a bike repair shop, and a sewing collective.

Another contingent that included myself and co-founder Stephanie Sherman argued that we were faced with a historical happenstance, and that the collection should determine our direction like pieces of a puzzle, continually arranged and rearranged to make visible the concepts and communities that passed through. From this notion, we founded Elsewhere, a living museum and residency that invites artists to use the collection to create site-specific artworks, works that become part of the ever transforming museum. In a way, we chose to let things linger, to not presuppose their purpose or value, to resist inserting our ideas of what could be in place of what already was.

The action of lingering once related the affective values of a place, but the very language itself evolved to became an indicator of non-place. The fourteenth-century Middle English term *lenger* meant to dwell, abide, stay (in a place). By the sixteenth century, the term had come to suggest hesitation, delay, and dawdling. Through the linguistic morphology of two centuries the rooted overtones of a dwelling place and a place to dwell gave way to something more trivial, unsure, and tardy. Martin Heidegger (2001) alerts us to the same morphology in the German term *bauen*, building, which also holds the connotation of dwelling. Heidegger suggests that

the linguistic relation between building and dwelling denotes that, as human beings, it is in our nature to build and to dwell, and essential to our human character to erect buildings that are dwellings. If it is indeed true that at the interstices of our language and culture a basic character of our humanity is contained, then our way of inhabiting, building, and lingering in our world is as dwelling beings. This has become unfurled with the evolution of our language. We have become alienated from the buildings we construct, the environments we inhabit, precisely because we don't allow ourselves to dwell with what lingers.

At the corner of Arlington and Bragg Streets, about two blocks from Elsewhere, a small cove of trees defines a grassy lot beside the outskirts of Ole Asheboro, a historically Black neighborhood south of downtown. The empty field, tangled underbrush, and property fences signal a dividing line between downtown and its adjacent neighborhoods. On one side of Bragg Street, the Business Improvement District offers preferential zoning and developer incentives. On the other side, a neighborhood speaks to Greensboro's historic roots and the effects of an explicit and systematic divestment in the Black community's fabric. Along this boundary of investment and divestment, three multi-million dollar development projects are just breaking ground.

Set back against the trees and rising up from a field of wild grass, artist Heather Hart is creating a home for her "Porch Project: Black Lunch Tables." The work is an outdoor pavilion composed of five, tiered, pentagonal platforms with pentagon-shaped picnic tables at their center. The pavilion is loosely organized around the principles of sacred geometry, and theories of ideal conversational dynamics. As part of a series of public projects commissioned by Elsewhere with funds from ArtPlace America, "Porch Project: Black Lunch Tables" imposes a conversational infrastructure at the center of multiple development interests. Simply, it is a place for picnics and dining, a stage for performances, classes, and events situated on a plot of land with a wildness that serves to obscure the existence of clearly aligned socio-political boundaries.

"Porch Project: Black Lunch Tables" combines two of Hart's previous projects. "The Porch Project" is a series of sculptural works in the forms of roofs and porches that serve as social, performative, and dialogical platforms. The "Black Lunch Tables" project is an ongoing dialogic artwork begun in 2005 at Skowhegan by Hart and North Carolina-based artist Jina Valentine. Designed as a self-segregating conversation among artists of African descent, the project has evolved as an ongoing series of recorded conversations among Black artists. The emergence of #blacklivesmatter as a national conversation on White privilege and state violence transformed the "Black Lunch Tables" into integrated conversations focused on supporting the movement from an artistic center.

Combined, "The Porch Project Project" and "Black Lunch Tables" situate a potential conversation on the implicit power and forms of institutional racism that are operating at the center of multiple development interests. As a site-specific sculpture, it takes the lunchroom phenomenon of self-segregation as a starting point for reserving a place for communication among current neighbors that pre-empts a constructed neighborhood of new housing, university buildings, and an urban greenway. Without an accompanying house or building, the pavilion simply, and in an almost mournful way, holds the place and makes more visible an uncertain wildness of what this site could become. At the moment this is written, the project is too new, and the dis-

tance between communities too great, to anticipate whether the presence of this work at this geographical intersection will bring needed attention to the critical issues of social equity facing our community. The implicit power arrangements – availability of land, national foundation funding, and the city's ample support of Elsewhere, an organization made more secure and able to take risk by its White privilege – have made this project possible in the first place, but threaten to situate the work in the image of the encroacher rather than the encroached. Without a certain emergent social gravity toward the pavilion's use, this social sculpture may simply become another lingering sign of unbalanced development and a symbol of a conversation not being had.

Lingering serves both action and inaction. It is a way of waiting, of abiding, of dwelling, not a form of transition or stasis. The desires and threats embedded at these geographical and social boundaries linger with or without an awning, a museum, or a lunch table. In particular, they face the threats of increasing property values displacing home owners, White gentrification of a historically Black neighborhood, the disproportionate investment in downtown at the expense of adjacent communities, and the precarious and dangerous role of art, aesthetics, and urban design in changing the culture of a place *for* people and not *with* them. These forces of transformation are well underway. But everything that lingers holds a place for another – or counter – conversation. Buildings linger in disrepair like old trucks in a front yard. Bad feelings linger, as does the feeling of lost love. On the other hand, lovers linger to watch the movie credits just so they can sit longer with one another. A kiss lingers on lips, on the pale blue eyes of a lover. We linger to let excitement build, because there may be something to gain, learn, or prospect. Lingering is a mode of waiting that allows power to transform.

# SMALL ACTS, FORLORN PRACTICES

*Radhika Subramaniam*

*I*

Small acts have big mythologies. Despite their scale, they are accompanied by enduring beliefs in their capacity to have sustained and meaningful impact. The accumulation of small acts, across time and space, repeated and determined, can multiply and grow enough to topple the largest bastion. Individual pulsating energies can overcome their solitary directions to stand side by side, shoulder to shoulder, to fill the largest Tahrir or Taksim Square with a vast, almost invulnerable, force. Within this is what Elias Canetti (1978), in his wide-ranging analysis of the power of crowds, called the "discharge," the moment at which a cheek-by-jowl collective, still aware of its individual articulation, overcomes any caution over contact and becomes something else altogether: the crowd. Differences and hierarchies are shed in these proximities to form an inherently fragile yet potent phenomenon. Canetti's focus on this moment of transformation set him apart from his nineteenth-century precursors, such as Gustave Le Bon, with their theories of the violence of mobs, but it also set his work apart from that of those like George Rudé, whose repudiation of the likes of Le Bon was through a focus on the "faces" in the crowd. Canetti put his finger on the cusp of the movement from the inchoate teeming of an urban everyday to the charged power of a self-aware collective: a deeply psychological and kinesthetic experience of intimacy and loss of separation.

Democracy has its own mythic belief in the power of small act. The "one person one vote" formula of direct democracy carries with it the conviction that the outcome of this action, multiplied by its performers, has binding consequences. Through this process, the people speak as if with one voice. For the individual voter, the results can feel like a curious mixture of both individual and collective achievement – we did it! – or loss. Of course, there are those who refuse to vote because they are disabled by the belief that the process is rigged and others because they have been driven to the conclusion, rightly or wrongly, that political decision-making happens in some rarefied zone above them. Get-out-the-vote campaigns are directed against the lassitude of

the latter to impress upon them the assurance that their voice can and will be heard.

Yes, we believe that a great deal could hinge on … well, a hinge – or a nail. As the old nursery rhyme warns us, an entire kingdom was lost all for want of a horseshoe nail. In the rhyme, the impact of the nail's absence is methodically escalated by pointing out its significance for the horseshoe, the horse, the rider, the battle, all the way up to the kingdom, reminding us that a very small thing indeed has the potential to unseat history.

Small acts matter. How fervently we need to believe that! Google the term and you will get a glimpse of what many people perceive to be the way they work, and their value and power. Small acts of generosity go around in a kind of *kula* ring with small acts of kindness, both rippling outward with the potential of creating a larger world of reciprocity and goodwill.

This could be the background we need to understand artistic and political efforts and actions that are seemingly modest in scope. We need to believe that their modesty belies their ambition – that the ambition that rides on the promise that small acts of resistance will ultimately erode the foundations of the greatest edifice. Yet, no matter how well fortified one might be by the strength of this assurance, it seems to me that sometimes a small gesture is just that: small. By saying so, I don't mean to disparage these gestures; rather, I think that something else is going on in the finitude and quietness, as well as the ephemerality and intimacy, of such actions that bears consideration – something that is not easily recuperated as aggregative, targeted or, indeed, useful. These are acts that I call "forlorn:" acts that are a little diffuse, a little alone, that seem to go a little astray. What is the place of this kind of practice, and what is the labor if there is no function – political, aesthetic, affective – that it can be said to perform? Or, like Melville's notoriously recalcitrant scrivener, does it prefer not to?

## II

Since 2009, I have been involved in a public art/performance festival in New York City called "Art in Odd Places" (AiOP) (see http://www.artinoddplaces.org). Initiated and directed by artist Ed Woodham, the project takes place over several days in October along Manhattan's major thoroughfare, 14th Street, to celebrate, as we phrased it in 2009, "the odd, ordinary and ingenious in the spectacle of daily life." Through an open call process around a specific annual theme, guest curators for the year select artist proposals for performance or installation along the street, all adhering to AiOP's principles; that projects should not block pedestrians or traffic, and also that projects should move continually through crowds, not allowing them to gather. This seeming deference to public life actually stems from a more radical premise, which is the decision not to acquire any type of municipal or police permission for festival activity. Instead, artists are encouraged to find the apertures in public space regulations in an insistence that there are still parts of urban public life that remain unfettered and not subject to forms of control and surveillance. AiOP's political impulse was born in the pall cast on public life in the city and beyond in the years after 2001, as a result of tightening public space regulations.

I co-curated the festival with Erin Donnelly in 2009, and was the sole curator in 2013. In each edition, there were between thirty and sixty artists who participated, engaging the street in a range of pointed, poignant, light-hearted, and astute ways. In each edition, which had a

different theme (Sign in 2009 and Number in 2013) there were also a few artists whose projects were decidedly *forlorn*. Two of them adopted the form of extended solitary walkers bearing signs of strange ambiguity and melancholy. Two others employed forms of exchange that are rapidly turning obsolete, if they are not already so: letter writing and the placing of a telephone call through an exchange operator.

The first sign project was that of Bokyung Jun, who walked from Brooklyn to Manhattan and then along 14th Street in 2009 carrying a sign that said, "Life is Not Easy for Any of Us." Karen Elaine Spencer took up the same format in 2013, walking back and forth from one end of the street to the other, bearing a homemade sandwich board that said, "How many is too many?" What did the signs mean? In 2009, the United States was at the crest of a recession following the subprime mortgage and foreclosure crises, a desperate time when lines at the Department of Labor and Salvation Army offices along 14th Street, as well as its many closed storefronts, robbed the street of any veneer of urban insouciance.

Jun's work surely evoked these immediate experiences, but it was also inevitably universal – at any moment in time, one assumes, a city street might furnish a person inclined to respond in agreement to such a statement. It was a singular and direct address, one that expressed a kind of existential feeling in an empathetic, even solidary, way but not one that invited commiseration. The bearer of the sign walked by, the sign light and the burden heavy, and as some photographs taken on behalf of AiOP show, as just another figure in the middle of a zebra crossing amid a surge of fellow crossers.

Spencer's sign was more ambiguous. To what did it refer? It was left to the viewers to project their own preoccupations and answer the question. As she stood, carrying the somewhat shabby white cardboard sign with its big black letters, people would call out, "A trillion! One! Two! It depends." Occasionally, someone stopped to ask what it actually meant and Spencer would repeat the question, "How many is too many?" If they continued to wonder, she might gently suggest a context: homelessness. When she recounted her experience to me (also available on her website, http://www.likewritingwithwater.wordpress.com), she spoke of how one man, standing with his lunchtime sandwich, engaged her in conversation, his confusion persisting beyond her effort at clarification. Finally, she specified, "It's like saying one homeless person is one too many." "Ah," he took it in. As he left, he said to her, "I hope you find a home." Spencer thanked him. "Me too." She described herself as thrown by the way in which his kind wish actually seemed to render her homeless, revealing the little fear that lies curled within so many of us: will we ever find home? Will we ever belong somewhere?

Jun's sign was stenciled in black on a white background, but she carried it under her arm so that, at any given time, a few of its words were obscured. What people saw was a young Asian woman in jeans and sneakers, the casualness of the sign and her carriage implying, even assuring, that it could only be seen by a chance glance. This gave it a kind of intimacy as if it were only meant for the viewer – a sort of mute outreach from a fellow city dweller. Spencer's sign, on the other hand, was on cardboard, large and hand-drawn with words in different sizes, more explicitly reflecting the signage of the involuntary residents of the street. Undoubtedly, her appearance as a White woman with dark clothes, short, cropped hair, and sunglasses gave it a slightly per-

formative air, but the makeshift quality of the sign undercut the presentation, rendering it just "a little off." According to their reports, these were lonely and tiring performances. The artists' feet and legs hurt. Despite the large signs and the occasional interactions in Spencer's case, these projects did not invite conversational engagement. They snagged their audience in fleeting encounters, intentionally presenting themselves in that way.

In 2009, if you were waiting for a bus or woolgathering on a street corner on 14th Street, or about to push open the barred gate leading to the Our Lady of Guadalupe church, you might chance on an ornate envelope that indicated that it was meant for you, the finder: Take it. It's yours. It was written for you. Inside, on thick, beautiful paper, was a love letter. The letters were real or fictive epistles written by historical or famous queer people. Oscar wrote to Bosie, Alice to Gertrude, Sappho and Socrates to their lovers. This was Cyriaco Lopes' project, ironically titled "Big Bronze Statues," which was a counter-monument to the LGBTQ histories of Greenwich Village and Chelsea. Lopes sometimes included drawings and photographs, and worked with poet Terri Witek who wrote some of the fictional letters. There was no guarantee of who might find such a letter (I never did, and not for want of searching, although others were luckier), and there was no guarantee of its effect or impact; quite frankly, nor could one be sure about whether it was read through, treasured, or simply tossed. Lopes' letters mimicked the intimate public secrecy of gay life in New York, and in so much of the world, but enacted it in a wayward way. One could suppose a variety of lucky finders and readers – from someone ignorant of this history to someone delighting in the discovery, from the simply bemused to the offended – but most of this would have to occur in our imagination. However, for the person who chanced on it, it would reach out as a gift of love from the vast anonymous thrum of city life.

With a nod to Proust's magnum opus, LuLu LoLo's project in 2013 was called "Remembrance of Numbers Past." Dressed as a telephone operator circa 1950, LuLu was Operator Loretta standing at the street corner by an old-fashioned instrument complete with a cord and plug ready to insert into the switchboard, offering to connect any passer-by to a phone number in their past. The effect was startling. People otherwise tethered to their mobile phones took the invitation to step out into another dimension. They called their old girlfriends, Eric spoke to his late friend, Davidson called Kitty Carlisle, someone else called W. Somerset Maugham, and Angela rang her old landline on Ludlow, and spoke to them – or to their own pasts – in complete sincerity. Of course, it was patently obvious that the instrument was not connected to anything, nor was there a voice at the other end. In fact, the callers were asked to sign a consent form if they were willing to have their calls recorded for the artist's website so that the initial exchange was absolutely cut and dried. Yet, on a frantic New York street corner, a series of haunting and haunted conversations were conducted. The effort of summoning up an old number, still holding fast to a disused groove of memory, together with the operator's performance of connecting the call via switchboard, encouraged an involuntary suspension of disbelief. A caller who spoke to his father who had passed away said to Operator Loretta, "This was really cathartic."

*III*

In one of the marvelously idiosyncratic and insightful series of short prose texts collected as *One-Way Street*, Walter Benjamin (2004) states that, for effectiveness, one cannot rely on standard universal gestures. He is speaking of literary political effectiveness for which, he suggests, the pretentious gesture of the book is a limited solution. In fact, one must nurture inconspicuous forms such as leaflets, articles, and placards whose "promptness" makes them more equal to the moment. He continues, "Opinions are to the vast apparatus of social existence what oil is to machines: one does not go up to a turbine and pour machine oil over it; one applies a little to hidden spindles and joints that one has to know" (2004: 444). Herein lies the clue to understanding how these forlorn acts work. Solitary yet solidary, ambiguous yet expansive, melancholic yet precise, light yet profound, they labor at a level either below or between small acts. But they are not some sort of quotidian lubricant. Benjamin is more specific: the oil is applied to hidden parts that *one has to know*.

It is in this strangely psychic space that forlorn practices operate, creating intimate moments that are not readily apprehended but come to one as a sudden surprise. Yes, one is suddenly aware that life really isn't easy for any of us. At these moments lies the "discharge," that juncture at which there is a startling reduction of distance between people, of contact – a sensation of feeling directly addressed by the world – that often only remains as a trace in one's memory. Inconspicuous though it may be, it is indelible. Thus do forlorn acts get to the heart of the matter without which all is lost.

# Postscript: An Activist's Discourse

# POSTSCRIPT: AN ACTIVIST'S DISCOURSE

*Sheryl Oring*

In this concluding part, I explore the various inspirations for and the evolution of the "I Wish to Say" project with Svetlana Mintcheva, Director of Programs at the National Coalition Against Censorship in New York. The discussion begins by introducing "Writer's Block," an earlier work in which I collected hundreds of antique typewriters, "caged" them in metal rebar sculptures, and showed them on Bebelplatz, the site of the 1933 Nazi book burning in Berlin. We talk about how "I Wish to Say" grew out of "Writer's Block" and then move on to discuss other elements of the project.

This section concludes with images of projects that have grown out of "I Wish to Say." From "Collective Memory," a work commissioned by Bryant Park in New York City for the 10th anniversary of 9/11, to "Maueramt," a work done to mark the 25th anniversary of the fall of the Berlin Wall, a number of my recent works are based on the methodological framework developed with "I Wish to Say." The typewriter stands at the center of these new works, but in each case, the topics explored through public interactions are completely different. Each project has a distinct question that informs it. In "Collective Memory," I asked, "What would you like the world to remember about 9/11?" In "Alma Mater," a work commissioned in 2012 for the centennial celebration at the University of Memphis, I wanted to explore the future of the university, and asked students, faculty, and staff, "What do you think the university *could* be?" I first presented "Role Model" at the Art Prospect festival in St. Petersburg, Russia, in 2012. The project asked, "What can Russia teach the world?" In subsequent performances in Brazil and Dubai, the question was altered for the local audience. Meanwhile, "Travel Desk," a work developed during the period 2012–15 through a public art commission at the San Diego International Airport, started with a large-scale public performance that asked people to share their travel stories. Excerpts from these stories were later laser etched on the top of a twenty-foot-long table made from eucalyptus wood, which now serves as a central meeting place in the airport.

In 2014, I returned to Berlin and created "Maueramt," which examined public memories and views about the Berlin Wall some twenty-five years after its demise. Sue Day of England recalled:

> I can remember when the Wall came down. And I can always remember how unjust I thought it was, that a wall could be built across a city, and how people on either side of the wall must feel. Imagine if they put a wall in between us now – suddenly we couldn't see each other anymore. And something like that really must not happen again anywhere. And how I take my freedom for granted.

A representative of a much younger generation, my daughter Shira, age six at the time of the 2014 performance, said this: "Some people might ask how did they force the government to take it down – they went on the road and lots of people did it and the government went with it because they couldn't stand to hear all the shouting and see all the signs."

The power of having a say!

# Q&A:

## Q&A: Sheryl Oring and Svetlana Mintcheva

**Svetlana:** We first met when you were working on the "Writer's Block" project, then this evolved into "I Wish to Say." At what point did one project evolve into the other?

**Sheryl:** I made the "Writer's Block" installation in Germany as a tribute to the authors whose books were burned and then toured it to Budapest, Boston, and New York, and that's when we met. I was interested in showing "Writer's Block" in other places and through the Free Expression Network I met David Greene, who was running the First Amendment Project in Oakland. David was very interested in showing "Writer's Block" in the Bay Area – but it was expensive for them to ship it out from the East Coast. So he said, "Why don't you come to San Francisco and talk to us about it. But if you're going be here, and you have an idea for something else you'd want to do that doesn't have a very big budget, let me know."

I had been thinking about the idea of doing what ultimately became "I Wish to Say" for a while. It grew partly out of my experience in newspapers – the idea of the person-on-the-street interview. But there's a more personal connection as well. My grandmother was a secretary in the Political Science Department at the University of Maryland. She was the kind of secretary who always went to work dressed to the nines. When I was a kid, she let me go into her closet and into her jewelry boxes, her many jewelry boxes, and dress up when I visited. I think that is also one of the sources of the idea for this work. And I had been living in Berlin for six years and came back to the country and felt completely out of touch with the American public and what people were thinking about politics. Many things came together for me when I thought about going out onto the street with a typewriter and asking people what they'd like to say to the president. I should mention that "I Wish to Say" also came to be partly because I saw the movie *Central Station*. There's a woman sitting in the central train station in Rio taking dictation for people who are illiterate. I was drawn to the idea of a typist taking dictation of letters from strangers in a public space. That was another inspiration for the project.

**Svetlana:** What inspires you art-wise? Were you inspired by some other work?

**Sheryl:** One early inspiration was the work of Israeli

sculptor Micha Ullman, whose *Bibliothek* memorial on Berlin's Bebelplatz (the site of that city's Nazi book burnings) made a big impression on me. The memorial is a one-meter-square window that looks down into a room that is completely painted white, filled with empty bookshelves. I discovered this piece soon after I arrived in Berlin and I kept going back to it. I tried to think about what had happened at that site and it was definitely the inspiration for "Writer's Block."

And when I was living in Berlin, I met Christine Hill. I was collecting typewriters and doing this crazy project. She took me seriously in this way that made me think it was an okay thing to do. It's kind of surprising because I was nobody and she had already been in Documenta.

**Svetlana:** Which project of hers did you first see?

**Sheryl:** "Volksboutique," a project that Christine did in Berlin (and at Documenta) where she opened up a second-hand store as an art project. Soon after we met, I was telling her about *Writer's Block* and she really took it seriously. I think that was an important exchange early on when I was starting to make work.

**Svetlana:** That was before the sculptural project?

**Sheryl:** Yes, that was before "Writer's Block."

**Svetlana:** Because hers in a way is more similar to "I Wish to Say," the interactive project.

**Sheryl:** Some of the timing is a little bit hazy, because she was in Berlin and I was in Berlin, then we were both in Brooklyn, and she was working on the "Tour Guide" project, where she was creating tours of New York as an art project.

**Svetlana:** What's interesting about "I Wish to Say" is that you actually get really sincere human participation from people who do not share your political position. But also, they're not being demonized as the political other.

They're being understood and heard. It functions as a true democratic platform. And I'm curious how, in your interaction, you managed to keep that political neutrality?

**Sheryl:** That goes back to my training in journalism. I'm not sure journalists can ever be completely neutral or truly neutral, but I do think that journalism school taught me how to talk to people from different backgrounds. It also stems from my own biography. I grew up in a fairly liberal family in North Dakota, which is a pretty conservative place. We were used to interacting with people with different political viewpoints because we were the minority in my hometown.

**Svetlana:** I was also curious about the trust that people displayed, because if I see an artist coming with a project of social practice, I'll think that they'll probably come from a particular political position already. So, if I were a right-wing Republican, I might have a moment of distrust. But all these people trusted you. Do you think it's the costume? The kind of secretarial, and also motherly image. What created this kind of trust given the framing of it as an art project? Or did anyone realize it was an art project?

**Sheryl:** To the issue of trust: one thing I've noticed is that people really appreciate the effort that I go to in order to make these performances. I'm all dressed up, my hair is done up in this big style, I've got the makeup, and the clothes look really great and then I'm there with a typewriter. It's a little absurd. I think people appreciate the risk I'm taking of putting myself out there and doing this kind of project that they tend to put away some of their inhibitions. Maybe this is a tangential thing, but I have also had a number of people through the years tell me that it is very much like a therapy session – they feel so much better after they have participated. And I'll never forget this guy in Chicago, at one of the last shows, who had participated (I was taking photographs at that show), and he came down to where I was taking photographs and he said, "I just want you to know that I am a

better American because I participated in your project." And I said, "Thank you sir, thank you so much." I was busy taking photographs but he wouldn't go away and he kept repeating that. It was so important to him that I understand that he really felt changed by participating in this project. He felt like he had done his civic duty. He had really done something meaningful. Sometimes people ask me why I keep doing this, but tiny moments are the things that really make the project meaningful for me.

**Svetlana:** Do you have any other specific moments and encounters that you remember strongly?

**Sheryl:** There are a couple from 2004 that had to do with people whose family members were in the military. There was a mother from Arizona who sat down and she said, "Bring our children home," and signed it "Just one mother." And the other one was a young woman at McCarren Park in Brooklyn who said, "Bring my uncle home. My aunt needs him." They were about family members who were serving somewhere overseas in the military and it was very touching. And then there are *a lot* of cards that have to do with people sharing their views on healthcare and health issues in very personal ways.

**Svetlana:** How much faith do you have in the political process – of somebody who is in power actually changing things?

**Sheryl:** That's such a big question. Now that I've been doing it for twelve years, you can see some of the issues that people bring up starting to be addressed. Early on, when people would talk about healthcare issues, there was no Obamacare. So even though we can find a lot to criticize about Obamacare, there is some progress. I was at the gay pride parade in New York in 2004 taking dictation, and there were so many people talking about wanting to have gay marriage, and now it exists, so you see the evolution of things.

**Svetlana:** So there is a pulse on the ground that in a way is predictive of the political process.

**Sheryl:** It seems that way.

**Svetlana:** It seems like if there is enough communal will, something does move. Does this make you optimistic?

**Sheryl:** Well, I guess I couldn't be pessimistic and do this project, right, or I think I would quit. I have to maintain a certain level of optimism. I guess I am cautiously optimistic, let's say. There is also some optimism that comes from my work in the classroom – my students do inspire hope.

**Svetlana:** What happened in the evolution of the project? Because at first it was just you. And then it becomes a very different work when it becomes many performers and typists. And you're normally one of them too?

**Sheryl:** Yes. I'm normally one of the typists. Although not always. In this last version in Chicago, I was actually not typing. I was dressed up. But I was the one taking Polaroid photos of the people after they dictated their cards. As it changes, the logistics become much more complex – thinking through everything in terms of the set-up and how it actually works.

**Svetlana:** It becomes a kind of choreography almost?

**Sheryl:** Yes.

**Svetlana:** But is it a different work?

**Sheryl:** It's a different version. I haven't given it a different title. It definitely is an evolution, I think partly because I just want to do something different with it. In Spring 2016, I collaborated with the PEN World Voices Festival in New York and sixty students from the University of North Carolina at Greensboro to create the largest version of the project to date at Bryant Park.

Working with the students added an important element to the project and in some ways, it felt like it was coming into its own. The level of the students engagement was really remarkable.

**Svetlana:** I was thinking about social media and it actually occurred to me that you started this before the explosion of social media and digital activism. Did the project change with the advent of digital activism?

**Sheryl:** Well I do think that may be part of its popularity. And part of the reason it hasn't gone away is because of that: people do really appreciate human interaction and the listening – human listening – that is part of this project. Maybe the fact I'm still getting asked to do it twelve years after the project was launched has to do with that. I think people appreciate it because it is so grounded in the human exchange.

When I first started the project, by the way, there was no grand plan for this to become an ongoing project. I did shows in San Francisco and Oakland, and people were lining up to participate. It was kind of remarkable. People got in line and waited to send their letters to the president. At that point I had very little money, I had no funding, I had no real support. I met Stephanie Elizondo Griest, who had just published a book, and she was planning to do a book tour. She didn't drive, so she asked me if I would come with her and drive. And so we ended up helping each other out. She had organized readings at different bookstores across the Southwest and I tagged along and did a number of "I Wish to Say" shows, with very little organizational support. There were a couple of small, non-profit organizations that had me come in. But mostly I was just showing up and typing in different places. Then through that next summer of 2004, I was in New York during the Republican National Convention, and I happened to get a lot of press during the convention. I think that really helped.

After that, I got a grant from the New York Foundation for the Arts, and then after that, I got a grant from Creative Capital. Through Creative Capital, I met Dread Scott and Hasan Elahi – two people who have been really instrumental in supporting my work and helping me strategize about the work and figuring out how to grow it and keep it going. When I met Hasan, he started telling me, "You know, you should really be teaching." And so that started this whole different trajectory for me. I was living in New York, doing "I Wish to Say," and I had some funding, but I was still working full-time at that point in an architecture firm, which isn't necessarily unrelated, but not exactly what I wanted to be doing and so I left my job at Skidmore, Owings and Merrill in New York and moved to San Diego and did a Master of Fine Arts at the University of California, San Diego.

**Svetlana:** You mentioned Stephanie Elizondo Griest. Can we talk a little more about collaboration? Because for a lot of this project you have partners, you have amazing photo documentation and you have the other typists. Can you talk a little about your relationship with the photographers?

**Sheryl:** From the very first shows, I was taking Polaroids of some of the participants. Not all of them, I didn't ever have the logistics down enough to take every single person. Then when I got back to New York after the road trip with Stephanie, I met Damoso Reyes, a young photojournalist, who got very interested in the project and volunteered to be the photographer that summer. The photo material from that summer is quite astounding. He took candid photos that I think convey the essence of the show. I was really struck by that as I look back on them.

**Svetlana:** Yes, that's interesting because it makes very tangible the humanity of people behind what are primarily political communications. But you can see a real, feeling person there and also the diversity of participants is fantastic.

**Sheryl:** Then in 2005, Hurricane Katrina happened. I was living in New York and I felt compelled to document

the response to the situation in New Orleans. Not by going to New Orleans – I felt like it was too soon to go to New Orleans – but I knew I wanted to go someplace where some of the people from New Orleans were going. A friend of mine in New York suggested Memphis, and she put me in touch with a friend who taught at the University of Memphis. Then when I got there, this friend of a friend put me in touch with a photographer in case I needed photos of the shows. That was Dhanraj Emanuel – who has been photographing the shows ever since and eventually became my husband. When I met Dhanraj, he was on his way back to India. I had gotten the grant from Creative Capital, which was going to pay for me to go on this cross-country tour with "The Birthday Project" – sending birthday cards to President Bush. So Dhanraj was about to go home, and I said, "Hey, I've got this money for this really fabulous road trip, do you want to come with me and document the performances?" He agreed and we took a two-month road trip from Brooklyn to California and back.

**Svetlana:** What did you learn about America on this trip and throughout the project?

**Sheryl:** One thing is that you can never guess what someone's politics are going to be when you sit down and talk to them. Sometimes people surprise you with their political views, so I've learned to be open and not have preconceived notions about what someone might think.

**Svetlana:** So I'm going back to "Writer's Block," which was about the Nazi book burning. It was about the killing of democracy and censorship, and you continued the same use of the typewriter as a symbol of democratic participation. Where does that come in: the typewriter as an expression of democracy? I grew up in a totalitarian country where typewriters had a fingerprint and you could trace everybody's typewriter. And here you can speak anonymously. Is that leading to more participation? You look at people participating in elections, and

it's very low participation. But the people participating in your project – even though this is a postcard, not an election – they're willing and lining up to participate!

**Sheryl:** Yes. In an essay, political scientist David B. Holian writes about the idea of political efficacy and what it is that gets voters to actually participate. He says projects like "I Wish to Say" might actually contribute to voter participation. Is there a scientific study that's proved it? No. I haven't actually tracked things.

**Svetlana:** There is a need to be heard. And perhaps the participants in "I Wish to Say" felt that they were heard more with a person listening rather than through the political process where they don't think there's a person listening. When the votes are received, you have a certain configuration of powers that you are powerless to topple, but here you have somebody listening.

**Sheryl:** Yes. I think listening and presence are the crucial elements – that there's a person present there. There were a couple of times where I had exhibitions of the cards and photographs and left a typewriter in the space for people to type more cards. And people did participate, but the quality of the comments was noticeably different. I feel very strongly that the human presence has a huge effect and has made this project so successful. With the unattended typewriter, people were mouthing off – making flippant comments. The quality and tenor of what people said was very different.

**Svetlana:** How long do you think you'll be doing this for?

**Sheryl:** I will definitely be doing it in the 2016 election. There's part of me that thinks I'll do this every election season until I can't do it anymore. and part of me thinks it's time to pass it on to other people and free myself up to do some other projects.

**Svetlana:** "I Wish to Say" is a project of voices, of the

democratic clamor. With "Writer's Block," the typewriters were a project of silence.

**Sheryl:** It was about taking your voice away. But the typewriters were placed in this really dynamic way within these cages. It was clear that they were struggling to speak, they wanted to speak. So I'm not sure if it's actually silence or just the caged voice. Which is different.

**Svetlana:** Thinking of the caged voice, to what extent is a voice uncaged meaningful? We were talking about "I Wish to Say" as a kind of therapy, a kind of self-expression that is an end in itself and when you think of the typewriters of caged voices, of the empty bookshelves, it is about the arrest of meaning, the arrest of certain kind of meaningful conversation in the early twentieth century. And now are we back to meaning. You know, you look on the Internet and there is a clamor of voices – maybe too many voices. But is there meaning and consequence to them? Do you feel "I Wish to Say" is producing meaning beyond the need for personal self-expression and being heard on political subjects?

**Sheryl:** The most important thing for me is that moment of interaction. We were just at the Yoko Ono exhibition at MOMA. I think one of her strongest works is *Cut Piece*. But I'll never see the actual work. It was fleeting, ephemeral. I can only see the documentation. But I'm also drawn to her *Grapefruit* book of typewritten instructions. When you look at all my work – even "Writer's Block," massive steel sculptures – they've always been shown in an ephemeral way. When they were first shown, it was only for one day. There is something about the ephemeral that is really powerful for me – something about these fleeting interactions, something relating to memory. I think that the power is in these small moments. Not in some lasting thing. But then the way these small moments get remembered can be really powerful as well.

**Svetlana:** What does "I Wish to Say" do for you?

**Sheryl:** Why is giving voice to people important? I was thinking about that recently for many reasons. And I think that goes back to growing up. I think that girls often … and definitely I felt like I didn't really have a voice, or my voice wasn't important. There was a period in my life when I was growing up where I didn't really feel listened to. And so, I think that's where it comes from.

To be listened to has become really important to me. I want to be listened to and I also want to listen. One thing that people say when they participate is that they really feel heard. I think listening is such an important thing and not something that we always do in our daily lives. And then the other thing I think a lot about is questions – about asking questions. I see it all the time in my students. They're just sitting there; they don't ask any questions. And I get really upset about it. That probably goes back to my journalism training. I think that learning to ask questions, formulating thoughts through a question, figuring out what you think by asking questions is important. "If I were the president, what would you wish to say to me?" That was the founding question. If you could say anything to the president, what would you wish to say? So there is this question at the heart of the project.

Beyond that, "I Wish to Say" allows me to talk to a whole bunch of people who I would never get to talk to if I were just going about my regular life. One might think of the secretary role as a lowly profession, but to me, the secretary role is powerful. I think playing that role in a public way is fun. It allows you a sort of respite from reality. It's this little surreal, kind of playful thing.

**Svetlana:** It's interesting that you think of it as a respite from reality because it is grounded in the political.

**Sheryl:** Of course it is grounded in the political. But when I'm playing that role, it's also very fun.

**Svetlana:** I can understand that it's fun. You're leaving your social and political positioning and trying on another, which could be liberating.

**Sheryl:** Yes. And there is this interesting tension between the ephemeral and the more lasting elements of some of this. Like with "Writer's Block," you have these big steel things. They are very non-ephemeral, but then they have been shown for short amounts of time. So they also have some interesting connections with the text and with words, with books, with that idea of documentation. That definitely goes back to my training as a journalist, I'm sure.

**Svetlana:** Right, because a lot of performance is about the ephemeral. And sometimes that is not documented, but with your project the documentation is part of it.

**Sheryl:** Yes. We mentioned photography, and I also I keep a copy of the cards. I have a whole archive of the project, so there is a very almost journalistic or scientific side of the project.

**Svetlana:** It's a snapshot of time. It's not just a moment of interaction.

**Sheryl:** Yes. There are these conflicts, these tensions, but that's part of what makes it interesting. There is an ephemeral moment between me and this person dictating the card, but then of course, it's now part of this larger thing that has been going on for twelve years. It is like a historical archive and paints a different type of portrait. Here's another aspect that I thought about recently. As the Internet has become so prevalent and advertising revenue has gone away and newspapers have been cutting back, the media have definitely suffered, and the watchdog function of the press is in question. There aren't so many reporters anymore. Most newspapers don't have half the staff they had fifteen years ago when I was working in journalism. So it also plays a journalistic role.

**Svetlana:** If you read human-interest stories, they are typically little non-political things and then the political stories are about politicians. So there is the story about the presence of citizenship, but the individual's story within politics is just not being told.

**Sheryl:** It's just not there. And that was the motivation at the very start of the project: to try to talk to people who were not appearing in the press, or to tell the story of people who had no voice in the mainstream media. I think that has happened. I think the project has done that. Is there more the project can do? Absolutely.

**Svetlana:** Some of the criticism of social practice art is that it feeds into a kind of neo-liberal fiction of agency. Do you think about theory when you're doing this? Do you think about art as social practice or any of the critical debates around it?

**Sheryl:** I don't think about the theory when I'm making my work. But once you make it, you think about how people are going to categorize it.

**Svetlana:** The participants?

**Sheryl:** No. The participants don't care. But within an academic context, it is important to address how it fits in with the theorists' views of the world. I wanted this project to reach out to the broadest spectrum of participants, voices, and people. I didn't want it to be a highbrow thing. It was important to me to do it in locations where it was not just a set audience of gallery and museumgoers. I set the parameters fairly specifically, and whatever happens within those parameters I have nothing to do with. How does that fit a theoretical framework? What is the role of theory within this genre? Those are big questions.

**Svetlana:** Theory is a little like history – looking back and trying to make sense of what has already happened. Theory tries to look and define what is happening right now. It's in a way bound to failure because it is always

forcing a shape on something.

Let's get back to the importance of the question in your work. The question is a very interesting modality of knowledge. It's sharing what you don't know and expecting someone else to fill the gap. I don't think any other species would ask a question. They would communicate information, but not ask a question. A question expresses an awareness of a lack.

**Sheryl:** Having the confidence to ask a question means you're admitting that you don't know the answer. That's hard for a lot of people. I guess it must be my training as a journalist. The question is the core of that profession – asking questions. It's always stayed with me. I think that it's really important no matter what you do – to feel comfortable asking questions. That's what science is based on. I find that young people are not comfortable asking questions; they really shy away from it and don't want to admit that they don't have the answer.

In graduate school, I took a course from Haim Steinbach. He became known in the 1970s for his work with ordinary objects. He taught a seminar called "The Object" at the University of California, San Diego, for many years. In that seminar, you brought an object on the first day of class and the entire course was based around psychoanalyzing that object – asking questions, trying to understand in a really intense way. My object was the typewriter. It was a very frustrating but also super provocative course.

**Svetlana:** Frustrating how?

**Sheryl:** Because you sit for three hours and literally discuss one object.

**Svetlana:** That's great.

**Sheryl:** The class was brilliant. I was really interested in how the class was an extension of Haim's art practice. It was basically research for his art practice or a continu-

ation of his practice. I was really interested in that. So when I started teaching a graduate seminar at the University of North Carolina at Greensboro, I asked myself how would I extend my practice into the classroom? What would be so quintessentially me in my work that I could share with my students? And so I created this course that was called "In Search of the Quintessential Question." The whole course was about finding the questions in your work and your practice. I've taught it twice and I think it worked really well. The students got a lot out of it. You had to start with a list of questions and then make many revisions. You had to go out and find other artists who were dealing with similar questions and share how they went about handling their questions, and then go back and edit your questions. And then at the end of the course you had this really great list of questions about your practice. It helps students come to a deeper understanding of their work.

**Svetlana:** What are your questions?

**Sheryl:** The central one is, "What is the role of the artist in activating the public?" And then, beyond that, I have done a series of projects built around questions. With "Role Model," I asked, "What can Russia (and later Brazil and Dubai) teach the world?" With "Collective Memory," the question was, "What would you like the world to remember about 9/11?"

**Svetlana:** The project seems to be around the political process, but it's actually coming back to this: people's self-expression and listening and a kind of recognition that you become human with somebody listening. So in a way it's not really about politics, it's about individuals and interpersonal recognition.

**Sheryl:** It's political, but on a personal level.

**Svetlana:** I'm so surprised that people would have enough faith to write to the president. Or are they writ-

ing to you? I've never done a card and I wouldn't do one, because I don't think they'll read it. I wouldn't care to say anything to them.

**Sheryl:** Sometimes I do think people are just talking to me and it just happens to get sent to the White House. You never did one? Are you sure?

**Svetlana:** I never did one. Why would I speak to somebody who would never listen? Why would I write a card to a president?

**Sheryl:** You feel like nobody is listening, but I'm listening.

**Svetlana:** So they're talking to you.

**Sheryl:** Yes, I think they're talking to me.

**Svetlana:** Well, they are addressing it to the president.

**Sheryl:** Yes.

**Svetlana:** And for you it's the enjoying of the roles. Maybe it is for them too. It's kind of a temporary fictional space.

**Sheryl:** Right. You suspend reality in order to do this.

**Svetlana:** Or push it a little bit.

**Sheryl:** Yes.

**Svetlana:** Did you mail the postcards?

**Sheryl:** Yes. The project has had several iterations. At the beginning I gave people the original and a stamp and they took the stamped original with them and mailed it. Then there was a period of time when I collected the originals and sent them off all together. I partly did that because I wanted to scan the original before I mailed it

off instead of scanning the copy. Then I sent them all off in one bunch.

**Svetlana:** Did they reach their destination?

**Sheryl:** I never received a reply. In 2004, Peter Jennings did a report about my project and he actually called the White House and asked for a comment. They said that the correspondence was a private matter between the sender and the president so they wouldn't comment. I thought that was really funny.

**Svetlana:** When you sent them off together, did you include a cover letter explaining the project?

**Sheryl:** Yes, I put a letter and the cards. But I never received a response. Now I've gone back. I think the original method was more authentic. I like putting the stamped card in the hands of the person who dictated it and making them take that action to send it.

I wanted to explain a little bit about how "I Wish to Say" became a framework for other works and then also a little about issues of scale and my connections to architecture. I was living in New York when I started "I Wish to Say," and that was 2003–04. Then in 2005, I was invited to do a project at the Eldridge Street Project, which is in this old synagogue on the Lower East Side. It's an interesting location because it was once a Jewish neighborhood and now it's basically Chinatown. I did a project called "Writing Home" there. It had the same setup as "I Wish to Say." I wore 1960s attire, and I had a typewriter. But for this project, I asked people to dictate letters to their ancestors. People sat down and wrote letters to deceased ancestors and told them things they wished they had told them before they died. It was a very emotional project.

The event happened during a festival at the synagogue. There were neighborhood people and also people who were supporters of the synagogue. It was an interesting mix of people: Jews, Chinese, a lot of Asian immigrants. And that led to another version of that per-

formance at a place called the International Center of New York, which works with recent immigrants. So I did the same performance at the International Center with a group of very, very recent immigrants: people who had been in this country for maybe a couple of years from all backgrounds, all different countries. And it was a very emotional, intense exchange. People told stories they wanted their families back home to know, and some said things they wanted to say to other people that they were no longer able to see.

One person said, "I miss you, Dad. I regret all kinds of things. I should have visited Japan again before you died. I should have said to you, thank you ... Now I'm living in New York strongly because of you. I appreciate you."

Another person said, "Dear Father, It has been almost one year since I came to the United States. It is not easy to live here and understand, but I'm getting used to it. The lessons you taught me about truth are really precious."

In New York, I was working at the architecture firm Skidmore, Owings and Merrill (SOM), helping document the building of the World Trade Center. So I had already been thinking about scale for a number of years through my work at SOM. And then I went to graduate school at the University of California, San Diego (UCSD), in part to work with Teddy Cruz, who is an architect teaching in the Visual Arts Department. Teddy works at a different scale than SOM, more at the scale of the neighborhood, but still works at a scale larger than my little "I Wish to Say" table. So he and I were talking about issues of scale and impact and working in the public sphere. And I started thinking a lot about that. In 2010, I did my first large-scale version of "I Wish to Say" at UCSD. I worked with other graduate students as a typist and we did a special version for the University of California system. President Yudof was making cuts and raising tuition and doing all sorts of things that students were upset about. So I set up on campus with eight typists, and participants wrote letters to President Yudof. That was the first time that I had expanded the typist pool and it was part of an organized protest day on campus.

The project has attained a different type of scale with more than 2,500 cards typed over the past twelve years. Even though it's not scale in a physical sense, it's scale in a spectrum of time, which has a different weight than if I had just done this for a year.

And behind the typists there are a whole bunch of people – this network of free expression advocates that I got involved with when I was working on bringing "Writer's Block" to this country. But then there are all these other people too. Radhika Subramaniam presented the work really early on at one her conferences. And then sometimes the connections are so random. I met Miriam Schaer because I took a screen printing workshop at the Lower East Side Printshop because I wanted to screen print covers for an artist book based on "I Wish to Say."

**Svetlana:** That's what interests me about this idea of social practice art. Not so much the interaction with the audience, but also that to get a project going, because of the logistics, it involves a whole network of collaborators. So it becomes a collaborative social enterprise before it even comes to the intended target audience.

**Sheryl:** Absolutely. And that also takes time. I was recently rereading Pablo Helguera's book on socially engaged art where he talks about time as a factor, which is so true. You cannot do these projects quickly. If I hadn't actually already had the network of free speech advocates, if I hadn't made connections through prior work, then this work wouldn't have been as easy to start. Not that it was easy, but easier than if I were starting from scratch. And then, of course, over the years there have been so many other people who have come into the network.

**Svetlana:** And there are the logistics of public work.

Did you go through permission processes? Especially around political conventions? Those places are very contested and booked in advance.

**Sheryl:** I have to go back to "Writer's Block" to answer that. When I did "Writer's Block" in Berlin, I tried to do everything right and I applied for a permit and they didn't answer me for forever and finally someone told me off the record that it really scared them. The wall had fallen, but officials in this particular district were from East Germany and they were a little bit afraid of it because they considered it to be very political. Ultimately, they denied it.

What happened then? I knew someone at the *Berliner Zeitung* and that person wrote an article saying the city had denied my permit – and then the city changed its mind. So the power of the press really worked in that case. I had applied to have it on the site for at least ten days. And they gave me permission to have it there for one day. And I listened. I was so sleep deprived and not thinking straight and I was probably being too good at that point, but I installed this crazy massive thing that I had worked on for so long, and I took it down after a day. That was probably one big mistake. I should have left it for them to take it down. I should have just left it. What were they going to do – throw me in jail? What I learned was that it's better to ask for forgiveness than to ask for permission. That said, early on with "I Wish to Say," I still sometimes tried to ask for permission. And some places you couldn't do it if you didn't have permission. Like Bryant Park – I probably would've been kicked out if I hadn't gotten permission to do it. I had worked with Bryant Park for a really long time before I was invited to do "Writer's Block" there. That happened, and it went really well. It was in the *New York Times*; it got a lot of really good press. I think that experience convinced them that I was okay to work with. They've been very supportive.

**Svetlana:** Wait. I remember you went through a lot of negotiation.

**Sheryl:** Tons of negotiation.

**Svetlana:** Working with individuals and convincing them to do that, working behind the scenes.

**Sheryl:** Tons and tons of work. Tons of negotiating. At the beginning with Bryant Park, it took a lot of convincing.

But the other story I wanted to talk about was during 2004. When I was doing shows all over New York during the Republican National Convention. For those shows, I didn't get permission. I just set up wherever and if someone kicked me out, I moved. Mostly, I didn't get kicked out. Then I wanted to go to Boston where the Democrats were having their national convention, and I tried to get permission to set up in Cambridge Square. They also didn't answer for a long time and then they said no. They told me that if I could stand up and type, I could be there. I'm not sure why I have this trait, but when someone tells me "no," I'm more determined to find a way to do something. So I decided to go and figure it out. My photographer friend Damaso Reyes agreed to come with me. We went on the Chinatown bus from New York to Boston for twenty bucks or something. And what was on the square? Vendors – all these people sitting and selling stuff. So I sat down to type and it was very busy, lots of people waiting in line to participate. Then some cops came. They were watching me for a while and I was looking at them out of the corner of my eye, and I kept telling myself, "Just keep typing. Listen to the person and just focus on typing. Ignore the cops." So the cops waited for a really long time and then one came over and asked me what I was doing and I told him. And then he shook my hand and said, "If you ever need help in Boston, give me a call." And he gave me twenty dollars. It was so sweet.

Now I firmly believe that it's often better to just do things and then if someone tells you not to do them, you figure out how you're going to respond. Not always. I could not have done anything in Bryant Park without

permission – they would have kicked me out really quickly. So it depends on the location.

There was this laundromat on the Navajo Nation in Arizona, for instance, one of those self-serve laundromats with nobody working there. I set up and it was a little bit hard to start talking to people, I do remember that. People were a little suspicious. But then people started talking, and one by one they told the most amazing stories.

# "I WISH TO SAY:" SEQUELS

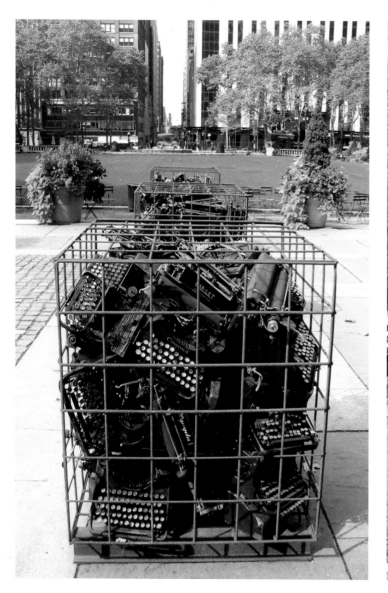

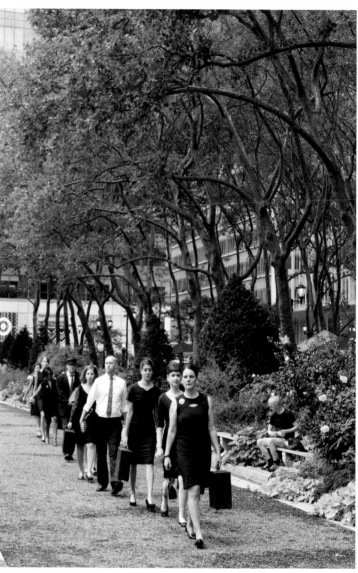

"Writer's Block" at Bryant Park in New York in 2003.
This work was first shown on Berlin's Bebelplabtz,
site of that city's Nazi book burning, then traveled to
Budapest, Boston and New York
*By Sheryl Oring*

In September 2011, Sheryl Oring led a crew of 10
typists in a performance commissioned by Bryant Park
to mark the 10th anniversary of 9/11.
*By Dhanraj Emanuel*

**194**

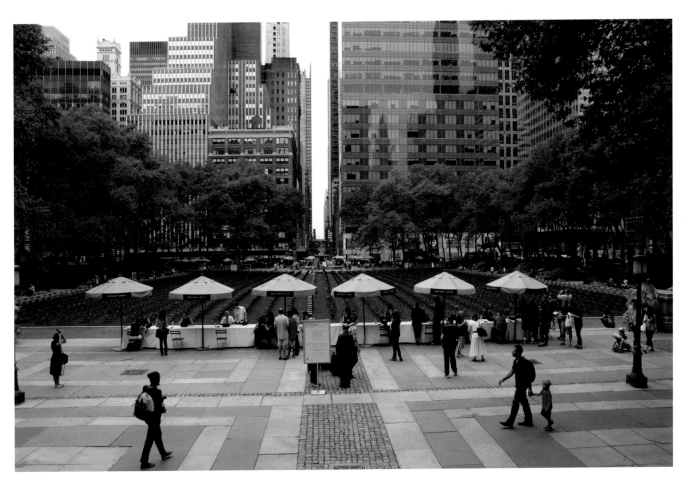

With the "Collective Memory" project, park visitors were asked: "What would you like the world to remember about 9/11?"
*By Dhanraj Emanuel*

SEP 0 9 2011

My daughter took her first steps
that night after I walked over
the 59th st bridge. My husband
said I have a surprise for you.
            --Susan
               Yonkers, NY

IMPORTANT

SEP 0 9 2011

The silver particles in the air
and the silence.

Ben Miller
New York City

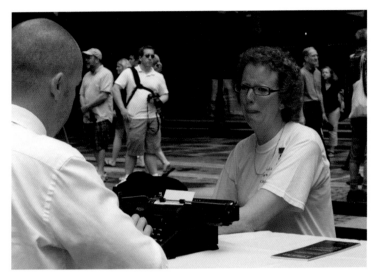

The "Collective Memory" performances recorded more than 300 messages about 9/11, including many emotional stories.

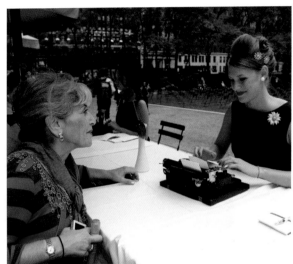

*By Dhanraj Emanuel*

After the New York performances, the "Collective Memory" cards were displayed at the Weatherspoon Art Museum at the University of North Carolina at Greensboro.
*By Dhanraj Emanuel*

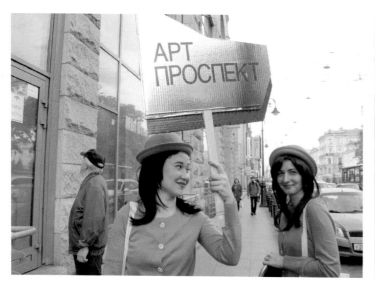

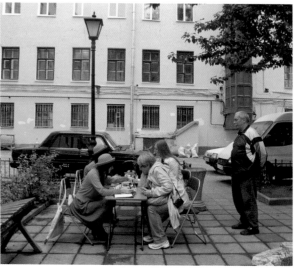

In Fall 2012, Sheryl Oring presented "Role Model" during the Art Prospect Festival in St. Petersburg, Russia. People were asked: "What can Russia teach the world?"
*By Sheryl Oring*

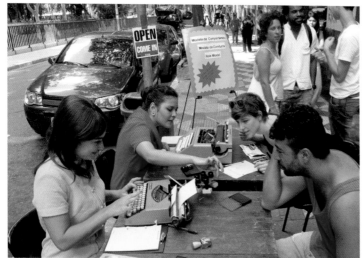

In early 2013, the "Role Model" project traveled to Brazil, where people on the streets of São Paulo were asked: "What can Brazil teach the world?"
*By Sheryl Oring*

l think deception and political
lawlessness. How to drink. You know
about the deep Russian soul, we can
teach to be a man with a Russian soul.

N.A. Zemlaynin

TRUE
COPY

SEP 22 2012

Suffering.

Vera Shvetsova

TRUE
COPY

2 2 СЕН 2012

Страдать.

Швецова Вера Александровна

КОПИЯ
ВЕРНА

## MEMORANDO

Nº _____

JAN 1 8 2013

De _____

Para _____

Magical fornication, Portuguese, derivatives of yucca root, coffee made in the style of Minas Gerais, "touch-touch", acai, ginga, Copacabana. Brazil has difficulties teaching things to the world, because it does not know how to teach its own people.

Teaching without academicism, emancipating education, an example: www.jardimequatorial.info

Ana Dupas

**urgente**

Modelo de Comportamento | Modelo de Conducta / Role Model
Encuentro 2013
São Paulo

TAMOIO
Boas Impressões

## MEMORANDO

Nº _____

JAN 1 8 2013

De _____

Para _____

Brazil can teach the world how to samba, the recipe for acai, positive spirits to live, breathe, make good caipirinha, generosity and diversity, hospitality, human heat.

**urgente**

Carolina and Ana

Modelo de Comportamento | Modelo de Conducta / Role Model
Encuentro 2013
São Paulo

TAMOIO
Boas Impressões

## MEMORANDO

Nº _____

De ANA DUPAS _____

Para O BRASIL _____

JAN 1 8 2013

Mandingo furnicação, português, derivados da mandioca, cafezin, mineirin, tóuc h-touch, açaí, ginga, Cop cabana.

O Brasil, está com dificuldade de ensinar coisas para o mundo, porque ele não sabe ensinar os próprios brasileiros.

Ensinar sem academiscismo, emancipar a educação, exemplo: www.jardim equatorial.info

Ana Dupas

**urgente**

TAMOIO
Boas Impressões

## MEMORANDO

Nº _____

De _____

Para _____

JAN 1 8 2013

O Brasil pode ensinar o mundo a sambar, a receita do açai, um espírito positivo para viver, respirar, fazer boas caipirinha generosidade e diversidade, hospitalidade calor humano.

**urgente**

Carolina e Ana

Do Portugal com Amor

TAMOIO
Boas Impressões

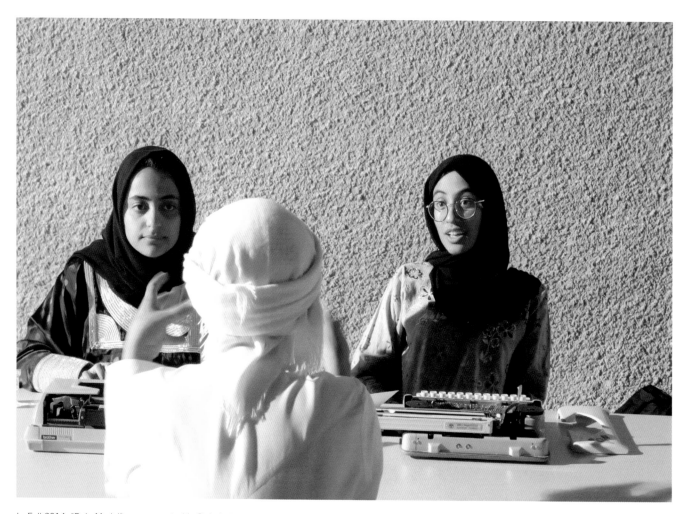

In Fall 2014, "Role Model" was presented in Dubai at
the International Symposium on Electronic Art.
*By Sheryl Oring*

No. 36

Determination.

ORIGINAL

Dimah Mahmoud Ph.D.
Sudan

0 4 NOV 2014

No. 36

الإراده.

ديمه محمود
السودان

ORIGINAL

0 4 NOV 2014

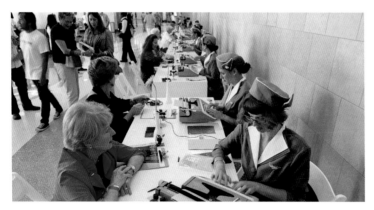

"Travel Desk" was created in 2013 as part of a public art commission at the San Diego International Airport. Visitors were asked to share a travel story, and comments were typed on manual typewriters.
*By Dhanraj Emanuel*

Excerpts from the travel stories shared in the performances were laser etched on the top of this 20-foot-long table designed by Jonathon R. Anderson and made from urban harvest sugar gum eucalyptus.
*By Mingzhao Dong*

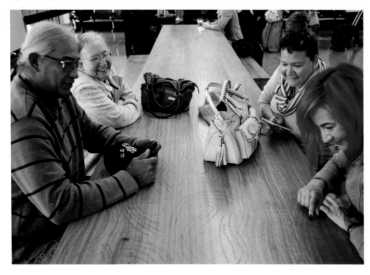

The table has become a meeting place at the San Diego International Airport.
*By Mingzhao Dong*

In Fall 2014, on the 25th anniversary of the fall of the Berlin Wall, Sheryl Oring set up her office at the Berlin Wall Memorial and invited people to share memories and stories about the Wall.
*By Dhanraj Emanuel*

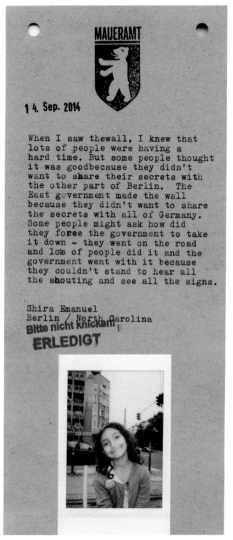

14. Sep. 2014

When I saw thewall, I knew that lots of people were having a hard time. But some people thought it was goodbecause they didn't want to share their secrets with the other part of Berlin. The East government made the wall because they didn't want to share the secrets with all of Germany. Some people might ask how did they force the government to take it down — they went on the road and lots of people did it and the government went with it because they couldn't stand to hear all the shouting and see all the signs.

Shira Emanuel
Berlin / North Carolina
Bitte nicht knicken!
ERLEDIGT

An exhibition at the Museum the Kennedys in Berlin featured stories about the wall and photographs of the people who shared them.
*By Dhanraj Emanuel*

# "I WISH TO SAY:" CHRONOLOGY AND CREDITS

Feb. 8, 2004
**Location:** The Canvas Cafe, San Francisco, California
**Presenter:** First Amendment Project
**Typist:** Sheryl Oring
**Assistant:** Leah Herman

Feb. 10, 2004
**Location:** Oakland Box Theater, Oakland, California
**Presenter:** First Amendment Project
**Typist:** Sheryl Oring
**Assistant:** Leah Herman

April 2, 2004
**Location:** University of Texas at Austin
**Typist:** Sheryl Oring
**Assistant:** Stephanie Elizondo Griest

April 4, 2004
**Location:** The town square in Mesilla, New Mexico

**Presenter:** Border Book Festival
**Typist:** Sheryl Oring
**Presenter:** Stephanie Elizondo Griest

April 6, 2004
**Location:** University of Texas at El Paso
**Typist:** Sheryl Oring
**Assistant:** Stephanie Elizondo Griest

April 10, 2004
**Location:** Laundromat at the Toh Nanees Dizi Shopping Center, Tuba City, Arizona
**Typist:** Sheryl Oring
**Assistant:** Stephanie Elizondo Griest

April 11, 2004
**Location:** Rest stop and truck stop along I-15 in Utah
**Typist:** Sheryl Oring
**Assistant:** Stephanie Elizondo Griest

April 11, 2004
**Location:** Las Vegas Strip
**Typist:** Sheryl Oring
**Assistant:** Stephanie Elizondo Griest

April 15, 2004
**Location:** Fresh Start Walnut Creek, Walnut Creek, California
**Presenter:** Fresh Start Walnut Creek
**Typist:** Sheryl Oring
**Assistant:** Stephanie Elizondo Griest

April 21, 2004
**Location:** San Julian Park, Los Angeles
**Presenter:** SRO Housing Corp.
**Typist:** Sheryl Oring
**Assistant:** Stephanie Elizondo Griest
**Photographer:** Dagmar Hovestädt

June 27, 2004
**Location:** PrideFest 2004,
New York, New York
**Typist:** Sheryl Oring
**Photographer:** Damaso Reyes

July 19 – 22, 2004
**Location:** Bryant Park, New York,
New York
**Typist:** Sheryl Oring
**Photographer:** Damaso Reyes

July 23, 2004
**Location:** Coffee House, Brooklyn,
New York
**Typist:** Sheryl Oring
**Photographer:** Damaso Reyes

July 25, 2004
**Location:** Central Square,
Cambridge, Masssachusetts
**Typist:** Sheryl Oring
**Photographer:** Damaso Reyes

July 26, 2004
**Location:** Wharf near Children's
Museum in Boston and Harvard
Square
**Typist:** Sheryl Oring
**Photographer:** Damaso Reyes

July 27, 2004
**Location:** Boston, Massachusetts,
at Democratic National Convention
ceremony for veterans
**Typist:** Sheryl Oring
**Photographer:** Damaso Reyes

Aug. 6, 2004
**Location:** Bryant Park, New York,
New York
**Typist:** Sheryl Oring

**Photographer:** Damaso Reyes
Aug. 17, 2004
**Location:** Foley Square, New York,
New York
**Presenter:** Creative Time
**Typist:** Sheryl Oring

Aug. 29, 2004
**Location:** McCarren Park,
Brooklyn, New York
**Typist:** Sheryl Oring
**Photographer:** Damaso Reyes

August 30, 2004
**Location:** Liberty Plaza and in front
of the Adam Clayton Powell Jr. State
Office Building, New York,
New York
**Typist:** Sheryl Oring
**Photographer:** Damaso Reyes

August 31, 2004
**Location:** Eighth Avenue, near
Republican National Convention,
New York, New York
**Typist:** Sheryl Oring
**Photographer:** Damaso Reyes

Sept. 1, 2004
**Location:** Foley Square and
near St. Mark's Church, New York,
New York
**Typist:** Sheryl Oring
**Photographer:** Brian Palmer

Sept. 13, 2004
**Location:** Junno's, New York,
New York
**Typist:** Sheryl Oring
**Photographer:** Damaso Reyes

Sept. 30, 2004
**Location:** Georgia State University,
Atlanta, Georgia
**Presenter:** Cathy Byrd, Georgia
State University
**Typist:** Sheryl Oring
Photographer: Sarah Barrick

Oct. 1, 2004
**Location:** New York Is Book
Country, New York, New York
**Presenter:** National Coalition
Against Censorship
**Typist:** Sheryl Oring
**Assistant:** April Lynch

Oct. 17, 2004
**Location:** Madiera Beach, Florida
**Typist:** Sheryl Oring
**Assistant:** Kate Bernier Carpenter

Oct. 18, 2004
**Location:** Tampa, Florida
**Typist:** Sheryl Oring
**Assistant:** Kate Bernier Carpenter

Oct. 24, 2004
**Location:** New Haven, Connecticut
**Typist:** Sheryl Oring
**Presenter:** New Haven Council for
the Arts

Nov. 1, 2004
**Location:** Delray Beach, Florida
**Typist:** Sheryl Oring
**Presenter:** Americans Coming
Together
**Assistant:** Kate Bernier Carpenter

Nov. 5, 2004
**Location:** First Friday in St.
Petersburg, Florida

**Typist:** Sheryl Oring
**Assistant:** Kate Bernier Carpenter
Jan. 20, 2005
**Location:** McPherson Square,
Washington, D.C.
**Presenter:** American Civil Liberties
Union, D.C. chapter
**Typist:** Sheryl Oring
**Assistant:** Kate Bernier Carpenter

March 17, 2005
**Location:** Rotunda Gallery,
Brooklyn, New York
**Presenter:** Project Diversity
**Typist:** Sheryl Oring

Sept. 9 & 11, 2005
**Location:** South Street Seaport,
New York, New York
**Presenter:** Lower Manhattan
Cultural Council
**Typist:** Sheryl Oring

Sept. 17 & 20, 2005
**Location:** Memphis, Tennessee
**Presenter:** University of Memphis
**Typist:** Sheryl Oring
**Photographer:** Dhanraj Emanuel

Sept. 25, 2005
**Location:** CultureFest, New York,
New York
**Presenter:** Lower Manhattan
Cultural Council
**Typist:** Sheryl Oring

April 10, 2006
**Location:** Immigration rally at City
Hall Park, New York, New York
**Typist:** Sheryl Oring
**Photographer:** Damaso Reyes

May 27, 2006
**Location:** Prospect Park, Brooklyn,
New York
**Typist:** Sheryl Oring
**Photographer:** Dhanraj Emanuel

June 4, 2006
**Location:** Circle City Flea Market,
Indianapolis, Indiana
**Typist:** Sheryl Oring
**Photographer:** Dhanraj Emanuel

June 11, 2006
**Location:** Flea market at North
Carolina State Fairgrounds, Raleigh,
North Carolina
**Typist:** Sheryl Oring
**Photographer:** Dhanraj Emanuel

June 15, 2006
**Location:** Fun-Lan Swap Shop,
Tampa, Florida
**Typist:** Sheryl Oring
**Photographer:** Dhanraj Emanuel

June 18, 2006
**Location:** Traders Village Flea
Market, Houston, Texas
**Typist:** Sheryl Oring
**Photographer:** Dhanraj Emanuel

June 22, 2006
**Location:** Valley Junction Farmers
Market, Des Moines, Iowa
**Typist:** Sheryl Oring
**Photographer:** Dhanraj Emanuel

June 25, 2006
**Location:** Flea market, New Mexico
State Fairgrounds, Albuquerque,
New Mexico

**Typist:** Sheryl Oring
**Photographer:** Dhanraj Emanuel

July 2, 2006
**Location:** Yosemite National Park
**Typist:** Sheryl Oring
**Photographer:** Dhanraj Emanuel

Sept. 29, 2007
**Location:** Brooklyn, New York
**Presenter:** Brooklyn Arts Council
**Typist:** Sheryl Oring
**Photographer:** Dhanraj Emanuel

Feb. 21 & 22, 2008
**Location:** College Art Association
conference, Dallas, Texas
**Typist:** Sheryl Oring
**Photographer:** Dhanraj Emanuel

March 17, 2008
**Location:** State University of New
York - Fredonia
**Typist:** Sheryl Oring
**Photographer:** Dhanraj Emanuel

March 27, 2008
**Location:** Salisbury University,
Maryland
**Typist:** Sheryl Oring
**Photographer:** Dhanraj Emanuel

April 7, 2008
**Location:** Miami University, Ohio
**Typist:** Sheryl Oring
**Photographer:** Dhanraj Emanuel

April 18, 2008
**Location:** Oakland, California
**Presenter:** First Amendment
Project

**Typist:** Sheryl Oring
**Photographer:** Dhanraj Emanuel

April 19, 2008
**Location:** The Embarcadero, San Francisco, California
**Presenter:** First Amendment Project
**Typist:** Sheryl Oring
**Photographer:** Dhanraj Emanuel

April 22, 2008
**Location:** St. Mary's College
**Typist:** Sheryl Oring
**Photographer:** Dhanraj Emanuel

April 23, 2008
**Location:** Monterrey Institute for International Studies
**Typist:** Sheryl Oring
**Photographer:** Dhanraj Emanuel

April 26, 2008
**Location:** Venice Beach Boardwalk, Venice, California
**Typist:** Sheryl Oring
**Photographer:** Dhanraj Emanuel
**Videographer:** Dagmar Hovestädt

April 28, 2008
**Location:** Pitzer College
**Typist:** Sheryl Oring
**Photographer:** Dhanraj Emanuel

April 30, 2008
**Location:** Northern Arizona University
**Typist:** Sheryl Oring
Photographer: Dhanraj Emanuel

May 19 & 20, 2008
**Location:** Bryant Park, New York, New York
**Typist:** Sheryl Oring
**Photographer:** Dhanraj Emanuel

June 7, 2008
**Location:** Printer's Row Bookfair, Chicago, Illinois
**Presenter:** McCormick Freedom Museum
**Typist:** Sheryl Oring
**Photographer:** Dhanraj Emanuel

June 8, 2008
**Location:** Michigan Avenue, Chicago, Illinois
**Presenter:** McCormick Freedom Museum
**Typist:** Sheryl Oring
**Photographer:** Dhanraj Emanuel

Sept. 25, 2008
**Location:** Wichita State University, Wichita, Kansas
**Typist:** Sheryl Oring
**Photographer:** Dhanraj Emanuel

Oct. 1, 2008
**Location:** Belmont University, Nashville, Tennessee
**Typist:** Sheryl Oring
**Photographer:** Dhanraj Emanuel

Oct. 2, 2008
**Location:** Victoria College, Victoria, Texas
**Typist:** Sheryl Oring
**Photographer:** Dhanraj Emanuel

Oct. 27, 2008
**Location:** Muhlenberg College, Allentown, Pennsylvania
**Typist:** Sheryl Oring
**Photographer:** Dhanraj Emanuel

Nov. 15, 2008
**Location:** McCormick Freedom Museum, Chicago, Illinois
**Typist:** Sheryl Oring
**Photographer:** Dhanraj Emanuel

Nov. 21, 2008
**Location:** Longwood University, Farmville, Virginia
**Typist:** Sheryl Oring
**Photographer:** Dhanraj Emanuel

Dec. 5, 2008
**Location:** University of California, San Diego
**Typist:** Sheryl Oring
**Photographer:** Dhanraj Emanuel

May 1, 2010
**Location:** Downtown San Diego, California
**Typist:** Sheryl Oring

June 10, 2010
**Location:** San Diego Museum of Art
**Typists:** Sheryl Oring and Jessica Sledge
**Photographer:** Dhanraj Emanuel

September 17, 2010
**Location:** 01SJ Biennial, San Jose, California
**Typists:** Stephanie Lee and Sheryl Oring
**Photographer:** Dhanraj Emanuel

June 16, 2011
**Location:** Americans for the Arts convention, San Diego, California
**Typist:** Sheryl Oring

September 3, 2012
**Location:** In front of the Bechtler Museum of Modern Art, Charlotte, North Carolina, during the Democratic National Convention
**Presenter:** Arts & Science Council of Charlotte-Mecklenburg
**Typists:** Polly Adkins, Corey Dzenko, Joanna Hardman, Caitlen Nelis Masters, and Sheryl Oring
**Stylist:** Kristina Hardin
**Photographer:** Dhanraj Emanuel

July 25 & 26, 2015
**Location:** Wicker Park Fest, Chicago, Illinois
**Presenter:** Carron Little, Out of Site festival
**Typists:** Amy Sayre Baptista, Jessica Kearney, Caroline Macon, Nora Sharp, and Shane Zimmer
**Assistants:** Amy Sinclair, Kevin Sparrow
**Photographers:** Dhanraj Emanuel and Sheryl Oring
**Videographer:** Laura Mitchell
**Stylist:** Mark Bazant

April 27, 2016
**Location:** Bryant Park, New York, New York
**Presenter:** Bryant Park and PEN World Voices Festival
**Artist/Project Manager:** Sheryl Oring
**Assistant Managers:** April Lynch, Hans Tester

**Volunteer Coordinator:** Julia Caston
**Producers:** Adam Carlin, Madelynn Poulson
**Project Assistant:** Sherrill Roland
**Political Consultant:** David B. Holian
**Typists:** Jasmine Best, Haley Blake-Lee, Ashley Boyer, Adrian Brune, Patty Burd, Haley Chilton, Olivia Coward, Therry Cromratie, Teresa Dale, Corey Dzenko, Dylan Edwards, Gabrielle Esperdy, Madison Forbes, Seanan Forbes, Morgan Goodwin, Amy Gottlieb, Ashley Hallenbeck, Sammie Harrill, Mal Harrison, Karen Heuler, Amelia Howerton, Scarlet Jovin-Fisher, LuLu LoLo, Mary Martinez, Yasmeen Mjalli, Ebony Nicholson, Jessica Otten, Alta Price, Kelly Rambo, Kendra Rasmussen, Dafne Sanchez, Hailee Shepherd, Samantha Sillaman, Andrea Springs, Maren Stange, Mirland Terlonge, Diego Vergara, Carolyn Zezima, John Zindar
**Typist Trainers:** Ashley Boyer, Corey Dzenko, Mary Martinez, Kendra Rasmussen, Hailee Shepherd
**Stylist:** Antonia Troiano
**News Hawkers:** McKenzie Bagwell, Corina Brown, Sierra Clark, Andrew Duke, Jamee Grossman, Hallie Tyner
**Communications Director:** Barbara DeLollis
**Social Media Coordinator:** Charles Williams
**Social Media Assistants:** Ebony Hogan, Tamesha Squire, Jamie

Waynick
**Photographers:** Christopher Burleson, Christian Carter-Ross, Quinn Hunter, Jiyoung Park, Lena Rodriguez, Randall Whitney
**Videographers:** Olivia Bond, Merve Kayan, Bradley Scott Rosen
**Audio:** Caley Monahon-Ward
**Video Assistants:** Alexis Michelle, Dingling Zhong
**Readings Coordinators:** Robert Rose and Hans Tester
**Readers:** Carol Bergman, Jan Castro, Anne-Marie Cusson, Madelynn Poulson, Hans Tester, Katherine Wessling
**Production / Sound Assistant:** Todd Turner
**Team Leaders:** Christopher Burleson, Quinn Hunter, Carley Kimzey, Nicole Moore, Diego Vergara
**General Volunteers:** Brianna Abrams, McKenzie Bagwell, Jasmine Best, Corina Brown, Hailey Chilton, Olivia Coward, Therry Cromratie, Teresa Dale, Dylan Edwards, Madison Forbes, Morgan Goodwin, Jamee Grossman, Ashley Hallenbeck, Sammie Harrill, Amelia Howerton, Kayla Huante, Scarlet Jovin-Fisher, Andrew Kennedy, Ian Miller, Ebony Nicholson, Jessica Otten, Kelly Rambo, Dafne Sanchez, Andrea Springs, Hallie Tyner
**Typewriter repairs:** Scott Scherzer, Carolina Office Machines, Greensboro, North Carolina

# ENDNOTES

### Taking a Moment to Have a Say

1   Most participants wrote to the then-president Barack Obama. A few participants composed their notes in the future tense and addressed Hillary Clinton as though she had won the Democratic Party's nomination and the subsequent general election.

2   While the vast majority of Oring's secretaries are women, men have occasionally served as typists in her projects. For example, two of the ten typists in "Collective Memory" were men.

3   In 1973, at the Wadsworth Atheneum, Ukeles conducted some – though not all – of the Maintenance events she proposed in her manifesto.

4   Although critics often describe how many participatory artworks emphasize the relationships between people over aesthetic concerns, we can understand a "lack" of aesthetics as a motivated aesthetic decision itself. Oring's detailed attention to visuals counters the frequently casual look of many social works.

### Chapter 13: Toward a Sociability of Objects

1   More recently Kester has borrowed the phrase "the intellectual baroque" from Jacques Derrida to describe this aesthetic distance in post-structuralist discourse. He has also extended his critique to include transformations in the Frankfurt School after 1940 (see Kester 2011: 14 for the former; and Kester 2015 for the latter).

2   Kester borrows the shift towards dialog from Habermas, though retooled towards empathy to address the more recent feminists' criticisms of Habermas' insistence on rational persuasion (see Kester 2004: 16). The question remains open whether or not this transformation of Habermas' theory does not in fact lead directly back to his critique of Adorno, ultimately opening the door to the idealist aesthetics he is trying to work around; for more on the Habermas' critique of Adorno, see Morris (1997: 755–87).

3   In his more recent work, Kester has begun to address precisely these kinds of issues. See, for example, his analysis of the work of Mumbai artist Navjot Altaf and Kondagaon artists Rajkumar, Shantibai, and Gessuram, in Kester (2011: 86–7), where the creation of objects and the reframing of the social forms within which those objects are produced and circulated are crucial aspects of the work.

4   For a sociological critique of the meaning of objects, see Bourdieu (1984).

### Chapter 16: Free Speech in a Digital Era

1   *Southeastern Promotions, Ltd. v. Conrad*, 420 U.S. 546, 557 (1974). ("Each medium of expression, of course, must be assessed for First Amendment purposes by standards suited to it, for each may present its own problems."); Red Lion Broadcasting Corp. v. Federal Communications Commission, 395 U.S. 367, 386 (1969) ("[D]ifferences in the characteristics of new media justify differences in the First Amendment standards applied to them."); Joseph Burstyn, Inc. v. Wilson, 343 U.S. 495, 503 (1952) ("Each method tends to present its own peculiar problems").

2   "But the basic principles of freedom of speech and the press, like the First Amendment's command, do not vary. Those principles, as they have frequently been enunciated by this Court, make freedom of expression the rule." Joseph Burstyn, Inc. v. Wilson, 343 U.S. 495, 503 (1952).

3   Joseph Burstyn, Inc., 343 U.S. 495, 502 (1952) (overruling Mutual Film Corp. v. Industrial Commission, 236 U.S. 230 (1915)).

4   Red Lion Broadcasting Corp. v. Federal Communications Commission, 395 U.S. 367 (1969).

5   Reno v. American Civil Liberties Union, 521 U.S. 844 (1997).

### Chapter 17: Efficacy, Trust, and the Future of Civic Engagement

1   The ANES did not begin surveying American public opinion during midterm election years until 1954.

2   The data displayed in all three figures are from the American National Election Studies cumulative file. The lines represent the percentage of Americans agreeing with the statement displayed in each figure's title. In each case, agreement represents low internal (Figure 17.1) or external (Figures 17.2 and 17.3) efficacy. There are gaps between the lines in each figure for two reasons. First, the statement displayed in Figure 17.1 was not included in the 2004 ANES, hence the gap in Figure 17.1 between 2000 and 2008. Second, the potential responses to each statement changed in 1988, hence the gap in each figure after 1984. From 1952 to 1984, respondents could only agree or disagree with the statements. From 1988 on, respondents were given a third option: they could express neutrality by neither agreeing nor disagreeing. The practical effect of this change is that, beginning in 1988, some percentage of respondents who chose to "neither agree nor disagree" would have selected "agree" had the third choice been unavailable to them. Therefore, the percentage agreeing from 1988 to 2012 is artificially depressed relative to the earlier time period.

3   While the trend is clearly downward, this is not necessarily the case for the level of internal efficacy relative to the period before 1988. See note 2 for details.

4   The 37 percent turnout rate in the 2014 midterm elections, and the generally anemic turnout – often less than 20 percent – in local, off-year elections are another story.

# BIBLIOGRAPHY

Abramson, Paul R. and John H. Aldrich. 1982. "The decline of electoral participation in America." *American Political Science Review*, 76(3), pp. 502–21.

Adriani, Goetz, Winfried Konnertz, and Karin Thomas. 1979. *Joseph Beuys: Life and Works*. New York: Woodbury.

Atlas, Caron, R. Lena Richardson and Carlton Turner. 2011. "Who will carry the work forward?" In *Bridge Conversations: People Who Live and Work in Multiple Worlds*. Brooklyn, NY: Arts & Democracy Project.

Barthes, Roland. 1972. *Mythologies*. New York: Hill and Wang.

—— 1981. *Camera Lucida*. London: Vintage.

Benjamin, Walter. 1969. *Illuminations*. New York: Schocken

—— 1970. "The author as producer." *New Left Review*, July–August (original speech from 1934).

—— 2004. "One-way street." In *Walter Benjamin: Selected Writings Volume 1, 1913–1926*. Edited by Marcus Bullock and Michael W. Jennings. Cambridge, MA: Harvard University Press.

Beronä, David A. 2003. 'Wordless novels in woodcuts." *Print Quarterly*, 20(1), pp. 61–73.

Bishop, Claire. 2006. *Participation*. London and Cambridge, MA: Whitechapel and MIT Press.

—— 2012. *Artificial Hells: Participatory Art and the Politics of Spectatorship*. London and New York: Verso.

Bourdieu, Pierre. 1984. *Distinction: A Social Critique of the Judgment of Taste*. Translated by Richard Nice. Cambridge, MA: Harvard University Press.

Cage, John. 1961. *Silence: Lectures and Writings*. Middletown, CT: Wesleyan University Press.

Campbell, Angus, Gerald Gurin, and Warren E. Miller. 1954. *The Voter Decides*. Evanston, IL: Row, Peterson, and Co.

Canetti, Elias. 1978. *Crowds and Power*. New York: The Seabury Press.

Chandler, Annmarie and Noris Neumark (eds). 2005. *At a Distance: Precursors to Art and Activism on the Internet*. Cambridge, MA: MIT Press.

Collins, Bradford R. 1991. "Report from Charleston." *Art in America*, November, pp. 65–71.

Costello, Diarmuid and Margaret Iversen (eds). 2010. *Photography After Conceptual Art*. West

Sussex, UK: Wiley-Blackwell.

Crow, Thomas. 2005. "Vision and Performance." In *The Rise of the Sixties: American and European Art in the Era of Dissent*. New Haven: Yale University Press, pp. 105–34.

De Zegher, Catherine (ed.). 1998. *Martha Rosler: Positions in the Life World*. Cambridge, MA: MIT Press.

Doherty, Claire (ed.). 2015. *Public Art (Now): Out of Time, Out of Place*. London: Art Books.

—— 2008. "Public art as situation: Towards an aesthetics of the wrong place in contemporary art practice in commissioning." In Jan Debbaut (ed.), *Out of the Studio! Art and Public Space*. Brussels: Hasselt, http://ebook-aktuell.com/22000816-ebook-out-of-the-studio-a-symposium-on-art-and-public-space-by-jan-debbaut-download-pdf-mobi-free.html. Accessed February 20, 2015.

Edelman, Murray. 1995. *From Art to Politics: How Artistic Creations Shape Political Conceptions*. Chicago: University of Chicago Press.

Edwards III, George C. 2011. *Why the Electoral College is Bad for America*, 2nd ed. New Haven, CT: Yale University Press.

Enwezor, Okwui. 2004. "The artist as producer in times of crisis," lecture at the European Cultural Conference, "Almost," Utrecht, April 15.

—— 2009. *Archive Fever: Uses of the Document in Contemporary Art*. New York: International Center for Photography.

Finkelpearl, Tom. 2013. *What We Made: Conversations on Art and Social Cooperation*. Durham, NC: Duke University Press.

Fonseca, Felicia. 2015. "Navajo families receive electricity for the first time." *Salon*, April 14, http://www.salon.com/2014/04/13/navajo_families_receive_electricity_for_first_time. Accessed January 19, 2016.

Fried, Michael. 1998 [1967]. "Art and Objecthood." In *Art and Objecthood: Essays and Reviews*. Chicago: University of Chicago Press, pp. 148–72.

Frieling, Rudolf and Boris Groys (eds). 2008. *The Art of Participation: 1950 to Now*. New York: Thames and Hudson.

Gaulke, Cheri. 2011. *Doin' It In Public: Feminism and Art at the Women's Building*. Los Angeles: Otis College of Art and Design.

Harder, Joshua and Jon A. Krosnick. 2008. "Why do people vote? A psychological analysis of the causes of voter turnout." *Journal of Social Issues*, 64(3), pp. 525–49.

Harvey, David. 2005. *A Brief History of Neoliberalism*. Oxford: Oxford University Press.

Heartfield, John. 1977. *Photomontages of the Nazi Period*. New York: Universe Books.

Heartney, Eleanor. 1997. "Report from Charleston." *Art in America*, December, pp. 33–37.

—— 2002. "Report from Charleston." *Art in America*, December, pp. 69–71.

—— 2005. "Artists in the city: Engagement with the urban environment and the local public was the theme of this year's Istanbul Biennial." *Art in America*, December, pp. 54–57.

Heidegger, Martin. 2001. Poetry, Language, Thought. New York: HarperCollins.

Helguera, Pablo. 2011. *Education for Socially Engaged Art*. New York: Jorge Pinto Books.

hooks, bell. 1995. *Art on My Mind: Visual Politics*. New York: The New Press.

Jameson, Frederic. 1982. "Postmodernism and Consumer Society." In Hal Foster (ed.), *The*

*Anti-Aesthetic: Essays on Postmodern Culture*. New York: The New Press, pp. 127–44.

Jones, Amelia. 2012. "The Now and the Has Been: Paradoxes of Live Art in History." In Amelia Jones and Adrian Heathfield (eds), *Perform, Repeat, Record: Live Art in History* Bristol/Chicago: Intellect/University of Chicago Press, pp. 9–25.

Kaye, Harvey J. 2006. *Thomas Paine and the Promise of America*. New York: Hill and Wang.

Kester, Grant H. 2004. *Conversation Pieces: Community and Communication in Modern Art*. Berkeley, CA: University of California Press.

—— 2005. "Eminent domain: Art and the public sphere in America." In Amelia Jones (ed.), *A Companion to Contemporary Art Since 1945*. Oxford: Blackwell.

—— 2011. *The One and the Many: Contemporary Collaborative Art in a Global Context*. Durham, NC: Duke University Press.

—— 2015. "On the Relationship between Theory and Practice in Socially Engaged Art." http://www.abladeofgrass.org/fertile-ground/between-theory-and-practice/. Accessed July 29, 2015.

Klin, Richard. 2011. *Something to Say: Thoughts on Art and Politics in America*. Teaticket, Massachusetts: Leapfrog Press.

Kwon, Miwon. 1997. "For Hamburg: Public Art and Urban Identities." In Christian Philipp Muller (ed.), *Kunst Auf Schritt und Tritt*. Hamburg: Kellner.

—— 2004. *One Place after Another: Site-Specific Art and Locational Identity*. Cambridge, MA: MIT Press.

Lacy, Suzanne. 2010. *Leaving Art: Writings on Performance, Politics, and Publics, 1974–2007*. Durham, NC: Duke University Press.

Lane, Robert E. 1959. *Political Life: Why People Get Involved in Politics*. Glencoe, IL: The Free Press.

Lederach, John Paul. 2005. *The Moral Imagination: The Art and Soul of Building Peace*. New York: Oxford University Press.

Lippard, Lucy. 1984. *Get the Message? A Decade of Art for Social Change*. New York: E.P. Dutton.

—— 1998. *The Lure of the Local: Senses of Place in a Multicentered Society*. New York: The New Press.

Morris, Martin. 1997. "The Paradigm Shift to Communication and the Eclipse of the Object." South Atlantic Quarterly, 96(4), pp. 755–87.

—— 2001. *Rethinking the Communicative Turn: Adorno, Habermas, and the Problem of Communicative Freedom*. New York: State University of New York Press.

Oliver, James A. 2010. *The Pamphleteers: The Birth of Journalism*. London: Information Architects.

Oring, Sheryl. *I Wish to Say*, http://www.sheryloring.org/i-wish-to-say. Accessed June 16, 2015.

Pound, Ezra and Ernest Fenollosa. 1967. *Instigations of Ezra Pound*. New York: Books for Libraries Press.

Roberts, Sam. "Striking Change in Bedford-Stuyvesant as the White Population Soars." *New York Times*, August 4, 2011. http://www.nytimes.com/2011/08/05/nyregion/in-bedford-stuyvesant-a-black-stronghold-a-growing-pool-of-whites.html?_r=0. Accessed June 6, 2016.

Sharoni, Sari. 2012. "e-citizenship: Trust in Government, Political Efficacy, and Political Partici-
pation in the Internet Era." *Electronic Media & Politics*, 1(8), pp. 119–35.

Sholette, Gregory. 2011. *Dark Matter: Art and Politics in the Age of Enterprise Culture*. London:
Pluto Press.

—— 2013. *It's the Political Economy, Stupid: The Global Financial Crisis in Art and Theory*.
London: Pluto Press.

—— n.d. *A Collectography of PAD/D: Political Art Documentation and Distribution: A 1980s
Activist Art and Networking Collective*. http://www.gregorysholette.com/wp-content/up-
loads/2011/04/14_collectography1.pdf. Accessed April 20, 2016.

Sligh, Clarissa. 1989. *Reading Dick and Jane with Me*. http://clarissasligh.com/themes/identity/
reading-dick-jane. Accessed April 20, 2016.

—— 2011. *Wrongly Bodied Two*. http://clarissasligh.com/themes/identity/wrongly-bodied-two.
Accessed April 20, 2016.

Spieker, Sven. 2008. *The Big Archive: Art From Bureaucracy*. Cambridge, MA: MIT Press.

Stein, Gertrude. 2000. *Stanzas in Meditation*. Los Angeles: Sun & Moon Press.

Stimson, Blake and Gregory Sholette (eds). 2007. *Collectivism After Modernism: The Art of
Social Imagination After 1945*. Minneapolis: University of Minnesota Press.

Takala, Pilvi. 2006. *Easy Rider*. https://vimeo.com/124031385. 25. Accessed June 21, 2016.

Taylor, Paul. 2008. "Hans Haacke: The Art of Politics." *Flash Art,* July/September, pp. 145–47.
(Reprinted from issue no. 126, 1986.)

Thompson, Nato (ed.). 2012. *Living as Form: Socially Engaged Art from 1991–2011*. London
and Cambridge, MA: Whitechapel and MIT Press.

Thompson, Nato and Gregory Sholette (eds). 2004. *The Interventionists: Users' Manuel for the
Creative Disruption of Everyday Life*. Cambridge, MA: MIT Press.

Thompson, Wendy. 2000. "Woodcut book illustration in Renaissance Italy: The First Illustrated
Books." In *Heilbrunn Timeline of Art History*. New York: The Metropolitan Museum of Art.
http://www.metmuseum.org/toah/hd/wifb/hd_wifb.htm. Accessed March 20, 2016.

Ukeles, Mierle Laderman. 1969. "For Maintenance Art: Proposal for an Exhibition 'CARE,'"
http://www.feldmangallery.com/media/pdfs/Ukeles_MANIFESTO.pdf. Accessed
June 16, 2015.

—— 1998. "25 Years Later," *Mierle Laderman Ukeles: Matrix,* 137 (September 20–November
15, 1998), http://thewadsworth.org/wp-content/uploads/2011/06/Matrix-137.pdf. Accessed
June 16, 2015.

Verba, Sidney and Norman H. Nie. 1987. *Participation in America: Political Equality and Social
Equality*. Chicago: University of Chicago Press.

Vermeulen, Timotheus and Robin van der Akker. 2010. "Notes on Metamodernism." *Jour-
nal of Aesthetics & Culture*, 2, http://www.aestheticsandculture.net/index.php/jac/article/
view/5677/6304. Accessed August 8, 2011.

White, Michelle and Nato Thompson. 2009. "Curator as Producer." *Art Lies,* 59, http://archive.
turbulence.org/blog/2008/09/05/curator-as-producer-michelle-white-nato-thompson. Ac-
cessed 20 February, 2016.

Ziegler, Ulf Erdmann. 1997. "Report from Munster." *Art in America*, December, pp. 32–39.

# ABOUT THE CONTRIBUTORS

**Bill Anthes** is a professor in the Art Field Group at Pitzer College, where he teaches and writes about contemporary art in terms of multimedia practice and intercultural and interspecies exchange. He is the author, most recently, of *Edgar Heap of Birds* (Duke University Press, 2015). He was a contributing author to the textbook *Reframing Photography: Theory and Practice*, by Rebekah Modrak (Routledge, 2011). He has received fellowships and awards from the Georgia O'Keeffe Museum Research Center, the Center for the Arts in Society at Carnegie Mellon University, the Rockefeller Foundation/ Smithsonian Center for Folklife and Cultural Heritage, and the Creative Capital/Warhol Foundation Arts Writers Grant Program. He lives in Pomona, California.

**Chloë Bass** is a conceptual artist focusing on the co-creation of performances, situations, installations, and publications, all dedicated to deep questioning of the everyday. Her current project, *The Book of Everyday Instruction* (2015–17), is an investigation into one-on-one social interaction. She holds a BA in theater studies from Yale University and an MFA in performance and interactive media arts from Brooklyn College CUNY. Bass is based in New York City, where she was born and raised. You can learn more about her projects and writing at chloebass.com; she welcomes correspondence (and questions) at info@chloebass.com.

**Sarah Shun-lien Bynum** is the author of two novels, *Ms. Hempel Chronicles* (Houghton Mifflin Harcourt, 2008), a finalist for the 2009 PEN/Faulkner Award, and *Madeleine Is Sleeping* (Harcourt, 2004), a finalist for the 2004 National Book Award and winner of the Janet Heidinger Kafka Prize. Her fiction has appeared in many magazines and anthologies, including the *New Yorker, Ploughshares, Tin House,* the *Georgia Review*, and the *Best American Short Stories 2004, 2009,* and *2016.* The recipient of a Whiting Writers' Award and an NEA Fellowship, she was named one of "20 Under 40" fiction writers by the *New Yorker.* She lives in Los Angeles.

**Teddy Cruz** is known internationally for his urban research on the Tijuana/San Diego border, advancing border neighborhoods as sites of cultural production from which to rethink urban policy, affordable housing, and civic infrastructure. His honors include the Rome Prize in Architecture in 1991, the Ford Foundation Visionaries Award in 2011, and the 2013 Architecture Award from the U.S. Academy of Arts and Letters. His architectural and artistic work has been exhibited nationally and internationally in venues such as the Venice Architecture Biennale and the Museum of Modern Art in New York. Cruz is Professor of Public Culture and Urbanism at the University of California, San Diego, where he is Founding co-director of the Center for Urban Ecologies and the Blum Cross-Border Initiative.

**Ricardo Dominguez** is a co-founder of the Electronic Disturbance Theater (EDT), a group that developed virtual sit-in technologies in solidarity with the Zapatistas communities in Chiapas, Mexico, in 1998. His recent Electronic Disturbance Theater 2.0/b.a.n.g. lab project (http://bang.transreal.org) with Brett Stalbaum, Micha Cardenas, Amy Sara Carroll, and Elle Mehrmand, the Transborder Immigrant Tool (a GPS cell phone safety net tool for crossing the Mexico–United States border), was the winner of the Transnational Communities Award (2008), funded by Cultural Contact in Mexico. Dominguez is an Associate Professor in the Visual Arts Department at the University of California, San Diego.

**Corey Dzenko** is an Assistant Professor of Art History at Monmouth University. Her research interests include contemporary art history and theory; the history and theories of photography and expanded/new media; art as an agent of social change; and ideologies of identity. She earned her PhD in Art History from the University of New Mexico and was a Visiting Fellow at the University of Nottingham in 2014. Dzenko has presented her work at various national and international conferences, and has publications included in *Men and Masculinities*, *Afterimage: The Journal of Media Arts and Cultural Criticism*, and the anthology *Gravity in Art*.

**Santiago Echeverry** is a Colombian new media and digital artist with a background in film and television production. Thanks to a Fulbright Grant, he received his master's degree from the Interactive Telecommunications Program at New York University. He moved to the United States in 2003 to teach interactivity at the University of Maryland, Baltimore County, then relocated to Florida in Fall 2005 to teach Digital Arts and Interactive Media at the University of Tampa. He started exhibiting internationally in 1992, and his research interests are non-linear narration, video art, performance art, interactive design, creative code, and web experimentation.

**Dhanraj Emanuel** is originally from India. He comes from a long line of photographers, including his father, uncle, and grandfather. Influenced by the vibrant streetscapes of India, light, color, and texture are the building blocks of his photographs. He began his photographic career shooting for editorial and advertising clients in India. He moved to the United States to pursue an MFA at the University of Memphis. His work focuses on issues of immigration, assimilation, and social cohesion. A frequent contributor to the *Washington Post* and the *Wall Street Journal*, Emanuel is based in Greensboro, North Carolina, and teaches at Randolph Community College.

**Hasan Elahi** is an artist working with issues in surveillance, privacy, migration, citizenship, technology, and the challenges of borders. His work has been presented in numerous exhibitions at venues and events such as SITE Santa Fe, Centre Georges Pompidou, Sundance Film Festival, and the Venice Biennale. Elahi has spoken at the Tate Modern, the American Association of Artificial Intelligence, the International Association of Privacy Professionals, TED Global, and the World Economic Forum. His work is frequently seen in the media, and has been covered by the *New York Times*, *Forbes*, and *Wired*, and has appeared on Al Jazeera, Fox News, and the *Colbert Report*. Elahi, who received a Guggenheim Fellowship in 2016, is an Associate Professor of Art at the University of Maryland, roughly equidistant from the CIA, FBI, and NSA headquarters.

**David Greene**, Senior Staff Attorney and Civil Liberties Director at the Electronic Frontier Foundation in San Francisco, has significant experience litigating First Amendment issues, and is one of the country's leading advocates for, and commentators on, freedom of expression in the arts. Greene was a founding member of the Internet Free Expression Alliance, and has served on the Northern California Society for Professional Journalists Freedom of Information Committee, the steering committee of the Free Expression Network, and advisory boards for several arts and free speech organizations across the country. Before joining EFF, he was the Executive Director and Lead Staff Counsel for the

Oakland-based First Amendment Project. He is a 1991 graduate of Duke University School of Law.

**Stephanie Elizondo Griest** is the author of the travel memoirs *Around the Bloc: My Life in Moscow, Beijing, and Havana* (Villard/Random House, 2004) and *Mexican Enough: My Life Between the Borderlines* (Washington Square Press/Simon & Schuster, 2008), along with the best-selling guidebook *100 Places Every Woman Should Go* (Traveller's Tales, 2007). She has also written for the *New York Times,* the *Washington Post, The Believer,* and *Oxford American,* and she edited *The Best Women's Travel Writing 2010* (Traveller's Tales, 2010). Her reportage on the U.S. borderlands won a Margolis Award for Social Justice Reporting and will be published as an essay collection called *All the Agents & Saints* by UNC Press in 2017. She is Assistant Professor of Creative Nonfiction at the University of North Carolina at Chapel Hill.

**David B. Holian** is an Associate Professor of Political Science at the University of North Carolina at Greensboro. His research interests include presidential rhetoric and campaigns and elections on the local and national levels. His research has appeared in a variety of journals including *Political Behavior, American Politics Research, Presidential Studies Quarterly, Legislative Studies Quarterly,* and *Urban Affairs Review.* He is the co-author (with Charles L. Prysby) of *Candidate Character Traits in Presidential Elections* (Routledge, 2014). Holian teaches courses on American institutions, including the presidency, Congress, and the mass media.

**Kemi Ilesanmi** is the Executive Director of The Laundromat Project (The LP), which brings arts, artists, and arts programming into public spaces to amplify the creativity that already exists within communities. Prior to joining The LP, she was Director of Grants and Services at the Creative Capital Foundation and visual arts curator at the Walker Art Center. She is on the boards of EMC Arts and NOCD-NY, and an alumna of Smith College, New York University and Coro Leadership New York. She is inspired by the immense possibilities for joy and social impact at the intersection of arts, justice, and community.

**Svetlana Mintcheva** is Director of Programs at the National Coalition Against Censorship, a forty-one-year-old alliance of U.S. national non-profit organizations. She is the founding director of NCAC's Arts Advocacy Program, the only U.S. national initiative devoted to the arts and free expression today. Mintcheva has written on emerging trends in censorship, organized public discussions and mobilized support for individual artists. She is the co-editor of *Censoring Culture: Contemporary Threats to Free Expression* (New Press, 2006). An academic as well as an activist, Mintcheva has taught literature and critical theory at the University of Sofia, Bulgaria, and at Duke University, North Carolina, from which she received her PhD in Critical Theory in 1999. She teaches part time at New York University. Her current research focuses on ethics, censorship, and the notion of "offense."

**Miriam Schaer** (http://www.miriamschaer.com) is a multimedia book artist based in Brooklyn, New York, and a Lecturer in the Art & Art History Department at Columbia College, Chicago. She exhibits extensively and is represented in numerous public and private collections, including those of Yale and Harvard Universities and the Brooklyn Museum. Her work has earned a New York Foundation for the Arts Fellowship, inclusion in the Elizabeth A. Sackler Center for the Feminist Art Base at the Brooklyn Museum, and representation at the Cheongju International Craft Biennale in South Korea. Schaer, who is a 2016-17 Fulbright Fellow in the Republic of Georgia, has taught book structure and printmaking at several universities and art centers in the United States and abroad. She is a frequent speaker at conferences devoted to education and the arts. Her most recent book is *The Presence of Their Absence* (Ariadne's Thread, 2015).

**George Scheer** is co-founder and director of Elsewhere, a living museum and artist residency set in a former thrift store in Greensboro, North Carolina. Scheer is a writer, scholar, and artist who fosters creative communities at the intersection of aesthetics and social change. Other projects include Kulturpark, a public investigation of an abandoned amusement park in East Berlin, and South Elm Projects, a curated series of place-based public art commissions in downtown Greensboro. He holds an MA in Critical Theory and Visual Culture from Duke University and is pursuing a PhD in Communication and Performance Studies, writing about the cultural economy of art and urbanism.

**Edward Sterrett** is an art historian whose work focuses on early modern European art, as well as twentieth- and twenty-first-century American art. He recently completed his PhD in the Visual Arts Department at the University of California, San Diego, and currently works as a Research Assistant at the Getty Research Institute in Los Angeles, where he is conducting research on the rise of the American art market at the turn of the twentieth century. Much of his work focuses on theories of reception, particularly with respect to situating models of aesthetic experience within their historical and material contexts.

**Radhika Subramaniam** is a curator and researcher interested in urban crises and surprises, particularly crowds, cultures of catastrophe, and human–animal relationships. She is Director/Chief Curator of the Sheila C. Johnson Design Center (SJDC) at Parsons School of Design/The New School, where she teaches. She was the Director of Cultural Programs at the Lower Manhattan Cultural Council and the founding executive editor of an interdisciplinary journal, *Connect: Art.Politics.Theory. Practice*. She was the SEED Foundation teaching fellow in urban studies at the San Francisco Art Institute (2012) and an artist-in-residence at The Banff Centre (2014). She has a master's degree in Anthropology and a PhD in Performance Studies.

**Lee Walton** is an experiential artist and educator who reframes social and individual experience through chance operations and rule-based interventions. His work takes many forms and utilizes the language of popular culture and contemporary media to activate and engage broad publics. Walton works with museums, institutions, universities, and cities around the world to develop participatory public events, lead workshops, exhibit, and educate. Walton is an Associate Professor of Art at the University of North Carolina at Greensboro and Director of Social Practice

**Ed Woodham** has been active in community art, education, and civic interventions across media and culture for over twenty-five years. Responding to constriction of civil liberties, Woodham created the project ""Art in Odd Places" presenting visual and performance art to reclaim public spaces in New York City and beyond. In New York, Woodham teaches "City as Site: Public Art as Social Intervention" at the School of Visual Art, as well as workshops in politically based public performance at New York University's Hemispheric Institute's EMERGENYC. He was a 2013 Blade of Grass Fellow in Social Engagement. For Summer 2014, Woodham was selected for the drawing shed residency IdeasFromElse[W]here to create a performance at Lloyd Park in East London. Currently, he is working on a commissioned work, "The Keepers," for 2016 in his longtime neighborhood of Gowanus, Brooklyn.

## THE PHOTOGRAPHERS

**Sarah Barrick** graduated *summa cum laude* with a presidential award and the Ernest G. Welch Undergraduate Photographer of the Year award from Georgia State University in 2005. In 2007, she traveled westward and planted roots in Seattle where she currently resides and works as an artist and a yogi. The peaceful beauty of the Pacific Northwest fuels her nature-inspired meditative modern art works, which strive to amplify and honor our divine connection with one another, with Mother Earth, and with the universe at large. Her work can be found in local shops and galleries in Seattle and online at www.sarahbarrick.com.

**Christian Carter-Ross** was born and raised in Winston-Salem, North Carolina. Carter-Ross, who graduated with a Bachelor's degree in Studio Art from the University of North Carolina in 2016, is now based in Greensboro, North Carolina. Predominantly a documentary photographer, his clients include the San Francisco Chronicle, a host of Greensboro-based venues and organizations, and the University of North Carolina at Greensboro.

**Mingzhao Dong** was born in China and spent the first seventeen years of his life there. He is now based in San Diego. Primarily a documentary photographer, Dong's upbringing offers him a unique perspective on the world. He understands the East better than most westerners and the West better than most easterners. Dong's clients include the New Children's Museum in San Diego, a number of California-based artists and the University of Memphis. He graduated from the University of California, San Diego, with a degree in Media Arts in 2011. His work may be seen online at http://mingzhaodong.com.

**Dagmar Hovestädt** grew up in a small town in western Germany. She studied communication and political science in Mainz (Germany), Boulder (Colorado), and Berlin, graduating with an MA in 1991. A TV journalist by trade, she worked in post-unification Germany throughout the 1990s as an investigative reporter for public broadcasting. Throughout the 00s she freelanced as a producer-reporter for German television from Los Angeles. In 2011, she became the spokeswoman for the Federal Commissioner of the Stasi Records in Berlin.

**Brian Palmer** is an independent visual journalist living in Richmond, Virginia, where he is producing *Make the Ground Talk,* a documentary that evokes life in a historic Black community that was uprooted during World War II. Before going freelance in 2002, Palmer served in a number of staff positions—photographer, assistant editor, Beijing bureau chief (*US News & World Report*); writer (*Fortune*); correspondent (CNN). Palmer was awarded a Ford Foundation grant for *Full Disclosure,* a documentary about his three embeds in Iraq with U.S. Marines. He is currently the *Newsday*/David Laventhol Visiting Professor of Journalism at Columbia Journalism School.

**Jiyoung Park** was born in South Korea and moved to the United States when she was fourteen years old. Park is based in Greensboro, North Carolina, where she is pursuing a double major in New Media and Design, and International and Global Arts and Belief Systems. She is also minoring in Media Studies, at the University of North Carolina at Greensboro.

**Damaso Reyes** was born and raised in Brooklyn, New York, and has been a photojournalist for over fifteen years. His credits include: The *New York Times*, the Associated Press, the *Wall Street Journal*, the *Miami Herald*, the *San Francisco Chronicle*, the *Christian Science Monitor*, and *Der Spiegel*. His projects have taken him to Rwanda, Indonesia, Tanzania, and throughout the United States and Europe. Reyes is also a Fulbright scholar and a Senior Fellow at the World Policy Institute focusing on migration. He is the principal photographer on "The Europeans" a documentary project examining the changes that Europe and its people are experiencing.

## THE EDITOR

**Sheryl Oring** examines critical social issues through projects that incorporate old and new media to tell stories, examine public opinion, and foster open exchange. Using tools typically employed by journalists (the camera, the typewriter, the pen, the interview, and the archive), she builds on experience in her former profession to create installations, performances, artist books, and Internet-based works. Oring has shown her work at the O1SJ Biennial, Bryant Park in Manhattan, the Jewish Museum in Berlin and the McCormick Freedom Museum in Chicago. She has also presented work at "Art in Odd Places" in New York, the Art Prospect festival in St. Petersburg, Russia, Encuentro in São Paulo, Brazil, and the International Symposium on Electronic Art in Dubai. Oring recently completed a public art commission at the San Diego International Airport and will complete a large-scale commissioned work for the Tampa International Airport in 2017. She received her MFA from the University of California, San Diego, and works as an Assistant Professor of Art at the University of North Carolina at Greensboro.